TEXAS A&M

DAILY DEVOTIONS FOR DIE-HARD FANS

AGGIES

TEXAS A&M

Also Available
Daily Devotions for Die-Hard Kids: Texas A&M Aggies

Daily Devotions for Die-Hard Fans: Texas A&M Aggies
© 2011, 2013, 2016 Ed McMinn
Extra Point Publishers; P.O. Box 871; Perry GA 31069

Visit us at www.die-hardfans.com.

Cover design by John Powell and Slynn McMinn
Interior design by Slynn McMinn

AGGIES

Daily Devotions for Die-Hard Fans
Available Titles

ACC

Clemson Tigers
Duke Blue Devils
FSU Seminoles
Georgia Tech Yellow Jackets
North Carolina Tar Heels
NC State Wolfpack
Notre Dame Fighting Irish
Virginia Cavaliers
Virginia Tech Hokies

BIG 10

Michigan Wolverines
Nebraska Cornhuskers
Ohio State Buckeyes
Penn State Nittany Lions

BIG 12

Baylor Bears
Oklahoma Sooners
Oklahoma State Cowboys
TCU Horned Frogs
Texas Longhorns
Texas Tech Red Raiders
West Virginia Mountaineers

SEC

Alabama Crimson Tide
MORE Alabama Crimson Tide
Arkansas Razorbacks
Auburn Tigers
MORE Auburn Tigers
Florida Gators
Georgia Bulldogs
MORE Georgia Bulldogs
Kentucky Wildcats
LSU Tigers
Mississippi State Bulldogs
Missouri Tigers
Ole Miss Rebels
South Carolina Gamecocks
MORE South Carolina Gamecocks
Texas A&M Aggies
Tennessee Volunteers

and *NASCAR*

Daily Devotions for Die-Hard Kids
Available Titles
Alabama, Auburn, Baylor, Georgia,
Miss. State, Ole Miss, Texas, Texas A&M

die-hardfans.com

TEXAS A&M

DAILY DEVOTIONS FOR DIE-HARD FANS

AGGIES

DAY 1

IN THE BEGINNING

Read Genesis 1; 2:1-3.

"God saw all that he had made, and it was very good" (v. 1:31).

A newspaper called the team "Bryan," they didn't have a single play, and exactly who their first opponent was has been lost to history. Still, this was the beginning of Texas A&M football.

In 1894, 18-year-old Milt Sims talked a couple of his fellow students, Art Watts and Charley Herndon, into organizing a team at Texas A&M. They soon had a squad of students, fifteen of whom made up A&M's first-ever football team. Dudley Perkins played end, trained, managed, and coached the team. The players chose red and white as the school colors.

They had only one football. The team "jersey" was a canvas jacket that laced up the front. Sims, the first team captain and the fullback, said the squad didn't have any set plays. "We just got the ball, bucked the line, and anything went," he recalled. "Fists, elbows, knees, anything."

The Farmers, as they were then known, scheduled a game against "Ball High" of Galveston. Despite the name, this may not have been a high-school team at all but rather "a hodgepodge of players of all ages from the Galveston Sports Association." The official A&M record, though, refers to the team as representing Galveston Ball High School. Another record simply calls them Galveston High School.

AGGIES

Whatever they were, history records that the A&M team beat Ball High 14-6 in that groundbreaking game. "We beat them so easy we got to thinking that we'd like to go over to Austin and play Texas," Sims recalled. So the team petitioned the school and got permission to make the trip to play the state's first-ever intercollegiate football game. Texas won, and the writer covering the game was apparently as inexperienced as were the Farmers; he consistently referred to the visitors only as "Bryan."

Football had begun at Texas A&M.

Beginnings are important, but what we make of them is even more important. Consider, for example, how far the Texas A&M football program has come since that first season.

Every morning, you get a gift from God: a new beginning. God hands to you as an expression of divine love a new day full of promise and the chance to right the wrongs in your life. You can use the day to pay a debt, start a new relationship, replace a burned-out light bulb, tell your family you love them, chase a dream, solve a nagging problem . . . or not.

God simply provides the gift. How you use it is up to you. People often talk wistfully about starting over or making a new beginning. God gives you the chance with the dawning of every new day. You have the chance today to make things right — and that includes your relationship with God.

Every day is a new opportunity. That's the way life is, with a new game every day.
— Hall of Fame pitcher Bob Feller

Every day is not just a dawn; it is a precious chance to start over or begin anew.

DANCING MACHINE

Read 2 Samuel 6:12-22.

"David danced before the Lord with all his might, while he and the entire house of Israel brought up the ark of the Lord with shouts and the sound of trumpets" (vv. 14-15).

What in the world could turn 65-year-old Texas A&M coach Gary Blair into a hip-hop dancing machine? Why, a national title of course.

Actually, Blair's whole team of Aggies busted moves after they beat Notre Dame 76-70 on April 5 to win the 2011 NCAA women's basketball national championship. A&M senior Danielle Adams, the program's first All-America and the tournament MVP, scored 30 points, 22 of them in the last half, to pace the win.

Both No. 2 seeds, the Aggies and the Irish played one of the most exciting and competitive games the women's finals have ever seen. "The two powers tonight were the two that earned it," Blair said.

Despite her dominance, Adams certainly didn't do it alone. Tyra White scored 18 points, hitting the shot that drove a knife deep into the collective Irish heart. As the shot-clock buzzer sounded, she nailed a three-pointer to propel the Aggies to a 73-68 lead with 1:07 to play.

Minutes after the game ended and the celebration began, the 33-5 national champions traded their sneakers in for dancing shoes and broke out into the Dougie. Blair, perhaps the least like-

ly person in the entire arena to pull off a hip-hop dance, was just too caught up in the festivities, the joy, and the emotion to resist. The coach "dipped, bounced, swayed and wiped his hand across his forehead to music" as he busted a move at the Big Dance. While Blair's gyrations may never earn him a spot on *Dancing with the Stars*, his coaching moves and his players' talent and efforts did bring a national championship home to College Station.

One of the more enduring stereotypes of the Christian is of a dour, sour-faced person always on the prowl to sniff out fun and frivolity and shut it down. "Somewhere, sometime, somebody's having fun — and it's got to stop!" Many understand this to be the mandate that governs the Christian life.

But nothing could be further from reality. Ages ago King David, he who would eventually number Jesus Christ among his house and lineage, set the standard for those who love and worship the Lord when he danced in the presence of God with unrestrained joy. Many centuries and one savior later, David's example today reminds us that a life spent in an awareness of God's presence is all about celebrating, rejoicing, and enjoying God's countless gifts, including salvation in Jesus Christ.

Yes, dancing can be vulgar and coarse, but as with David, God looks into our hearts to see what is there. Our very life should be one long song and dance for Jesus.

Dancers are the athletes of God.

— Albert Einstein

While dancing and music can be vulgar and obscene, they can also be inspiring expressions of abiding love for God.

DAY 3

IN A WORD

Read Matthew 12:33-37.

*"For out of the overflow of the heart the mouth speaks.
The good man brings good things out of the good stored
up in him, and the evil man brings evil things out of the
evil stored up in him" (vv. 34b-35).*

Enclosed please find one railroad ticket." With those few words,
coach Homer Norton changed the history of A&M football.

In 1937, Norton paid a personal visit to the West-Texas home of
high-school star John Kimbrough. After suffering losing seasons
his first two years, Norton had the Aggie football program back on
track with an 8-3-1 record in 1936. He needed blue-chippers like
Kimbrough, though, to field a consistent winner. The youngest of
six boys was so good that he made his high-school squad in the
seventh grade.

Norton earnestly pitched the advantages of an A&M education
to Kimbrough, even mentioning free khakis, which came along
with the mandatory membership in the Cadet Corps. But the star
player was the son of a physician, and an older brother was an
intern at the time. He wanted to follow in their footsteps with a
medical career, so he was determined to attend Tulane and play
fullback for the Green Wave. Kimbrough thus declined Norton's
offer and packed up for New Orleans.

It took only two weeks on the Tulane campus for Kimbrough
to have a change of heart. He sat down and wrote Norton a note:

"Dear Coach: You were right. I'm unhappy here and plan to change schools. Would you still have a spot for me at A&M?" The result was Norton's extremely pithy, effective reply: "Enclosed please find one railroad ticket."

With those words, Norton secured "the marquee player on what may have been the greatest team the greatest generation ever knew." Kimbrough was the star fullback for the undefeated national champions of 1939.

Words. These days, it seems as though everybody's got something to say and likely as not a place to say it. Talk radio, 24-hour sports and news TV channels, late-night talk shows. Daytime gabfests. Talk has really become cheap.

But words still have power, and that includes not just those of the talking heads, hucksters, and pundits on television, but ours also. Our words are perhaps the most powerful force we possess for good or for bad. The words we speak today can belittle, wound, humiliate, and destroy. They can also inspire, heal, protect, and create. Our words both shape and define us. They also reveal to the world the depth of our faith.

We should never make the mistake of underestimating the power of the spoken word. After all, speaking the Word was the only means Jesus had to get his message across — and look what he managed to do.

We must always watch what we say, because others sure will.

Don't talk too much or too soon.

— *Bear Bryant*

Choose your words carefully; they are the most powerful force you have for good or for bad.

DAY 4

PROMISES, PROMISES

Read 2 Corinthians 1:16-20.

"No matter how many promises God has made, they are 'Yes' in Christ" (v. 20).

Terrence Murphy made a promise to his mama and followed up on it. He thus became one of the most decorated and honored receivers ever to put on an Aggie uniform.

Murphy finished his playing days in College Station in 2004. He was twice first-team All-Big 12 and was named three times to the Academic All-Big 12 team. He was twice a team captain and set A&M records with 172 receptions for 2,600 yards despite not playing receiver until he arrived at A&M. (Ryan Swope (2209-12) broke both records with 252 receptions and 3,117 yards.) Murphy also returned kickoffs and had seventeen rushes.

All that success, which led to Murphy's being drafted by the Green Bay Packers in 2005, was actually the keeping of a promise Murphy made to his mama when he was a child. After a string of heartaches in the Murphy family that left his mother in tears, Murphy promised her he'd never let her down. "Growing up, I'd seen what other family members had done to my mom, and it hurt her a lot," Murphy remembered. So he made his promise. "That's why I've tried to work as hard as I can — for my mom."

Born prematurely, Murphy was sickly as a child. He recalled that for the first five or six years of his life, he was "always in and out of the hospital." He never forgot how his mother cared for

him. "When I'd be awake all night because I was sick, she was in the room with me," he remembered.

A&M safety Jaxson Appel saw the results of Murphy's promise in his teammate's daily life. "He's a devout Christian, and he is one of those people you really want to be associated with," Appel said of Murphy. A&M fans also benefited from Murphy's promise. He decided against turning pro after the 2003 season because his mother wanted him to get his degree.

The promises you make don't say much about you; the promises you keep tell everything.

The promise to your daughter to be there for her softball game. To your son to help him with his math homework. To your spouse to remain faithful until death parts you. Maybe even a promise to your mother. And remember what you promised God that time you were so desperate?

You may carelessly throw promises around, but you can never outpromise God, who is downright profligate with his promises. For instance, he has promised to love you always, to forgive you no matter what you do, and to prepare a place for you with him in Heaven.

And there's more good news in that God operates on this simple premise: Promises made are promises kept. You can rely absolutely on God's promises. The people to whom you make them should be able to rely just as surely on your promises.

I told her I'd never disappoint her.
— Terrence Murphy on the promise that guided his life

God keeps his promises just as those who rely on you expect you to keep yours.

HEART AND SOUL

Read Romans 12:1-2.

"Therefore, I urge you, brothers, in view of God's mercy,
to offer your bodies as living sacrifices, holy and pleasing
to God — this is your spiritual act of worship" (v. 1).

Despite pressure from as high up as the governor, Al Ogletree honored his commitment to play baseball for A&M. Aggie history was the result.

Before he became a college coaching legend, Ogletree was an All-Southwest Conference catcher in 1951. He is a member of the A&M Athletic Hall of Fame. A&M's Marty Karow was the only coach who contacted him in high school, so Ogletree committed to the Aggies though he had never seen the school.

After Ogletree graduated from high school in 1948, Texas made a late run at him. Despite an offer of tuition, books, and a job from the Longhorns ("I don't know if that was legal at the time," Ogletree said.), Ogletree stuck with his commitment.

As Ogletree starred on the A&M freshman team, Gov. Buford Jester got into the act, inviting the Aggie and his dad to dinner at the mansion. After supper, the governor asked Ogletree if he had thought about transferring to Texas. "No, sir. I am committed to A&M," the young catcher responded. The governor said that was good enough for him.

Ogletree went on to lead the Aggies "to a place no A&M team had been before": the College World Series. In a best-of-three play-

off against Arizona, the Aggies trailed 4-3 in the ninth inning of the first game. An error let Yale Lary score the tying run with two outs, and then Ogletree doubled to chase Henry Candelari home with the winning run. When the Aggies won the third game 14-2, they were on their way to Omaha for the first time ever, led by a player who honored his commitment to the school.

When you stood in a church and recited your wedding vows, did you make a decision that you could walk away from when things got tough or did you make a lifelong commitment? Is your job just a way to get a paycheck, or are you committed to it?

Commitment seems almost a dirty word in our society these days, a synonym for chains, an antonym for freedom. Perhaps this is why so many people are afraid of Jesus: Jesus demands commitment. To speak of offering yourself as "a living sacrifice" is not to speak blithely of making a decision but of heart-body-mind-and-soul commitment.

But commitment actually means "purpose and meaning," especially when you're talking about your life. Commitment makes life worthwhile. Anyway, in insisting upon commitment, Jesus isn't asking anything from you that he hasn't already given to you himself. His commitment to you was so deep that he died for you.

There are only two options regarding commitment. You're either in or you're out. There is no such thing as life in-between.

— *Pat Riley*

**Rather than constraining you, commitment
to Jesus lends meaning to your life,
releasing you to move forward with purpose.**

THE HEALING TOUCH

Read Matthew 17:14-20.

"If you have faith as small as a mustard seed, you can say to this mountain, 'Move from here to there' and it will move. Nothing will be impossible for you" (v. 20).

The doctors weren't sure Antonio Armstrong would live. When he did, they told him he would have severe headaches the rest of his life. And then God did what the doctors couldn't do: God healed him.

Armstrong is one of A&M's greatest players. He was an All-American linebacker in 1994 who was first-team All-SWC in 1993 and '94. With eight tackles and three sacks, he was the defensive MVP in the 24-21 win over Notre Dame in the 1994 Cotton Bowl. As a senior in '94, he led an Aggie defensive unit that finished fourth nationally in scoring defense and fifth in total defense.

That Armstrong played college football at all was a miracle. His senior year in high school he developed a brain aneurysm. "The doctors didn't know if I was going to live or die," he recalled. "They said that if I did come out of it, I would never play football again." Doctors kept him sedated to prevent seizures; for days at a time, Armstrong wouldn't know where he was.

But he had on his side something stronger and more powerful than the doctors and all their skills and medicines. He had a praying mother. "She wouldn't stop praying," Armstrong said. Her prayers were answered; her son lived.

But Armstrong wasn't completely healed. He later had a CAT scan that revealed scar tissue. Doctors told him he would have severe headaches the rest of his life.

During a subsequent church service, Armstrong responded when the preacher asked if anyone had any physical ailments. "I went up and he prayed for me," he said. When Armstrong made his next visit to the doctors, they could find no trace of scar tissue and released him to play football.

The doctors couldn't heal him. Only God could.

If we believe in miraculous healing at all, we have pretty much come to consider it to be a relatively rare occurrence. All too often, our initial reaction when we are ill or hurting is to call a doctor rather than to pray. If we really want to move a mountain, we'll round up some heavy-duty earthmoving equipment rather than pray about it.

The truth is, though, that divine healing occurs with quite astonishing regularity; the problem is our perspective. We are usually quite effusive in our thanks to and praise for a doctor or a particular medicine without considering that God is the one who is responsible for all healing.

We should remember also that "natural" healing occurs because our bodies react as God created them to. Those healings, too, are divine; they, too, are miraculous. Faith healing is actually nothing more — or less — than giving credit where credit is due.

It was nothing short of a miracle from God.
— Antonio Armstrong on his being healed

God does in fact heal continuously everywhere;
all too often we just don't notice.

DAY 7

DREAM WORLD

Read Joshua 3.

"All Israel passed by until the whole nation had completed the crossing on dry ground" (v. 17b).

Texas A&M's 2012 football season wasn't real, was it? It could only have been a dream.

Here's the dream:

1) The Aggies win 11 game for the fourth time in the program's history. That's dreamworthy enough, but let's make it their first season in the SEC, the nation's toughest football conference.

2) Head coach Kevin Sumlin is named the SEC Coach of the Year. It's a dream so make it his first season in College Station.

3) The quarterback wins the Heisman Trophy. That would be Johnny Manziel, who was battling for the starting job when fall practice started. Let's dream big and make him a redshirt freshman even though a rookie had never won the big prize.

4) As long as it's nothing but a dream, let's have offensive tackle Luke Joeckel become the first Aggie in history to win the Outland Trophy as the nation's best interior lineman.

5) Let's spread the dream around and have four All-Americas for the first time in Aggie history: Manziel, Joeckel, linebacker Damontre Moore, and tackle Kevin Matthews.

5) While we're dreaming on, let's have the Aggie offense shake up the venerable SEC by setting an all-time league mark for offense. Why not have also have Manziel set an SEC single-

season record for total yardage?

6) As long as we're dreaming and anything's possible, let have the Aggies go into Tuscaloosa and beat top-ranked Alabama. Never mind that A&M had never beaten a No.-1 team on the road.

7) Let's top off the dream by putting the Aggies in the Cotton Bowl and having them slaughter old nemesis Oklahoma 41-13.

Only thing is, none of it's a dream. It's all real. It happened.

No matter how tightly or how doggedly we cling to our dreams, devotion to them won't make them a reality. Moreover, the cold truth is that all too often dreams don't come true even when we put forth a mighty effort. The realization of dreams generally results from a head-on collision of persistence and timing.

But what if our dreams don't come true because they're not the same dreams God has for us? That is, they're not good enough and, in many cases, they're not big enough.

God calls us to great achievements because God's dreams for us are greater than our dreams for ourselves. Could the Israelites, wallowing in the misery of slavery, even dream of a land of their own? Could they imagine actually going to such a place?

The fulfillment of such great dreams occurs only when our dreams and God's will for our lives are the same. Our dreams should be worthy of our best — and worthy of God's involvement in making them come true.

[The win over Oklahoma] was the culmination of a season no one could have possibly imagined.
— Sportswriter Richard Croome on A&M's dream season in 2012

If our dreams are to come true, they must be worthy of God's involvement in them.

NOISEMAKER

Read Psalm 100.

"Shout for joy to the Lord, all the earth!" (v. 1)

Thanks to the crowd noise, the Texas Longhorns once committed football suicide in Kyle Field.

The 1985 game between the Aggies and the Horns was one of the most hyped and anticipated games in the storied series. Both teams were ranked, and to the winner went the conference title and a trip to the Cotton Bowl.

The frenzied A&M fans "cheered the punters in warm-ups as if they were rock stars," and the noise got louder and more intimidating by kickoff. The first half, however, was rather pedestrian. In the second quarter, Aggie Hall-of-Famer Kevin Murray hit wide receiver Jeff Nelson with a 10-yard TD toss, the only score of the half. Despite the lack of offensive firepower, the "electricity in the stands remained palpable." The crowd's finest hour lay ahead, though.

Murray and his receivers connected for three touchdown passes in the third quarter, each score sending "the already rocking stadium into a frenzy" that would not subside. Sensing the kill, the Aggie fans moved in. As a roar "cascad[ed] down the three decks of Kyle Field," the Texas quarterback made a fatal mistake. He "refused to snap the ball until the din subsided." But it didn't; it only got worse (or better for the Aggies). "With each passing minute of delay, [the Texas QB] looked to the referee for help.

There was none." The Horns were simply overwhelmed by "the howls that filled the stadium," and Texas never recovered.

"It was the worst thing he could have done," Murray observed. "He committed suicide by waiting to snap the ball."

When the game was over, the Aggie crowd was still yelling. A&M was headed to the Cotton Bowl with a 42-10 stomping of the Longhorns.

Whether you're at an Aggie game live or watching on TV, you no doubt have contributed to the general uproar generated by tens of thousands of fans at Kyle Field or your buddies in the den. You've probably been known to whoop it up pretty good at some other times in your life, too. The birth of your first child. The concert of your favorite band. That fishing trip when you caught that big ole bass.

But how many times have you ever let loose with a powerful shout to God in celebration of his love for you? Though God certainly deserves it, he doesn't require that you walk around waving pompoms and shouting "Yay, God!" He isn't particularly interested in having you arrested as a public menace.

No, God doesn't seek a big show or a spectacle. A nice little "thank you" is sufficient when it's delivered straight from the heart and comes bearing joy. That kind of noise carries all the way to Heaven; God hears it even if nobody else does.

I remember coming out of the locker room and feeling the stadium shaking. The 12th Man towels were everywhere.
— Linebacker Johnny Holland on the '85 Texas game

The noise God likes to hear is a heartfelt "thank you," even when it's whispered.

ON THE MONEY

Read Luke 16:1-15.

"You cannot serve both God and money" (v. 13b).

Texas A&M's football program was once so broke that the head coach agreed to play a game while the Aggies were on their way to another one.

Homer Norton arrived in College Station in 1934 to head up the Aggie football program, "and it must have occurred to him very quickly that he had not researched his new job with the proper diligence." He quickly learned two crucial facts about the program: he didn't have much talent and he had less money.

During Norton's first two seasons, football tickets were marked down to a dollar and a half. The discounts left the program short of the revenue it needed to make its interest payments on a note at a Dallas bank. Joe Utay, a halfback from 1905-07 who was later called the school's "first real star," railroaded a special bill through the state legislature that allowed the A&M financial office to lend the athletic department $30,000 to keep it afloat. But the bank now had to approve all expenses, forcing Norton to explain "why the players needed more than one pair of shoes and why, with 6,000 male students to pick from, he needed scholarships."

By 1936, Norton and the Aggies were winning, but they still had money problems that sometimes necessitated the use of extreme measures. The team was on its way by train to play the University of San Francisco on Saturday, Nov. 14, when Norton received a

telegram from the University of Utah begging the Aggies to bail them out of a jam. Their opponent for an Armistice Day observance in Salt Lake City had cancelled. "Since the Aggies were in the neighborhood," would they play the game?

Because A&M received a nice financial guarantee that didn't require any extra expenses, Norton agreed. The players slept on the train rather than in hotel rooms. A&M drubbed San Francisco 38-14 and then three days later whipped Utah 20-7. They came home with two wins under their belts and some extra cash in their coffers.

Having a little too much money at the end of the month may be as bothersome — if not as worrisome — as having a little too much month at the end of the money. The investment possibilities are bewildering: stocks, bonds, mutual funds, or that group pooling their money to open up a local coffee shop — that's a good idea.

You take your money seriously, as well you should. Jesus, too, took money seriously, warning us quite often of its perils. Money itself is not evil; its danger lies in the ease with which it can usurp God's rightful place as the master of our lives.

Certainly in our age and society, we often measure people by how much money they have. But like our other talents, gifts, and resources, money should primarily be used for God's purposes. God's love must touch not only our hearts but our wallets also.

How much of your wealth are you investing with God?

[Texas A&M] was a proud school reduced to barnstorming for a payday.
— Writer Mickey Herskowitz on the agreement to play Utah

**Your attitude about money says much about
your attitude toward God.**

WHOLEHEARTEDLY

Read 1 Samuel 13:1-14.

"The Lord has sought out a man after his own heart" (v. 14).

The Aggies of 2010 had the talent they needed to win. Against Baylor, they proved they had something more: They had heart.

On the night of Nov. 13, 2010, against the Bears in Waco, the A&M football team faced enough adversity to last it a season:

1) Starting running back Christine Michael was out for the season after suffering a broken leg against Texas Tech. So junior Cyrus Gray rushed for a career-high 134 yards and scored four touchdowns.

2) Baylor jumped out to a 10-0 lead before all the fans had even settled into their seats. So junior Coryell Judie ran back the second kick for a touchdown, becoming the first Aggie in history to return a kickoff for a TD in successive games.

3) The defense gave up nearly 400 yards of offense in the first half. So the modern-day Wrecking Crew came out in the last half and brutalized the Bears, giving up only 136 yards and zero points and making two big fourth-down stops.

4) Baylor led 30-14 at halftime as the Aggies had three touchdowns called back. So the offense responded with a near-flawless last half that resulted in 28 points.

When the A&M players had finished playing their hearts out, they had rolled past Baylor 42-30 to claim their fourth straight

win. "We had the will to win and never gave up," said junior quarterback Ryan Tannehill, who threw for 280 yards.

After the disastrous start, the Aggies could easily have folded. But head coach Mike Sherman kept the team calm in the halftime locker room. "This is not a time to panic; let's just get done what needs to be done," he told his players.

After the game, Baylor head coach Art Briles said, "We lost to a team that I thought we should not have lost to." He just didn't reckon on the size of the Aggies' collective heart.

We all face defeat in our lives. Sometimes, even though we fight with all we have, we lose. Even the Aggies doesn't always come back as they did against Baylor.

At some time, you probably have admitted you were whipped no matter how much it hurt. Always in your life, though, you have known that you would fight for some things with all your heart and never give them up: your family, your country, your friends, your core beliefs.

God should be on that list too. God seeks men and women who will never turn their back on him because they are people after God's own heart. That is, they will never betray God with their unbelief; they will never lose their childlike trust in God; they will never cease to love God with all their heart.

They are lifetime members of God's team; it's a mighty good one to be on, but it takes heart.

We have fighters on this team who will do anything to win.
— Ryan Tannehill after the win over Baylor

To be on God's team requires
the heart of a champion.

DAY 11

YOU DECIDE

Read John 6:60-69.

"The words I have spoken to you are spirit and they are life. Yet there are some of you who do not believe" (vv. 63b-64a).

Rachel Shipley was going to play soccer for Texas A&M. She just had to realize it and make the decision for herself.

From 2007-10, Shipley was one of the key players in a four-year soccer run that included two Big 12 titles and four berths in the NCAA tournament. That stretched A&M's streak of successive appearances to sixteen (a streak that was at 20 through the 2014 season). She scored the game-winning goal against Oklahoma State in 2010 to win the Big 12 Championship. She was All-Big 12 first team in 2009; in 2010, she was named to both the Academic All-Big 12 first team and the Big 12 All-Tournament team.

There never seemed to be any doubt that Shipley would play soccer for A&M. Aggie head coach G Guerrieri knew her family before she was born. He followed her career from the time she was a club player before high school.

Moreover, Aggie blood ran deep in her veins. Her grandfather was A&M's vice president of student affairs for twenty years. Her uncle, Ray Childress, was an All-American defensive tackle at A&M. Both her parents are A&M graduates. Growing up, she regularly visited her grandparents' house on campus and was thus immersed in the Aggie tradition almost from birth.

And yet, as the recruiting battle heated up, Shipley found herself hesitating. She seriously considered scholarship offers from the likes of Notre Dame, Florida, and (gasp!) Texas. One visit that "didn't really click" cured her of that latter misstep.

Eventually, Shipley realized she had already made her decision. "I was like, 'What am I doing?' I want to go to A&M," she said. And so she did.

As with Rachel Shipley, the decisions you have made along the way have shaped your life at every pivotal moment. Some decisions you made suddenly and carelessly; some you made carefully and deliberately; some were forced upon you. You may have discovered that some of those spur-of-the-moment decisions have turned out better than your carefully considered ones.

Of all your life's decisions, however, none is more important than one you cannot ignore: What have you done with Jesus? Even in his time, people chose to follow Jesus or to reject him, and nothing has changed; the decision must still be made and nobody can make it for you. Ignoring Jesus won't work either; that is, in fact, a decision, and neither he nor the consequences of your decision will go away.

Carefully considered or spontaneous — how you arrive at a decision for Jesus doesn't really matter; all that matters is that you get there.

I started thinking about all the reasons I loved it to begin with. It's unlike any other place in the country.
 — Rachel Shipley on her decision to attend A&M

A decision for Jesus may be spontaneous or considered; what counts is that you make it.

TOUGH AS NAILS

Read 2 Corinthians 11:21b-29.

"Besides everything else, I face daily the pressure of my concern for all the churches" (v. 28).

They may well be the toughest players in the history of college football. They were the Junction Boys of Coach Bear Bryant.

A sophomore in the fall of 1954, Gene Stallings, who would coach the Aggies from 1965-71, recalled, "When we reported for fall practice, Coach Bryant told us to get a blanket, pillow, and several changes of clothes because we were going on a trip." That trip took them west to Junction, Texas, for pre-season training that has become so legendary a movie has been made about it.

Bryant didn't take his team on a journey into what amounted to college football's nether regions just to establish himself as a petty tyrant. When Bryant arrived in College Station, he expected to find at least fifteen capable football players from the seventy-five prospects on scholarship. He didn't. His response was the most drastic training camp in college football history.

In Junction, on a parched, baked plot of land, the players suffered through three grueling practice sessions each day in heat that routinely reached 110 degrees. Bryant didn't allow any water breaks, equating water with weakness. Stallings said that the players were "pushed to the point of extinction," so much so that as the team rode the bus across a river in Junction each day, he hoped the brakes would fail. Being injured — or even dying —

"was a more 'honorable way out' as opposed to quitting."

Not surprisingly, "most of the players couldn't — or perhaps just wouldn't — take it," and the roster steadily dwindled. Of the original 111 who made the trip out, fewer than three dozen of the toughest football players in history made it back from the ten days in Junction. They went undefeated and won the conference championship in 1956.

You don't have to be a legendary Texas A&M football player to be tough. In America today, toughness isn't restricted to physical accomplishments and brute strength. Going to work every morning even when you're not feeling well, sticking by your rules for your children in a society that ridicules parental authority, making hard decisions about ethics and morality — you've got to be tough every day just to live honorably, decently, and justly.

Living faithfully requires toughness, too, though in America chances are you won't be imprisoned, stoned, or flogged this week for your faith as Paul was. Still, contemporary society exerts subtle, psychological, daily pressures on you to turn your back on your faith and your values. Popular culture promotes promiscuity, atheism, and gutter language; your children's schools have kicked God out; the corporate culture advocates amorality before the shrine of the almighty dollar.

You have to hang tough to keep the faith.

With the Junction Boys, Bryant established a standard of toughness Aggies to this day and those of the future know they have to meet.
— Writers Wilbur Evans and H.B. McElroy

**Life demands more than mere physical toughness;
you must be spiritually tough too.**

THEFT BY TAKING

Read Exodus 22:1-15.

"A thief must certainly make restitution" (v. 2b).

The dog was gone — and it made news all across the country.

In 1993, a band of thirty University of Texas students calling themselves the Rustlers pulled off a caper that had never been managed before: They kidnapped Reveille. They staked out the home of the cadet corporal assigned to care for Reveille VI. When the puppy was put into the backyard to take care of some doggie business, a Rustler called her to the fence and snatched her.

A&M officials did not initially reveal that Reveille VI had been dognapped, but then the Rustlers called the *Austin American Statesman*, announced they had the dog, and demanded a ransom with two conditions. A&M officials had to "say that UT is better than them," and Aggie quarterback Corey Pullig had to flash the "Hook 'em Horns" sign during the Cotton Bowl in which R.C. Slocum's three-time conference champs were playing Notre Dame.

University officials didn't treat the theft as a harmless college prank. "It's a serious felony," declared Rene Henry, the executive director of university relations. "In terms of marketing and tradition, she could be worth $1 million. You're talking about a superstar on the order of Lassie and Benji."

The story of Reveille's dognapping appeared in newspapers from New York to Los Angeles. University of Texas alums spoke out to condemn the theft. Said one UT grad, "The Neanderthals

that did this should be expelled."

Apparently coming to their senses, the Rustlers determined that the jig was up, telephoned a local radio station, and told them the dog's whereabouts. Unharmed except for the presence of some demeaning fleas and the loss of a little weight, Reveille was retrieved and bathed and was on time for her appearance at the Cotton Bowl. She received a raucous welcome.

Buckle up your seat belt. Wear a bicycle or motorcycle helmet. Use your pooper scooper to clean up after your dog. Don't walk on the grass. Picky ordinances, picky laws — in all their great abundance, they're an inescapable part of our modern lives.

When Moses came stumbling down Mt. Sinai after spending time as God's secretary, he brought with him a whole mess of laws and regulations, many of which undoubtedly seem picky to us today. What some of them provide, though, are practical examples of what for God is the basic principle underlying the theft of personal property: what is wrong must be made right.

While most of us today won't have to worry too much about the theft of livestock such as oxen, sheep, and donkeys, making what is wrong right remains a way of life for Christians. To get right with other people requires anything from restitution to apologies. To get right with God requires Jesus Christ.

I'd probably end up in something like a witness protection program [if Reveille were stolen].
— *The cadet handler of Reveille VI*

**To make right the wrong of stealing
requires restitution; to make right our
relationship with God requires Jesus Christ.**

YOU NEVER KNOW

Read Acts 26:1-20.

"'[I]n all Judea, and to the Gentiles also, I preached that they should repent and turn to God'" (v. 20).

He wasn't recruited, he didn't make the basketball team, and he stayed in shape practicing with the A&M women's team. Yet he won the football team's highest honor. You just never know.

Travis Labhart didn't have a single football scholarship offer out of high school. Since basketball was his first love and he was raised in an Aggie family, he headed to A&M to walk on to the basketball team. The squad was full his freshman season, so he worked out with the women's team to stay in shape.

In the fall of 2010, Labhart tried out for the men's basketball team but didn't make it. He went home over Christmas break disappointed and crushed. "While we were playing LSU [in the 2011 Cotton Bowl], I was in Colorado skiing," Labhart said. "I made a decision I really wanted to play football."

He made the team as a walk-on that spring and worked his way into the wide receiver rotation in the fall. He developed a close bond with another scout teamer, a guy named Johnny Manziel. A series of injuries set him back. One of them, a broken collarbone healed up while he spent time as a counselor at a Christian camp.

Prior to his senior season of 2013, the coaches awarded Labhart a scholarship. He eventually became a starter, nabbing 51 of Manziel's passes for 626 yards and eight touchdowns, including

three scoring catches in the 52-48 win over Duke in the Chick-fil-A Bowl. At the football banquet after the end of the regular season, Labhart capped off his remarkable and unlikely story by winning the Aggie Heart Award, the team's highest honor.

You never know what you can do until — like Travis Labhart — you want to bad enough or until — like Paul — you have to because God insists. Serving in the military, maybe even in combat. Standing by a friend while everyone else unjustly excoriates her. Undergoing agonizing medical treatment and managing to smile. You never know what life will demand of you.

It's that way also in your relationship with God. As Paul, discovered — he who was the most persistent persecutor of the first-century Christians — you just never know what God will ask of you. You can know that God expects you to be faithful; thus, you must be willing to trust him even when he calls you to tasks that appear daunting and beyond your abilities.

You can respond faithfully and confidently to whatever it is God calls you to do for him. That's because even though you never know what lies ahead, you can know with absolutely certainty that God will lead you and will provide what you need. As it was with the Israelites, God will never lead you into the wilderness and then leave you there.

It's been a very interesting ride. You don't hear about many people going from doing women's basketball to football. It's been a blessing.
— Travis Labhart on his unlikely journey to the A&M football team

You never know what God will ask you to do,
but you always know he will provide everything
you need to do it.

THE SCARS

Read John 20:19-31.

'"Put your finger here; see my hands. Reach out your hand and put it into my side. Stop doubting and believe'"
(v. 27).

Meagan May's scars tell the story of the day she was in a horrific car accident — that day she found God.

A freshman catcher in 2010, May established herself as a softball star for the powerhouse Aggies. She started every game, and her 24 home runs was both an A&M and a conference record. She led the team with 45 runs, 16 doubles, and 62 RBIs and was named first-team All-Big 12.

While she was working on her athletic skills, God was working on her heart. She confessed she was confused about religion, and she started asking questions. Her boyfriend suggested that she should pray about it. "All I did was ask for something, just something where I would know to believe in God," she said.

About a week later, on June 26, 2010, she got her sign. The car she was driving collided with another vehicle. Her car went airborne and flipped three and one-half times. The first respondents on the scene took one look at the car and how it had rolled and started marking the site for a death.

But May was far from dead. She suffered a concussion and a severe laceration that she described as "major carpet burn." The roof of the car "hit my head and scalped me a little bit," she said.

That was an apt description. The collision removed about four square inches of skin from her forehead.

The injury required four surgeries and left her with scars — and a new life. That she lived, that she suffered such relatively minor injuries (She couldn't play while she healed because she couldn't put a batting helmet on.), that the only surgeon on call at the hospital the day of the accident was a skin specialist — May knows none of that was luck. "I found God through that accident," she said. "I know that He has a plan for [my life]. . . . I'm extremely glad it all happened. It may not have been the way I expected, but I got my answer."

You have scars too. That car wreck left a good one. So did that bicycle crash. Maybe we better not talk about that time you said, "Hey, watch this!" Your scars are part of your life story, the residue of the pain you've encountered. People's scars are so unique and ubiquitous they're used to identify bodies.

Even Jesus proved who he was by the scars in his hands and in his side. How interesting it is that even after his resurrection, Jesus bore the scars of the pain he endured. Apparently, he bears them still even as he sits upon his throne in Heaven. Why would he even have them in the first place? Why would he, who had all the power in the universe, submit meekly to being tortured and slaughtered?

He did it for you. Jesus' scars tell the story of his love for you.

It's just a reminder that there are bigger things out there than just me.
— Meagan May on her scars

In your scars lie stories; the same is true for Jesus, whose scars tell of his love for you.

DAY 16

THE CHALLENGE

Read Matthew 4:12-25.

"Come, follow me," Jesus said (v. 19).

Aggie head coach Mike Sherman challenged his players' manhood, and the result left the opposing coach talking about his players' "fat little girlfriends."

The pundits had decided that Aggies were little better than cannon fodder when they showed up in Lubbock for the Oct. 24, 2009, game against the 21st-ranked Red Raiders of Texas Tech. Two weeks before, Tech had blasted Kansas State 66-14. A week later, State had embarrassed the Aggies 62-14 to drop them to 4-3 for the season. The line for the game had Tech favored by three touchdowns.

Sherman figured that for his players the Texas Tech game was about something much more visceral than proving they were good football players; they had to prove they were men. So the head man challenged them during the week to go out and prove what they really were made of. Sherman especially targeted his offensive linemen. "I really challenged those linemen," he said. "I was on them in practice and really backed them into a corner."

Their abilities and their manhood challenged, the Aggies, in the words of their proud coach, "came out swinging" against the Red Raiders. They stomped Texas Tech 52-30, the first A&M win in Lubbock in sixteen years.

And they played tough. On one play, tight end Jamie McCoy

snagged a pass across the middle and was blasted by the Raider defender. Both crumpled to the turf until a Texas Tech player came over and taunted McCoy. "I had to get up," McCoy said. He did, leaving the Tech player alone and down.

After the game, Tech coach Mike Leach said his players spent the whole week "strutt[ing] around and laugh[ing] and listen[ing] to their fat little girlfriends" tell them how good they were.

Like the A&M athletic teams every time they take the field or the court, we are challenged daily. Life is a testing ground; God intentionally set it up that way. If we are to grow in character, confidence, and perseverance, and if we are to make a difference in the world, we must meet challenges head-on. Few things in life are as boring and as destructive to our sense of self-worth as a job that doesn't offer any challenges.

Our faith life is the same way. The moment we answered Jesus' call to "Come, follow me," we took on the most difficult challenge we will ever face. We are called to be holy by walking in Jesus' footsteps in a world that seeks to render our Lord irrelevant and his influence negligible. The challenge Jesus places before us is to put our faith and our trust in him and not in ourselves or the transitory values of the secular world.

Daily walking in Jesus' footsteps is a challenge, but the path takes us all the way right up to the gates of Heaven — and then right on through.

Sports challenge you and build character for everything you do in life.
— Howie Long

To accept Jesus as Lord is to joyfully take on the challenge of living a holy life in an unholy world.

DAY 17

NAME DROPPING

Read Exodus 3:13-20.

"God said to Moses, 'I AM WHO I AM. This is what you are to say to the Israelites: 'I AM has sent me to you'"" (v. 14).

They'r-r-r-r-e back! Like a poltergeist from the past terrifying the opposition, the Wrecking Crew returned in 2010.

Defensive back Chet Brooks, who lettered for A&M from 1985-87, holds a special place in Aggie football lore. After a win, Brooks told a reporter that the defense played like a wrecking crew. One of college football's greatest nicknames was born.

"We had [linebackers] Aaron Wallace and John Roper and those guys blitzing" in 1986, said head coach R.C. Slocum. "Chet said it looked like a wrecking crew. . . . [We] started saying, 'We're going to wreck something else this week.'"

Players wore hard hats and carried tools in photographs that publicized the Crew. In a *Sports Illustrated* feature on the best game-wrecking plays in college football, the Crew's pass rush was the only defensive play included. The name was quoted and printed so frequently that the school patented it to market it.

Crew members developed a special handshake; coveted Crew baseball caps were presented to players who excelled. All that recognition and fun was possible, though, only because the Crew played a dominating defense that consistently ranked among the best in the nation.

The nickname gradually faded away after the 1990s until suddenly it reappeared on Nov. 6, 2010, when the Aggies dismantled 11th-ranked Oklahoma 33-19. The defense made three goal-line stands that kept the Sooners out of the end zone. At game's end, the fans honored the defense's play by chanting that most storied of A&M nicknames: "Wrecking Crew."

Nicknames such as the Wrecking Crew are not slapped haphazardly upon individuals but rather reflect widely held perceptions about the person named. Proper names do that also.

Nowhere throughout history has this concept been more prevalent than in the Bible, where a name is not a mere label but is an expression of the essential nature of the named one. That is, a person's name reveals his or her character. Even God shares this concept; to know the name of God is to know God as he has chosen to reveal himself to us.

What does your name say about you? Honest, trustworthy, a seeker of the truth and a person of God? Or does the mention of your name cause your coworkers to whisper snide remarks, your neighbors to roll their eyes, or your friends to start making allowances for you?

Most importantly, what does your name say about you to God? He, too, knows you by name.

Hearing the fans chanting 'Wrecking Crew' gave me chills. It's indescribable to hear the fans screaming that for us.
— Senior linebacker Michael Hodges

Live so that your name evokes positive associations by people you know, by the public, and by God.

BEING DIFFERENT

Read Daniel 3.

"We want you to know, O king, that we will not serve your gods or worship the image of gold you have set up" (v. 18).

Stacy Sykora wasn't just different because she was a great volleyball player. She was different because — well, for one thing, there was Bozo.

Sykora is truly one of the great athletes to pass through Texas A&M. In both 1997 and '98, she was All-America in volleyball, and in 1996, she won the Big 12 Conference title in the heptathlon. She competed with the U.S. volleyball team in three Olympics, winning the Silver Medal in Beijing in 2008.

Sykora is also one of Texas A&M's great characters. Perhaps her quirkiest trait was her devotion to a clown doll named Bozo, her "somewhat disturbing . . . sidekick . . . who had been by her side since she was in the second grade." Bozo even made road trips with the A&M team in 1995, "but Bozo learned to stay at home," deadpanned Aggie coach Laurie Corbelli. "We thought Bozo was gross." From then on, Sykora carried a mug shot of Bozo with her on road trips.

Described as "a raging beauty with a phenomenal vertical jump and a lion's heart," Sykora was always careful to show recruits her room, "just in case they were a little different, too." Among its features were a disco ball, Christmas lights, and "a frightfully

large poster of fellow eccentric Dennis Rodman."

Corbelli said the whole team was pulled into the quirky and delightful web cast by their teammate. "The team fed off her, and she didn't even realize it," Corbelli said. Outside hitter Kristie Smedsrud, who roomed with Sykora, said that sometimes they would all just sit around and watch her. Watching it all was Bozo, always in Sykora's bedroom and always armed with a quarter in one red shoe in case he got lost and needed to call someone.

While we live in a secular society that constantly pressures us to conform to its principles and values, we serve a risen Christ who calls us to be different. Therein lies the great conflict of the Christian life in contemporary America.

But how many of us really consider that even in our secular society we struggle to conform? We are all geeks in a sense. We can never truly conform because we were not created by God to live in such a sin-filled world in the first place. Thus, when Christ calls us to be different by following and espousing Christian beliefs, principles, and practices, he is summoning us to the lifestyle we were born for.

The most important step in being different for Jesus is realizing and admitting what we really are: We are children of God; we are Christians. Only secondarily are we citizens of a secular world. That world both scorns and disdains us for being different; Jesus both praises and loves us for it.

There are a lot of people who think I'm weird.

— *Stacy Sykora*

The lifestyle Jesus calls us to is different from that of the world, but it is the way we were born to live.

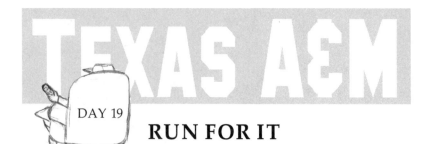

DAY 19

RUN FOR IT

Read John 20:1-10.

"Peter and the other disciple started for the tomb. Both were running, but the other disciple outran Peter and reached the tomb first" (vv. 3-4).

One of the slowest Aggies on the field once ran down the fastest player on the field because he was running for more than the tackle.

Bear Bryant's Aggies of 1957 were undefeated and had gone sixteen games without a loss when they took on Arkansas in Fayetteville on Nov. 2. Typical of the era, the game was a hard-fought, low-scoring defensive affair. A&M apparently had the win sewed up with a 7-6 lead and the ball at the Razorback 12 with only 1:20 to play. Bryant sent in a sub with instructions for his quarterback, Roddy Osborne, to run the ball and use up the clock.

On the next play, Osborne, however, found himself under a relentless rush, looked up, and saw Heisman-Trophy winner John David Crow all alone in the end zone. Much to his coach's amazement — and consternation — he threw the ball. A Hog defender, a sprinter who was the fastest player on the field, cut in front of Crow and intercepted the pass at the goal line. A blocker and one hundred yards of grass were all that was in front of him. He took off.

Only Osborne, the slowest player in the Aggie backfield, had a shot at a game-saving tackle. He took an angle, fought off a

blocker, and made the tackle at the A&M 27-yard line. Arkansas then hit a pass to the 15, but on the next play, Crow grabbed an interception in the end zone to preserve the 7-6 A&M win.

Monday morning, Bryant was on the phone with Bobby Dodd, the legendary head coach at Georgia Tech, who asked the A&M boss, "If the Arkansas boy is as fast as you say, and your boy is as slow as you say he is, how did your boy make the tackle?" "Easy," Bryant replied. "The Arkansas player was just running for a touchdown. Osborne was running for his life."

Hit the ground running — every morning that's what you do as you leave the house and re-enter the rat race. You run errands; you run though a presentation; you give someone a run for his money; you always want to be in the running and never run-of-the-mill.

You're always running toward something, such as your goals, or away from something, such as your past. Many of us spend much of our lives foolhardily attempting to run away from God, the purposes he has for us, and the blessings he is waiting to give us.

No matter how hard or how far you run, though, you can never outrun yourself or God. God keeps pace with you, calling you in the short run to take care of the long run by falling to your knees and running for your life — to Jesus — just as Peter and the other disciple ran that first Easter morning.

On your knees, you run all the way to glory.

It was as if God raised my arm.
— Roddy Osborne on why he threw the ball instead of taking a sack

You can run to eternity by going to your knees.

A RIPE OLD AGE

Read Psalm 92.

"[The righteous] will still bear fruit in old age, they will stay fresh and green, proclaiming, 'The Lord is upright'" (vv. 14-15).

Linebacker Mark Dodge was the old man on his Aggie teams, but he was older than the mere accumulation of days and years. Pulling bodies and body parts from rubble will do that to you.

Dodge was a two-year starter for the Aggies in 2006-07, earning honorable mention all-conference honors as a senior. He transferred to A&M after two years at junior college and was 25 when he began living his dream as a college football player. He combined maturity with youthful excitement. "He's really just one of those guys who is young at heart," said senior linebacker Justin Warren about Dodge in 2006, paying him something of a compliment by noting he didn't stick out around 18- and 19-year-olds.

Dodge came late to college football because he first served in the Third U.S. Infantry Regiment in Washington, D.C. He was at work at the Pentagon on the morning of Sept. 11, 2001, when American Airlines Flight 77 barreled into the building.

What followed left Dodge with nightmares for years. His unit helped with the rescue and recovery at the Pentagon. He let a numbness take over him as he pulled bodies and body parts from the rubble. "The training kicks in and you just go," he said. "Nothing else matters."

Thus, at A&M, Dodge was older than his years. In the hot and demanding days of football practice, he was inspired by friends of his who were serving overseas. "I get to play football while those guys are over there working, rolling in dirt," he said. That maturity let him urge his younger teammates on when they complained. "What are y'all thinking? It's not that big of a deal," the old man would say.

To consider someone old by age 25 as Mark Dodge was at A&M is rather extreme even for our youth-obsessed culture. However, we don't like to admit — even to ourselves — that we're not as young as we used to be.

So we keep plastic surgeons in business, dye our hair, buy cases of those miracle wrinkle-reducing creams, and redouble our efforts in the gym. Sometimes, though, we just have to face up to the cold, hard truth the mirror shamelessly reveals to us every time we take a look: We're getting older every day.

It's really all right, though, because aging and old age are part of the natural cycle of our lives, which was God's idea in the first place. God's conception of the golden years, though, doesn't include unlimited close encounters with a rocking chair and nothing more. God expects us to serve him as we are able all the days of our life. Those who serve God flourish no matter their age because the energizing power of God is in them.

He acts like he's real young, like he just got out of high school or something . . . in a mature type of way.
— Justin Warren on teammate Mark Dodge

Servants of God don't ever retire; they keep working until they get the ultimate promotion.

WORK ETHIC

Read Matthew 9:35-38.

"Then he said to his disciples, 'The harvest is plentiful but the workers are few. Ask the Lord of the harvest, therefore, to send out workers into his harvest field'" (vv. 37-38).

Richard Copeland Slocum knew all about work. After all, he had his first job when he was in the second grade.

The winningest coach in Texas A&M football history, R.C. Slocum earned each one of those wins as he did everything else in his life: by working for them. He was the head coach of the Aggies from 1989-2002 and won 123 games. Homer Norton (1934-47) is second in Aggie wins with 82.

In his office at Texas A&M, Slocum kept a shoe-shine box as a memento of his first job. He set out charging a dime for those shoe shines. By the time Slocum was in the fifth grade, inflation and the realization that he could charge more and get it had upped the tab to a quarter.

Slocum's dad worked in the shipyards of Orange, Texas, and his family lived in the town's poorest section, "little more than a wallow on the banks of the Sabine River." The neighborhood was "an uneasy mixture of struggling families like the Slocums and a transient, criminal element." Those bleak surroundings played a key role in shaping the young Slocum's work ethic, as he was "stricken by the thought of working the rest of his life waiting, as he put it, for a three-day weekend." He once called it "pathetic to

AGGIES

think I'd spend a third of my life waiting for a whistle to blow."

"It was the kind of place," Slocum said, "that you had to fight to get in and fight to get out." He got out by working. He shined shoes delivered newspapers, sacked groceries, scoured old ships, and punched a clock in a petro-chemical plant. By the time Slocum was a senior in high school, he had worked for ten years.

Football presented Slocum a chance to get out, but he was not good enough to earn a scholarship. His work ethic made up for the lack of talent, and that same drive followed him into coaching and took him right on into the A&M Hall of Fame.

Do you embrace hard work or try to avoid it? No matter how hard you may try, you really can't escape hard work. Funny thing about all these labor-saving devices like cell phones and laptop computers: You're working longer and harder than ever. For many of us, our work defines us perhaps more than any other aspect of our lives. But there's a workforce you're a part of that doesn't show up in any Labor Department statistics or any IRS records.

You're part of God's staff; God has a specific job that only you can do for him. It's often referred to as a "calling," but it amounts to your serving God where there is a need in the way that best suits your God-given abilities and talents.

You should stand ready to work for God all the time, 24-7. Those are awful hours, but the benefits are out of this world.

He had a lot of pride. That's why he worked so hard at [football].
— Frank Moates, R.C. Slocum's junior-high coach

God calls you to work for him using the talents
and gifts he gave you; whether you're a worker
or a malingerer is up to you.

DAY 22

FAMILY TIES

Read Mark 3:31-35.

"[Jesus] said, 'Here are my mother and my brothers! Whoever does God's will is my brother and sister and mother'" (vv. 34-35).

John Ray, Jr. did his whole family proud by becoming the most honored Twelfth Man in Aggie football history.

Ray never doubted where he would go to college even after he was offered football scholarships from several smaller schools. He would walk on at Texas A&M, continuing a family tradition. After all, his dad is an Aggie, class of '72. His mother is class of '74; they met while students at A&M. Two uncles are Aggies. A cousin is an Aggie. Both sisters are Aggies. "I told my kids they had a choice" about going to college, John Ray, Sr. said. "A&M would be paid for, the rest would not be. So that was their choice." "I've grown up, since day one, an Aggie," Ray, Jr. said.

So he walked on in the fall of 2002 and was redshirted. In 2003, though, before the Oklahoma game, coach Dennis Franchione called Ray over at practice and told him he had been voted the Twelfth Man for the week. "Being the 12th man is the greatest honor an Aggie could have," Ray said. "For me, being the 12th man is like a blessing."

But Ray wasn't just any Twelfth Man. The honor goes to the most productive walk-on player in the practices leading up to a game. Since the inception of the tradition, the most a player had ever

worn the coveted No. 12 jersey in a game was thirteen — by Blake Kendrick (2001-04). When he hung up his cleats for the last time in 2005, Ray was the most successful Twelfth man in Aggie history: He had worn that No. 12 twenty-three times in a game.

"I just had a lot of pride in my heart," Ray said, about putting on that coveted jersey. He wasn't a bit prouder of the jersey, though, than his family with its boatload of Aggies was of him.

Some wit said families are like fudge, mostly sweet with a few nuts. You can probably call the names of your sweetest relatives, the ones whom you cherish. On the other hand, you have no trouble remembering the nutty ones too, whom you earnestly try to avoid at a family reunion.

Like it or not, you have a family, and that's God's doing. God cherishes the family so much that he chose to live in one as a son, a brother, and a cousin.

One of Jesus' more startling actions was to redefine the family. No longer is it a single household of blood relatives or even a clan or a tribe. Jesus' family is the result not of an accident of birth but rather a conscious choice. All those who do God's will are members of Jesus' family.

What a startling and downright wonderful thought! You have family members out there you don't even know who stand ready to love you just because you're part of God's family.

It's goose bumps for us when we see him out there. I think, 'Man, look at that. Our little baby is out there playing for the Aggies.'
— John Ray, Sr., on the family's pride in John, Jr.

**For followers of Jesus, family comes not
from a shared ancestry but from a shared faith.**

GOD'S HOUSE

Read 2 Samuel 7:1-7.

"I have not dwelt in a house from the day I brought the Israelites up out of Egypt to this day. I have been moving from place to place with a tent as my dwelling" (v. 6).

From raccoons and squirrels to a marriage proposal, G. Rollie White Coliseum was the wellspring of a lot of memories.

"It was the most magnificent building," said Billy Pickard, a former Texas A&M director of facilities, about the coliseum when it opened in 1954. The "Holler House on the Brazos" became a volleyball-only facility when Reed Arena opened its doors in 1998. It was demolished in 2013 to make way for Kyle Field's expansion.

Former women's basketball coach and senior associate athletic director Lynn Hickey recalled that when the coaches watched videotape at night, they kept their feet in chairs because of the varmints. Mice would come out of the walls, raccoons out of the ceiling. Said Hickey, "The trees were so close to the windows the squirrels would crawl in, and we used to have some screaming ladies up there trying to get those squirrels back outside."

Assistant media relations director Brad Marquardt proposed to his wife in the old building. The night they met, the duo shot some hoops there, so returning to the gym to pop the big question must have been quite romantic. The two danced to "Unchained Melody" at midcourt before Marquardt took a knee.

The noise level is what many remember about the place. Randy

AGGIES

Matson, still regarded as the greatest shot putter ever, played basketball for coach Shelby Metcalf in 1966. He recalled that the packed gym was so loud that the players couldn't hear their coach during timeouts. Once, Matson asked guard Eddie Dominquez, "What did he say?" and his teammate responded, "I don't know. I didn't hear a word. Grab somebody and guard 'em."

Buildings such as the Holler House play pivotal roles in our lives, and we often become sentimentally attached to them. A favorite restaurant. A football stadium or basketball gymnasium. The house you grew up in.

But what about a church? How important is that particular facility to you? Is it just the place where you were married? Where you were baptized? Is it nothing more than a house of memories or where you go to out of habit just to placate the spouse or to get a decent meal on Wednesday night?

Or is it the place where you regularly go to meet God? After all, that's what a church building really is: a place built expressly for God. It's God house. Long ago, the only place God could visit his people was in a lousy tent. Nowadays, churches serve as the site where God's people meet both to worship and to encounter him.

In a church alive with a true love of God, he is always there. Whether you find him or not depends on how hard you look. And whether you're searching for him with your heart.

The gym wasn't a bad place to play. But the town is kind of hard to get to. They need to move the town and leave the gym where it is.
– Former UT coach Abe Lemons on the end of basketball at the coliseum

**When you visit God in his house,
do you find him there?**

DAY 24

REGRETS, ANYONE?

Read 2 Corinthians 7:8-13.

*"Godly sorrow brings repentance that leads to salvation
and leaves no regret" (v. 10).*

After a football game, a Louisiana state trooper expressed a sincere regret to Dave South, the radio voice of the Aggies: That an LSU fan hadn't hit him.

As part of the broadcasts during the 1988 season, South and the rest of his team did fan-in-the-stand features at each game. At the LSU game in Baton Rouge, South, as always wearing an Aggie shirt, took his recorder to the end-zone corner where the A&M fans sat. There he interviewed the father of A&M offensive lineman Jerry Fontenot.

As the two men talked, a drunk Tiger fan stopped by to unleash an impressive torrent of curses at South and any and all Aggies. South went right on with his interview; after about thirty seconds, though, the drunk suddenly went silent. When South ended the interview, he asked Fontenot what had happened to the cursing drunk. Fontenot replied that a state trooper had grabbed him by the neck and hauled him off.

After the game, coach Jackie Sherrill's postgame show was so lengthy that South and he missed the team bus and had to hitch a ride with a state trooper. In the car, the highway patrolman struck up a conversation. "Were you interviewing one of the Aggie fans before the game?" the trooper asked. South said that he was.

"What did you think about the guy who was cussing you?" South then realized that this was the trooper who had intervened. When South asked him about it, the patrolman verified that he was the one. Then he said something that surprised South.

Said the trooper, "I was hoping he'd hit you." South told him that was not exactly a proper thing for a law enforcement officer to say, but then the trooper explained: "If he had hit you, I could have hit him. I can't stand that guy. . . . I can't tell you how much I want to hit [him]."

In their classic hit "The Class of '57," the Statler Brothers served up some pure country truth when they sang, "Things get complicated when you get past 18." That complication includes regrets; you have them; so does everyone else: situations and relationships that upon reflection we wish we had handled differently.

Feeling troubled or remorseful over something you've done or left undone is not necessarily a bad thing. That's because God uses our regrets to spur us to repentance, which is the decision to change our ways. Repentance in turn is essential to salvation through Jesus Christ. You regret your un-Christlike actions, you repent by promising God to mend your ways, and then you seek and receive forgiveness for them.

The cold, hard truth is that you will have more regrets in your life. You can know absolutely, however, that you will never ever regret making Jesus the reason for that life.

I have no regrets because I know I did my best — all I could do.
— Figure skater Midori Ito

**Regrets are part of living,
but you'll never regret living for Jesus.**

DAY 25

DOWNRIGHT CRAZY

Read Luke 13:31-35.

"Some Pharisees came to Jesus and said to him, 'Leave this place and go somewhere else. Herod wants to kill you.' He replied, 'Go tell that fox . . . I must keep going today and tomorrow and the next day'" (vv. 31-33).

Defensive coordinator R.C. Slocum thought his head coach had gone crazy. He wasn't alone.

Prior to the 1983 football season, A&M head man Jackie Sherrill (1982-88) decided to take the school's unique Twelfth Man tradition out of the bleachers and onto the field. He reasoned such a step would bring the football team and the student body closer together, giving the students "a better understanding of how desperately the team wanted to win for them."

Sherrill's plan was to assemble a unit of twelve walk-on volunteers – ten regulars and two alternates – to cover kickoffs at home games. The head man admitted his idea was more than a little bizarre, if not downright crazy. "You couldn't do that anywhere but [here]," he said. "Some people thought I was crazy."

Slocum was among those who had some serious reservations about his boss' sanity. He could see only that the opponents would line up with some of the nation's most sought-after athletes, thus creating a "mismatch against a posse of volunteers." Sherrill said, "R.C. kept saying, 'You're not serious, are you?'" He was.

He placed ads in the student newspaper and distributed flyers,

"spark[ing] pandemonium on campus." Two hundred and fifty-two students — including two women — signed up for tryouts. Wearing jerseys with "12th Man" on the sleeves, the ten chosen as regulars made their debut in the 1983 opener against California.

Though uncertain about the whole idea, Slocum continued to use it after he took over as the head coach in 1989. He changed it, though, when Texas Tech ran back a kickoff for a touchdown in 1990. Gone was the entire unit of volunteers; instead, one student, wearing number 12, would be part of the kickoff coverage as the Twelfth Man. For Slocum, this approach wasn't crazy at all.

What some see as crazy often is shrewd instead. Like the time you went into business for yourself or when you decided to go back to school. Maybe it was when you fixed up that old house. Or when you bought that new company's stock.

You know a good thing when you see it but are also shrewd enough to spot something that's downright crazy. Jesus was that way too. He knew that his entering Jerusalem was in complete defiance of all apparent reason and logic since a whole bunch of folks who wanted to kill him were waiting for him there.

Nevertheless, he went because he also knew that when the great drama had played out he would defeat not only his personal enemies but the most fearsome enemy of all: death itself.

It was, after all, a shrewd move that provided the way to your salvation.

I knew there were enough kids on campus crazy enough to do it.
— Jackie Sherrill on having the 12th Man cover kickoffs

**It's so good it sounds crazy — but it's not: through
faith in Jesus, you can have eternal life with God.**

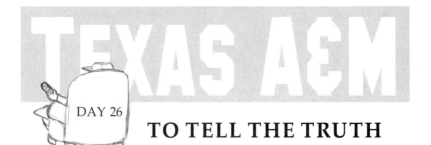

TO TELL THE TRUTH

Read Matthew 5:33-37.

*"Simply let your 'Yes' be 'Yes,' and your 'No,' 'No';
anything beyond this comes from the evil one" (v. 37).*

The players on coach Bob Brock's softball teams sometimes had a nasty habit of giving him something resembling apoplexy by telling him the truth when he asked a question.

Brock coached the Aggies for fifteen seasons, from 1981-96. His teams never had a losing season and won two NCAA national titles and one AIAW championship. Those AIAW champs of 1981-82 set a school record by winning an incredible 84 games. He was inducted into the A&M Athletic Hall of Fame in 2006.

Brock was a stern taskmaster who didn't especially appreciate being crossed. One day, for instance, Barbi Tuck, whose name is in the Aggie record book for the five triples she hit in 1994, showed up 45 minutes late for practice. "Where have you been?" Brock thundered at her. "In my room," Tuck replied, obviously not at all impressed by Tuck's attempt to intimidate her. "Doing what?" he asked. "Watching *Oprah*," she replied quite truthfully.

Tuck's honesty didn't get her out of trouble. Brock told her to start running and stop only when he told her to. Assistant coach Shawn Andaya (See Devotion No. 87.) witnessed the confrontation and couldn't stifle a giggle at Tuck's honesty. She said "the poor girl finally stopped [running] some time that season."

A truthful reply didn't even let an All-American player escape

the head coach's wrath. Third baseman Cindy Cooper once forget her jersey for a road game. The manager surreptitiously slipped her a replacement, but it didn't have Cooper's usual number on it and Brock noticed. "Where's your regular jersey?" he asked. "In College Station," Cooper answered. "What's it doing there?" the coach asked. "Hanging up on a hanger in the closet," Cooper said. That set the veins in Brock's head to bulging; he sat Cooper on the bench for the day's doubleheader.

No, that dress doesn't make you look fat. But, officer, I wasn't speeding. I didn't get the project finished because I've been at the hospital every night with my ailing grandmother. What good-looking guy? I didn't notice.

Sometimes we lie to spare the feelings of others; more often, though, we lie to bail ourselves out of a jam (apparently unlike some of A&M's softball players), to make ourselves look better to others, or to gain the upper hand over someone.

But Jesus admonishes us to tell the truth. Frequently in our faith life we fret about what is right and what is wrong, but we can have no such ambivalence when it comes to telling the truth or lying. God and his son are so closely associated with the truth that lying is ultimately attributed to the devil ("the evil one").

Given his character, God cannot lie; given his character, the devil lies as a way of life. Given your character, which is it?

Trampling on the truth has become as commonplace as overpaid athletes and bad television.
— *Former hockey coach Dan Bauer*

**Jesus declared himself to be the truth
so whose side are we on when we lie?**

DAY 27

MIRACLE PLAY

Read Matthew 12:38-42.

"He answered, 'A wicked and adulterous generation asks for a miraculous sign!'" (v. 39)

T he win was so miraculous that Aggie coach Steve Kragthorpe could only fall to his knees and whisper, "Thank you, Jesus."

The 1998 Big 12 championship game pitted 10-2 A&M against the undefeated Kansas State Wildcats, who had their eyes on the BCS national championship. Starting A&M quarterback Randy McCown had his shoulder in a sling. When backup Branndon Stewart hyperextended a knee in the first quarter, the Aggies faced the horrifying prospect of using punter Shane Lechler at quarterback. Stewart's knee recovered quickly, but the power-house Wildcats led 27-12 as the fourth quarter started.

At the time, nobody realized that the Aggies had a whole bag full of miracles. They began pulling them out when Stewart hit receiver Leroy Hodge with a 13-yard TD pass to make it a 27-19 game. Then with under three minutes left, linebacker Warrick Holdman caused a State fumble, and fellow linebacker Cornelius Anthony got the ball at the KSU 35. Stewart's 9-yard pass to Sirr Parker brought the Aggies to within two with 1:05 to play. The same combo worked for the two-point conversion.

Suddenly, the game was tied and headed for overtime after yet another Aggie miracle. Safety Toya Jones stopped a State Hail Mary pass at the one-yard line on the last play of regulation.

The teams swapped field goals in the first overtime, and in the second extra period, K-State kicked another one to lead 33-30. The Aggies needed another miracle, though, when they faced third-and-17 at the 32, well out of field goal range. They got it. Stewart hit Parker on a slant, and he raced toward the end zone. He was tackled at the pylon, but got the ball across the goal line.

Miraculously, the Aggies were Big 12 champions.

Miracles defy rational explanation. Like overcoming a 27-12 fourth-quarter deficit against an undefeated team to win the Big 12 title. Or escaping with minor abrasions from an accident that totals your car. Or recovering from an illness that seemed terminal. Underlying the notion of miracles is the idea that they are rare instances of direct divine intervention that reveal God.

But life shows us quite the contrary, that miracles are anything but rare. Since God made the world and everything in it, everything around you is miraculous. Even you are a miracle.

Your life thus can be mundane, dull, and ordinary, or it can be spent in a glorious attitude of childlike wonder and awe. The difference lies in whether or not you see the world through the eyes of faith. Only through faith can you discern the hand of God in any event; only through faith can you see the miraculous and thus see God.

Jesus knew that miracles don't produce faith, but rather faith produces miracles.

It was a miracle — a miracle finish.
— Offensive coordinator Steve Kragthorpe on the win over Kansas State

Miracles are all around us,
but it takes the eyes of faith to see them.

IN THE KNOW

Read John 4:19-26, 39-42.

"They said to the woman, . . . 'Now we have heard for ourselves, and we know that this man really is the Savior of the world'" (v. 42).

Because an A&M player for one day was in effect the first scout in Southwest football history, the Aggies had some inside information and used it to beat Texas for the first time.

After a 1-4 season in 1901, A&M's seventh year of football, the faculty decided athletics was receiving too much emphasis at the school. They thus passed a rule prohibiting A&M from playing other Texas colleges. What with the tight budgets and the cumbersome modes of travel of the time, the restriction effectively killed intercollegiate athletics at A&M. The student body rose up in protest, however, and to calm the campus down, a compromise was reached: The rule was rescinded, and the General Athletic Association was created to oversee A&M athletics.

One of the Association's first actions was to outbid Ohio State for head football coach James E. Platt. Platt came to town with some new ideas, especially the surprising notion of preseason training. Every player had to run at top speed from his dorm to practice and then back again once practice was over. Platt introduced calisthenics and rugged scrimmages. He also brought the best season in Aggie football history to that point.

The Aggies were 6-0-2 when they met Texas in Austin on Nov.

27, 1902. A&M had lost all seven games they had played against the Longhorns and had never even scored. For this game, though, Platt and his players had a secret weapon: They knew something.

Right end Josh Sterns had captained the 1897 Farmers (as the team was then known) before leaving school without graduating. But he returned in 1902, and in midseason he went to Austin and scouted the Longhorns. He came back with a one-line report, telling Platt, "The left side of the Texas line is weak."

Knowing that, Platt's Farmers ran behind Sterns all day, mercilessly pounding the left side of the Texas line and winning 11-0. They claimed the championship of the Southwest.

Those early Aggies just knew in the same way you know certain things in your life. That your spouse loves you, for instance. That you are good at your job. That really good tea should be iced and sweetened. That a bad day fishing is still better than a good day at work. You know these things even though no mathematician or philosopher can prove any of this on paper.

It's the same way with faith in Jesus: You just know that he is God's son and the savior of the world. You know it in the same way that you know Texas A&M is the only team worth pulling for: with every fiber of your being, with all your heart, your mind, and your soul.

You just know, and because you know him, Jesus knows you. And that is all you really need to know.

The explanation of the unexpected is that College had the best team.
 — Dallas News on A&M's first-ever football win over Texas

A life of faith is lived in certainty and conviction:
You just know you know.

COMEBACK KIDS

Read Acts 9:1-22.

*"All those who heard him were astonished and asked,
'Isn't he the man who raised havoc in Jerusalem among
those who call on this name?'" (v. 21)*

The Aggies were one play away from going 0-5. Yet they pulled off a remarkable comeback, winning the conference championship and beating Alabama in the Cotton Bowl.

A&M had endured nine straight losing seasons when the 1967 football season began with the cry "The Aggies Are Back." After four straight losses to open the season, however, the slogan on some bumper stickers read "The Aggies Are Way Back."

The season appeared to completely unravel when Texas Tech scored a touchdown to lead 24-21 with only 53 seconds left in the game. But on fourth and 15 with 11 seconds to play, Edd Hargett lofted a bomb to Bob Long, who was All-America at linebacker that season. He fought through a crowd of Red Raider defenders to come down with the ball at the Tech 15.

With time running out, Hargett rolled left to throw, but saw that all his receivers were covered. He tucked the ball and scored to give the Aggies a 28-24 win in what was called "one of the most miraculous comebacks of all time." That comeback began what was to be a season-long comeback.

The Aggies rolled over TCU and Baylor before scoring three times in the last quarter to rally past Arkansas 33-21. After an

18-3 win over Rice, A&M met Texas with the conference title up for grabs. Texas scored late for a 7-3 lead, but two plays later Hargett and Long bailed their team out again, this time on an 80-yard pass play for a 10-7 win. The comeback kids had won A&M's first conference championship in eleven seasons and had claimed the school's first berth in the Cotton Bowl in 26 years.

In Dallas on New Year's Day against former Aggie coach Bear Bryant, A&M completed its remarkable comeback with a 20-16 victory. After the game, Bryant, Aggie head coach Gene Stallings' mentor, give his former disciple a big hug.

Life has its setbacks whether they result from personal failures or from forces and people beyond your control. Being a Christian and a faithful follower of Jesus Christ doesn't insulate you from getting into deep trouble. Maybe financial problems suffocated you. A serious illness put you on the sidelines. Or your family was hit with a great tragedy. Life is a series of victories and defeats. Winning isn't about avoiding defeat; it's about getting back up to compete again. It's about making a comeback of your own.

When you avail yourself of God's grace and God's power, your comeback is always greater than your setback. You are never too far behind, and it's never too late in life's game for Jesus to lead you to victory, to turn trouble into triumph.

As it was with the Aggies of 1967 and with Paul, it's not how you start that counts; it's how you finish.

Turn a setback into a comeback.
— *Former football coach Billy Brewer*

In life, victory is truly a matter of how you finish and whether you finish with Jesus at your side.

THE PANIC BUTTON

Read Mark 4:35-41.

"He said to his disciples, 'Why are you so afraid? Do you still have no faith?'" (v. 40)

The improbable run by the A&M women to "the pinnacle of college basketball was nine seconds, 94 feet and one miracle away from coming to an abrupt halt." It would have been a pretty good time for senior point guard Sydney Colson to panic.

The mascot of the Stanford Cardinal is a tree, which was quite fitting since the lineup the Cardinal threw at the Aggies in their semifinal game in the 2011 NCAA Tournament was the tallest in the nation. Stanford used its overwhelming size advantage to dominate the glass and take a 10-point lead with 5:07 to play. That seemed like a right appropriate time for a little panic to set it.

But not this bunch. Rather than panic, they just kept on fighting. They played oppressive defense and forced turnovers. They hit shots and hustled as though their season would end if they lost. They fought their way to their first lead since early in the game.

Stanford responded by going inside to one of those trees, who scored with nine seconds left for a 62-61 lead.

That's for sure when panic should have set in. Rather, Colson took the inbounds pass, looked downcourt and saw the Cardinal with their backs to her. "Without hesitation, she bolted." She went the length of the court in six dribbles, calmly got to the basket and spotted guard Tyra White sailing in from the side. She laid down

a perfect bounce pass to White, who, just as calmly with no sign of panic, put in a layup with 3.3 seconds left.

The team that refused to panic was on its way to the national championship game where they maintained their poise one more time. And once again, they won.

Have you ever experienced that suffocating sensation of fear escalating into full-blown panic? Maybe the time when you couldn't find your child at the mall or at the beach? Or the heart-stopping moment when you looked out and saw that tornado headed your way?

As Jesus' disciples distressingly illustrate, the problem with panic is that it debilitates us. Here they were, professional fishermen in the bunch who were accustomed to bad weather, and they let a bad storm panic them into helplessness. All they could do was wake up an exhausted Jesus.

We shouldn't be too hard on them, though, because we often make an even more grievous mistake. They panicked and turned to Jesus; we panic and often turn away from Jesus by underestimating both his power and his ability to handle our crises.

We have a choice when fear clutches us: We can assume Jesus no longer cares for us, surrender to it, and descend into panic, or we can remember how much Jesus loves us and resist fear and panic by trusting in him.

They just fight. They scratch. They claw. Foremost, they don't panic.
— Writer David Harris on the 2011 national champs

To plunge into panic is to believe —
quite wrongly — that Jesus is incapable
of handling the crises in our lives.

THE MAKEOVER

Read 2 Corinthians 5:11-21.

*"If anyone is in Christ, he is a new creation; the old has
gone, the new has come!" (v. 17)*

I don't know what it was, but suddenly [Jack] Pardee was a foot-
ball player." What transformed just another body into an A&M
legend may well have been a fight in the stands at an Aggie base-
ball game.

Assistant coach Willie Zapalac uttered those words about Par-
dee's becoming a real football player. As a senior in 1956, the full-
back/linebacker was All-Southwest Conference and All-America.
He also made the Academic All-America squad. The *Houston Post*
named him the conference's most valuable player. He went on to
an All-Pro career in the NFL and was inducted into the College
Football Hall of Fame in 1986.

Pardee was not an instant sensation at College Station. In fact,
Zapalac recalled that as a sophomore, Pardee "wasn't much of a
player then. Bear (Bryant) had about given up on him." The knock
was that Pardee wasn't a fighter. "He had just been an arm tackler,
a bear hugger. He hadn't really hit anybody," Zapalac said.

But a transformation took place that began at an Aggie baseball
game in 1955. The team played Texas in Austin, and a bunch of the
football players, including Pardee, made the trip. Zapalac remem-
bered that a dozen or so fights broke out in the stands between
the Aggie and the Longhorn football players. "The big one," the

coach said, was between Pardee and a big Texas tackle. "They fought all over the stands. Who won? We thought Pardee did." That changed the staff's perception of Pardee. Back at College Station that night, trainer Smokey Harper saw Bryant and told him to quit worrying about Pardee. "I've always thought," Harper said, "that if Pardee hadn't had that fight he wouldn't have made us a football player."

However it happened, Jack Pardee was made over into a star.

Ever considered a makeover for yourself? Television programs show us how changes in clothes, hair, and makeup and some weight loss can radically alter the way a person looks. But these changes are only skin deep. Even with a makeover, the real you — the person inside — remains unchanged. How can you make over that part of you?

By giving your heart and soul to Jesus — just as you give up your hair to the makeover stylist. You won't look any different; you won't dance any better; you won't suddenly start spouting quantum mechanics or calculus.

The change is on the inside where you are brand new because the model for all you think and feel is now Jesus. He is the one you care about pleasing. Made over by Jesus, you realize that gaining his good opinion — not the world's — is all that really matters. And he isn't the least interested in how you look but how you act.

You can't tell when a boy is going to develop. One day he isn't a football player. The next day he is.
— *A&M assistant coach Willie Zapalac*

Jesus is the ultimate makeover artist; he can make you over without changing the way you look.

STRANGE BUT TRUE

Read Isaiah 9:2-7.

"The zeal of the Lord Almighty will accomplish this" (v. 7).

A strangeness unique to the Aggies is part of their history.

For instance, no team in A&M football history has produced more first-team All-Americas than the 1968 squad: four of them. Linebacker Bill Hobbs, tackle Rolf Krueger, punter Steve O'Neal, and safety Tommy Maxwell were all honored as the best as their respective positions. Strangely enough, despite all those stars, the '68 team went only 3-7.

The 1940 Aggies were so devastated by a season-ending loss to Texas that they refused — twice — to play in the Cotton Bowl. Only when head coach Homer Norton told the players they had no choice but to go did they finally vote to accept the invitation. They whipped Fordham 13-12.

Strange as it sounds, an appeal to the Civil War helped A&M win a key game in the drive to the 1939 national championship. In the locker room before the Villanova game, running back Jim Thomason stood up and announced, "Fellows, the granddaddy of those old boys shot my granddaddy right through the nose. Let's get 'em." All-American tackle Joe Boyd said, "It was so ridiculous to bring the Civil War into a pregame pep talk that we all rolled off our benches and broke into laughter." Totally relaxed, the Aggies went out and blasted the Pennsylvania boys 33-7.

AGGIES

In the 2004 game against Texas, the Longhorns scored a one-point safety. In what has got to be the rarest scoring play in football, the strange safety occurred on an extra point try. The snap was fumbled, the kick never got off the ground, and A&M gained possession before fumbling the ball into the end zone where the Horns recovered. Texas was awarded one point. "I didn't know there was such a thing," Texas coach Mack Brown said. "That's a unique call," agreed A&M's Dennis Franchione.

Life is just strange, isn't it? How else to explain people who go to a bar in hopes of meeting the "right" person, the prevalence of tattoos, tofu, the behavior of teenagers, and widespread acceptance of the idea that vulgar language is cool or sophisticated?

And how strange is God's plan to save us? Think a minute about what God did. He could have come roaring down, destroying and blasting everyone whose sinfulness offended him, which, of course, is pretty much all of us. Then he could have brushed off his hands, nodded the divine head, and left a scorched planet in his wake. All in a day's work.

Instead, God came up with a totally novel plan: He would save the world by becoming a human being, letting himself be humiliated, tortured, and killed, and thus establishing a kingdom of justice and righteousness that will last forever.

It's a strange way to save the world — but it's true.

It may sound strange, but many champions are made champions by setbacks.
— Olympic champion Bob Richards

**It's strange but true: God allowed himself
to be killed on a cross to save the world.**

THE PIONEER SPIRIT

Read Luke 5:1-11.

"So they pulled their boats up on shore, left everything and followed him" (v. 11).

The first week he was on campus, somebody burned a cross at his dorm door. Before long, though, Curtis Mills was exactly what he wanted to be: just another Aggie.

Mills was the first African-American athlete to be awarded a scholarship at A&M, arriving on campus in September 1967. That first week, he opened his dorm-room door to find a small, burning cross in the hallway. "I began thinking they didn't want us to go here," he said. But Mills and two fellow African-American athletes met with the coaches. The result was a meeting and a mandate. Nothing like that ever happened again.

Just the opposite, in fact. "We just wanted to fit in, to be Aggies," Mills said. Before long, he was "practically begging" the other athletes to treat him as badly as they did other underclassmen. "If there was an initiation, we said, 'Give it to us,'" Mills recalled. The freshman sprinter knew he had arrived when he was part of a group that was spray painted and dumped out in the country. "It was great," he said. "It was about being an Aggie."

At A&M and later in his life, Mills always made it very clear that the color he is defined by is maroon. That first-week incident aside, he has always been most proud of the way the students welcomed him and made him a part of the Aggie family.

He was also one of the school's greatest athletes. He set or was a part of eleven school records, won seven conference titles, and won the 1969 national title in the 440-yard dash. He was a three-time All-America who led the Aggies to the 1970 Southwest Conference outdoor track and field title. In 1979, this pioneer did it again, becoming the first African-American to be inducted into the Texas A&M Athletic Hall of Fame.

Going to a place in your life you've never been before requires a willingness to take risks and face uncertainty head-on. You may have never broken a social barrier as Curtis Mills did, but you've had your moments when your latent pioneer spirit manifested itself. That time you changed careers, ran a marathon, learned Spanish, volunteered at a homeless shelter, or went back to school.

While attempting new things invariably begets apprehension, the truth is that when life becomes too comfortable and too familiar, it gets boring. The same is true of God, who is downright dangerous because he calls us to be anything but comfortable as we serve him. He summons us to continuously blaze new trails in our faith life, to follow him no matter what.

Stepping out on faith is risky all right, but the reward is a life of accomplishment, adventure, and joy that just cannot be equaled anywhere else.

I just wanted to be an Aggie, and those students just wanted me to be an Aggie.
— *Curtis Mills on his pioneering days at A&M*

Unsafe and downright dangerous, God calls us out of the place where we are comfortable to a life of adventure and trailblazing in his name.

DAY 34

THE GOOD OLD DAYS

Read Psalm 102.

"My days vanish like smoke; . . . but you remain the same, and your years will never end" (vv. 3, 27).

Free substitution was unheard of, and the players wore leather helmets without a face mask. Texas A&M had a running back the pundits compared to Red Grange and Jim Thorpe. Ah, those were the good old days.

The year was 1939. Because of the rules governing substitution only fifteen players saw most of the action for A&M that season. "They played hurt because they didn't know any other way." The school "was a terrific place to be because, as the pros once said of Green Bay, there was nothing to do there except win."

That running back who was compared to Grange and Thorpe was John Kimbrough, who team center and "holler guy" Tommie Vaughn said was "as great a back as ever played the game." At 6-foot-3 and 225 pounds, Kimbrough was big for his time with a long stride and good speed.

A&M's coach was Homer Norton, whom Vaughn described as "twenty years ahead of his time." It was a time when college football "was glamorous, mysterious, important." No two teams ran the same offense, creating variations of the single, double, and triple wings, and spread and box formations.

With a derring-do that belies the perception that offenses of the time were dull, teams used shifts, men in motion, unbalanced

lines, reverses, laterals, flea flickers, shovel passes, button hooks, and long passes. Only after World War II started were the latter called "bombs." Despite all that razzle-dazzle, they often kicked on first down and turned the game over to their defenses.

College Station had no real main street, "just a drug store, a barber shop, a dry cleaners, and a movie theater" – and the White Way Cafe with its plate lunch.

Those were the good old days. And one thing more that made them even better: In 1939, the Aggies won the national title.

It's a brutal truth that time just never stands still. The current of your life sweeps you along until you realize one day you've lived long enough to have a past. Part of it you cling to fondly. The stunts you pulled with your high-school buddies. Your first apartment. That dance with your first love. That special vacation. Those "good old days."

You hold on relentlessly to the memory of those old, familiar ways because of the stability they provide in our uncertain world. They will always be there even as times change and you age.

Another constant exists in your life too. God has been a part of every event in your life that created a memory because he was there. He's always there with you; the question is whether you ignore him or make him a part of your day.

A "good old day" is any day shared with God.

Practically everything seemed better than it does today, except air conditioning.
<div align="right">

— Writer Dan Jenkins on the 1930s
</div>

<div align="center">

Today is one of the "good old days"
if you share it with God.
</div>

DAY 35

GOOD-BYE

Read John 13:33-38.

"My children, I will be with you only a little longer" (v. 33a).

The Aggies put on quite a show that night they said good-bye to the outgoing seniors, Johnny Manziel, All-American wide receiver Mike Evans, and to Kyle Field as they had known it.

On Nov. 9, 2013, the Aggies hosted Miss. State in the final game at Kyle Field before $450 million in renovations began. During player introductions, the seniors playing their final home game were recognized before the third largest home crowd ever.

Then Reveille led the rest of the Aggies onto the field. The last two to emerge out of the smoke from the tunnel were head coach Kevin Sumlin and Manziel. Before that, the redshirt sophomore had made an unusual detour back to the locker room. Behind the south end zone, his parents and his sister waited for him, and he hugged his mom.

Once the pre-game festivities were taken care of, showtime began. Manziel powered the 11th-ranked Aggies to a 51-41 win by passing for 446 yards and five touchdowns. One writer noted that the Aggies spent more time celebrating and saying good-bye after the game than they did scoring during it. Each of A&M's seven touchdown drives took less than two minutes.

Throughout the last half, the Aggie fans chanted, "One more year! One more year!" They knew, though, that this was a night

of good-byes, and those whom they would never see again in an Aggie uniform at Kyle Field included Manziel and Evans.

As the Aggies ran out the clock, Manziel turned to the fans between plays and gestured for them to be as loud as they could. They responded. When time ran out, he joined the frenzied mob by jumping into the stands. He then swayed along with the students as they sang the "Aggie War Hymn."

If you gotta say good-bye, this was the way to do it.

You've stood on the curb and watched someone you love drive off, or you've grabbed a last-minute hug before a plane leaves. Maybe it was a child leaving home for the first time or your best friends moving halfway across the country. It's an extended — maybe even permanent — separation, and good-byes hurt.

Jesus felt the pain of parting too. Throughout his brief ministry, Jesus had been surrounded by and had depended upon his friends and confidants, the disciples. About to leave them, he gathered them for a going-away supper and gave them a heads-up about what was about to happen. In the process, he offered them words of comfort. What a wonderful friend he was! Even though he was the one who was about to suffer unimaginable agony, Jesus' concern was for the pain his friends would feel.

But Jesus wasn't just saying good-bye. He was on his mission of providing the way through which none of us would ever have to say good-bye again.

For our seniors, it was a long-lasting memory.
— Kevin Sumlin on saying good-bye the night of the Miss. State game

Through Jesus, we will see the day
when we say good-bye to good-byes.

DAY 36

PRECIOUS MEMORIES

Read 1 Thessalonians 3:6-13.

"Timothy . . . has brought good news about your faith and love. He has told us that you always have pleasant memories of us" (v. 6).

A walk-on so obscure that the TV announcers didn't know his name is responsible for one of the most memorable and revered plays in Aggie football history.

In a survey conducted by the Texas A&M Letterman's Association, Warren Barhorst's theft of Tim Brown's towel in the 1988 Cotton Bowl was voted the fifth most memorable moment in Aggie history. An artist even created a limited-edition painting of it. Two decades after his play, Barhorst said, "I probably talk about it five times a week. Friends, colleagues, clients, strangers — you name it — bring it up."

Barhorst was a member of head coach Jackie Sherrill's 12th Man Kickoff Team. After A&M won its third straight Southwest Conference title in 1987, Barhorst and his fellow twelfth men faced a big challenge in the Cotton Bowl trying to stop Brown, the Irish record-holder for most career kickoff return yards.

Defensive back Chet Brooks, who came up with the legendary nickname the "Wrecking Crew" for the A&M defense (See Devotion No. 17.), had played against Brown in high school. He told the kickoff team they ought to steal Brown's towel. "Chet said that would drive him crazy," Barhorst said. He was right.

After A&M took a 28-10 lead in the fourth quarter (The final score was 35-10.), Barhorst tackled Brown, swiped the towel, and trotted toward the bench. A frustrated Brown jumped on Barhorst's back, thereby ensuring that Barhorst would forever have a secure place in the memories of Aggie fans. He never has known, though, what happened to that towel.

While you probably don't enjoy dwelling on such things, your whole life will one day be only a memory, just as Warren Barhorst's legendary play is. With that knowledge in hand, you can control much about your inevitable funeral. You can, for instance, select a funeral home, purchase a cemetery plot, pick out your casket or a tasteful urn, designate those who will deliver your eulogy, and make other less important decisions about your send-off.

What you cannot control about your death, however, is how you will be remembered and whether your demise leaves a gaping hole in the lives of those with whom you shared your life or a pothole that's quickly paved over. What determines whether those nice words someone will say about you are heartfelt truth or pleasant fabrications? What determines whether the tears that fall at your death result from heartfelt grief or a sinus infection?

Love does. Just as Paul wrote, the love you give away during your life decides whether or not memories of you will be precious and pleasant.

I just never figured that people would still remember me.
— Warren Barhorst

How you will be remembered after you die
is largely determined by how much
and how deeply you love others now.

QUIET TIME

1 Kings 19:1-13.

"And after the earthquake a fire, but the Lord was not in the fire: and after the fire a still small voice" (v. 12 KJV).

One of the loudest home courts in the county suddenly went eerily silent. The quiet, in fact, was deafening.

It's been called "The Night That Changed Everything," and Acie Law's trey with 25 seconds left has become so famous it is known in Aggie basketball lore simply as "The Shot."

On the night of Feb. 3, 2007, the 18-3 Aggies, ranked No. 8 in the country, took on the 19-3, 6th-ranked Kansas Jawhawks in KU's Phog Allen Fieldhouse. The media were squarely in Kansas' corner in large part because of Kansas' reputation and its home-court advantage. "Allen Fieldhouse is crazy," declared guard Josh Carter. "It is one of the loudest arenas you will ever play in."

And it was so on this night. "I remember the court shaking when the fans would start jumping up and down right before the game during tip-off," Carter said. That overpowering noise got even louder as Kansas built a double-digit lead in the last half.

But the Aggies rallied. They got five straight points from Law and a 3-point play from center Antanas Kavaliauskas to tie the game at 64. With 44 seconds left, Kansas scored to lead by two. Then came "The Shot" heard round the Aggie world that silenced the Jayhawk world.

With 25 seconds left, Law hit a three and the Aggies led 67-66.

"It was so loud you couldn't hear anything," recalled a student. "When Acie hit the shot, the place went dead quiet. I've never heard a building go from that loud to that quiet real quick."

Amid that quiet "in one of college basketball's greatest meccas, a program was born" as the Aggies won 69-66 on the night that changed the perception of A&M men's basketball.

The television blares; the ring tone sounds off; the dishwasher rattles. Outside, the roar of traffic assaults your ears; a siren screams until you wince; the garbage collectors bang the cans around; and everybody shouts to be heard above the din.

We live in a noisy world. Strangely enough, the most powerful voice of all — the one whose voice spoke the universe into being — does not join in the cacophony. We would expect Almighty God to speak in a thunderous roar, complete with lightning, that forces us to cover our ears to prevent damage and then to fall to our knees in dread.

Instead, God patiently waits for us to turn to him, nudging us gently with a still small voice. Thus, in the serenity of quiet time, expressly devoted to God, and not in the daily tumult, do we find God and discover something rather remarkable: that God's being with us is not remarkable at all. He's always there; we just can't hear him most of the time over the world's noise.

It's a lot better to be seen than heard. The sun is the most powerful thing I know of, and it doesn't make much noise.

— Bear Bryant

**God speaks in a whisper, not a shout,
so we must listen carefully or
we will miss his voice altogether.**

DAY 38

ALL DUE RESPECT

Read Mark 8:31-38.

"He then began to teach them that the Son of Man must suffer many things and be rejected by the elders, chief priests and teachers of the law, and that he must be killed" (v. 31).

The A&M football players understood that theirs wasn't exactly the most respected football program in the conference at the time — but a homecoming opponent?

Quite a few Aggies showed up in Ames, Iowa, on Oct. 20, 2004, with a big chip on their shoulders at the disrespect Iowa State had shown them by scheduling them as their homecoming game. As is well known, an opponent is chosen for homecoming because it is the biggest patsy on the schedule, a sure win.

While the blatant show of disrespect may have gotten some of the Aggies in a huff, the move was a logical one. After all, A&M had lost eight straight road games. As writer Neil Hohlfeld put it, "Schools look for a homecoming game that will make the alumni happy, and A&M had spread joy throughout the land the last two years."

Not this day, though. The Aggies put a real damper on the Iowa State party by romping to a 34-3 win.

A&M quarterback Reggie McNeal was among those miffed at the whole homecoming bit, suggesting during the week that they ruin the Cyclones' night by winning. He was more than up to the

task, hitting 16 of 27 passes for 222 yards and three touchdowns. He left the game in the third quarter with A&M up 28-3. Backup Ty Branyon went in and threw a TD pass to DeQawn Mobley.

The Aggies scored less than two minutes into the game when McNeal hit wide receiver Tydrick Riley with an 18-yard TD toss. McNeal then hit freshman tight end Joey Thomas with a 13-yard score on A&M's second possession.

Turn out the lights; this party was over.

Rodney Dangerfield made a good living as a comedian with a repertoire that was basically only countless variations on one punch line: "I don't get no respect." Dangerfield was successful because he struck a chord with his audience. No one wants to play football for a program that no one respects. You want the respect, the esteem, and the regard that you feel you've earned.

But more often than not, you don't get it. Still, you shouldn't feel too badly; you're in good company. In the ultimate example of disrespect, Jesus — the very Son of God — was treated as the worst type of criminal. He was arrested, bound, scorned, spit upon, ridiculed, tortured, condemned, and executed.

God allowed his son to undergo such treatment because of his high regard and his love for you. You are respected by almighty God! Could anyone else's respect really matter?

We'll be [Oklahoma State's] homecoming opponent, too, so we'll have another chance to kiss the queen.
 — Head coach Dennis Franchione after the win over Iowa State

**You may not get the respect you deserve,
but at least nobody's spitting on you
and driving nails into you as they did to Jesus.**

DAY 39

THE GREATEST

Read Mark 9:33-37.

"If anyone wants to be first, he must be the very last, and the servant of all" (v. 35).

This is the greatest day ever." What could make an A&M fan say that? How about a thorough beatdown of Notre Dame.

On Sept. 29, 2001, the Aggies hosted the Irish before what was then the largest crowd ever to watch a football game in the great state of Texas. Never mind that the Irish were a faint echo of their former glorious selves, that they were 0-2 for the season while the Aggies were 3-0, or that they hadn't even been ahead in a football game since sometime during the 2000 season. This was Notre Dame. And the Aggies beat them so thoroughly that one writer said Notre Dame looked like "it's playing blindfolded."

The whipping started on the first possession of the game as A&M marched 76 yards for a touchdown. Derek Farmer, the first true freshman to start at tailback for A&M since Dante Hall in 1996, capped the drive with a 31-yard romp. Farmer wound up with 100 yards on 20 carries, thereby becoming the first Aggie freshman to gain 100 yards since Joe Weber, who had 121 yards against Missouri in 1999. "I'd say he responded pretty well," said head coach R.C. Slocum in a bit of understatement.

The whole A&M team responded "pretty well" to the marquee match-up. The defense held Notre Dame to 191 yards of total offense despite the loss of nose guard Ty Warren — described by

Slocum as "arguably our best defensive player" — to an injury in the first quarter. Redshirt freshman Marcus Jasmin stepped in and stepped up.

Quarterback Mark Farris had a great day too. He hit wide receiver Terrence Murphy with a 45-yard bomb down the middle and then sneaked out of the backfield to catch a 22-yard touchdown pass from running back Oschlor Flemming.

When it was all over, the Aggies had a rousing 24-3 win, leaving their fans to revel in one of the program's greatest victories.

We all want to be the greatest. The goal for the Aggies and their fans every season is the national championship. The competition at work is to be the most productive sales person on the staff or the Teacher of the Year. In other words, we define being the greatest in terms of the struggle for personal success. It's nothing new; Jesus' disciples saw greatness in the same way.

As Jesus illustrated, though, greatness in the Kingdom of God has nothing to do with the secular world's understanding of success. Rather, the greatest are those who channel their ambition toward the furtherance of Christ's kingdom through love and service, rather than their own advancement, which is a complete reversal of status and values as the world sees them.

After all, who could be greater than the person who has Jesus for a brother and God for a father? And that's every one of us.

My goal was to be the greatest athlete that ever lived.
— *Babe Didrikson Zaharias*

**To be great for God has nothing to do
with personal advancement and everything to do
with the advancement of Christ's kingdom.**

PAIN RELIEF

Read 2 Corinthians 1:3-7.

"Just as the sufferings of Christ flow over into our lives, so also through Christ our comfort overflows" (v. 5).

I thought he was done." So declared head Aggie Kevin Sumlin as he watched senior wide receiver Malcome Kennedy lying on the turf with a serious injury. He was wrong.

At the 2014 team football banquet, Kennedy won the Aggie Heart Award, the highest honor for an A&M senior football player. He was a two-year starter who had 150 catches for 1,694 yards and fifteen touchdowns. At the banquet, Sumlin said Kennedy was "really the heart and soul of our team and a great leader."

Kennedy's leadership was never more apparent than during the Arkansas game of Sept. 27, 2014. A&M trailed 21-14 at halftime, and Kennedy told Sumlin he had something to say in the locker room. After Kennedy briefly spoke to his teammates, Sumlin said, "Yeah, that's better than anything I can say."

Arkansas led 28-14 before quarterback Kenny Hill and sophomore wide receiver Edward Pope teamed up for an 86-yard scoring play. When Hill and soph Josh Reynolds connected on a 59-yard touchdown pass with 2:09 left, the game was tied at 28.

With 57 seconds left in the game, Kennedy landed hard on his left shoulder and separated it. That's when Sumlin thought his receiver was finished for the day. But Kennedy had no intention of letting shoulder pain — no matter how intense — keep him

out of the game for long. The trainers popped the shoulder back in, and Kennedy was ready to go. Two plays after an injury that would have sidelined many a player, Kennedy subbed himself back into the game.

In the OT, offensive coordinator Jake Spavital knew the player he wanted to turn to. "When the game's on the line, Malcome's the guy we're going to," he said. So he called Kennedy's number, and on the first play, Hill hit him for a 25-yard touchdown.

The touchdown by a player who refused to let pain sideline him stood up for a 35-28 Aggie win.

Since you live on Earth and not in Heaven, you are forced to play with pain as Malcome Kennedy did. Whether it's a car wreck that left you battered, the end of a relationship that left you tattered, or a loved one's death that left you shattered — pain finds you and challenges you to keep going.

While God's word teaches that you will reap what you sow, life also teaches that pain and hardship are not necessarily the result of personal failure. Pain in fact can be one of the tools God uses to mold your character and change your life.

What are you to do when you are hit full-speed by the awful pain that seems to choke the very will to live out of you? Where is your consolation, your comfort, and your help?

In almighty God, whose love will never fail. When life knocks you to your knees, you're closer to God than ever before.

[The trainers] asked me if I was done. I said, 'No. I've got to go.'
— Malcome Kennedy after he separated his shoulder vs. Arkansas

When life hits you with pain, you can always
turn to God for comfort, consolation, and hope.

GOOD ADVICE

Read Isaiah 8:11-9:7.

"And he will be called Wonderful Counselor" (v. 9:6b).

With his team well ahead and only 57 seconds away from what was then the biggest win in school history, Gary Blair called a time out — to offer his players a little advice.

When the Aggie women met Baylor on March 29 for the fourth time in the 2010-11 season, the teams were playing in the NCAA Tournament for a trip to the Final Four. The odds weren't exactly stacked in A&M's favor since Baylor had beaten them in each of the previous three contests.

The fourth time turned out to be the charm, however, as the Aggies dispatched Baylor 58-46. As the score indicates, the game didn't go down to the last shot or even the last minute. But with only 57 seconds left and his team ahead by a dozen points and "so tantalizingly close to clinching a Final Four spot," Blair did something unexpected: He called a time out.

What advice did he have for his team? He told them not to dog-pile on the floor. "Act like you've been there before," he said. In other words, celebrate like veterans and not like rookies.

But they *were* rookies. Until that win over Baylor, which would, of course, be capped off by the national championship, the Aggie women had never been to a Final Four. The 2008 team had come close, losing to the eventual champions, Tennessee, by eight in the regional finals. So there was a newness to what was happening in

the Baylor game.

The Aggies respected their coach's advice. With the Bears duly dispatched, Blair ushered his team onto the floor for that most traditional celebration of all: the cutting down of the nets.

We all need a little advice now and then. More often that not, we turn to professional counselors, who are all over the place. Marriage counselors, grief counselors, guidance counselors in our schools, rehabilitation counselors, all sorts of mental health and addiction counselors — We even have pet counselors. No matter what our situation or problem, we can find plenty of advice for the taking.

The problem, of course, is that we find advice easy to offer but hard to take. We also have a tendency to go to the wrong source for advice, seeking counsel that doesn't really solve our problem but that instead enables us to continue with it.

Our need for outside advice, for an independent perspective on our situation, is actually God-given. God serves many functions in our lives, but one role clearly delineated in his Word is that of Counselor. Jesus himself is described as the "Wonderful Counselor." All the advice we need in our lives is right there for the asking; we don't even have to pay for it except with our faith. God is always there for us: to listen, to lead, and to guide.

Why do you want to ruin your best celebration on just getting to the Final Four? If we win the whole thing, I'll be on top of that dogpile.
— Gary Blair to his players

**We all need and seek advice in our lives,
but the ultimate and most wonderful Counselor
is of divine and not human origin.**

UNBELIEVABLE!

Read Hebrews 3:7-19.

"See to it, brothers, that none of you has a sinful, unbelieving heart that turns away from the living God" (v. 12).

What happened in the last half of A&M's 1914 game against LSU was so unbelievable that it was featured by *Ripley's Believe It or Not.*

The first half of the game on Oct. 31 in Dallas was rather pedestrian with LSU taking a 9-7 halftime lead. As A&M lined up to receive the second-half kickoff, team captain Tyree Bell told his teammates, "When [Dudley] Everett crosses that LSU goal line, I want everybody to be laying on somebody from LSU." Everybody must have been because Everett did indeed take the kick all the way. As John "Dough" Rollins put it, "Everything we tried thereafter turned out right."

Indeed, it did. Everett scored three touchdowns that last half and threw for another. Rollins had a good half, too, returning an interception 65 yards for a touchdown and kicking a field goal. In an unbelievable last-half performance, the Aggies rolled up 56 points to blast the Bayou Bengals 63-9.

Perhaps as unbelievable as the game itself was that Rollins even played in it, let alone excelled. He entered A&M in 1911 as a 15-year-old who had never even seen a football game. He had attended a school with only three teachers and had played a little

baseball. He was throwing a football around with a roommate one day when coach Charley Moran spotted him and told him, "I can use you down on the varsity football field."

The LSU game of 1914 was only the third one Rollins had ever seen. Unbelievably, he went on to letter three times, was an assistant coach under Homer Norton, and in 1970 was enshrined in the A&M Athletic Hall of Fame.

Much of what taxes the limits of our belief system has little direct effect on our lives. Maybe you don't believe in UFOs, Sasquatch, or the viability of electric cars. A healthy dose of skepticism is a natural defense mechanism that helps protect us in a world that all too often has designs on taking advantage of us.

That's not the case, however, when Jesus and God are part of the mix. Quite unbelievably, we often hear people blithely assert they don't believe in God. Or brazenly declare they believe in God but don't believe Jesus was anything but a good man and a great teacher.

At this point, unbelief becomes dangerous because God doesn't fool around with scoffers and non-believers. He locks them out of the Promised Land, which isn't a country in the Middle East but Heaven itself.

Given that scenario, it's downright unbelievable that anyone would not believe.

Football is an incredible game. Sometimes it's so incredible, it's unbelievable.

— Tom Landry

Perhaps nothing is as unbelievable as that some people insist on not believing in God or his son.

WEATHERPROOFED

Read Nahum 1:3-9.

"His way is in the whirlwind and the storm, and clouds are the dust of his feet" (v. 3b).

The weather was so horrible that the contest has become part of A&M lore as "The Hurricane Game."

Oct. 20, 1956, dawned sunny and beautiful at College Station. A sellout crowd packed Kyle Field for a battle of heavyweights: the 14th-ranked Aggies versus unbeaten and fourth-ranked TCU.

The Aggies were thus somewhat surprised when, in the locker room after warm-ups, head coach Bear Bryant warned them not to lose focus because the weather was so bad. John David Crow, A&M's first Heisman-Trophy winner, wondered what Bryant was talking about. "I was looking up at him and thinking the man must have lost his mind," Crow said.

But Crow later conceded that Bryant must have garnered some inside information from somewhere. That's because in the first half a "storm came with a fury never seen at a football game in College Station." A torrential downpour drove most of the spectators under the stands, but only a few of them gave up and left. Ignoring both the wind and some hail, the Cadet Corps stayed in the stands and cheered wildly on.

The rain was driven by winds of such strength that they bent the tower lights "to an alarming degree." More than 150 planes were overturned at Easterwood Airport. The playing field "be-

came 100 yards of pig slop" and brought the game to a complete standstill. The result was a "stormy, muddy scoreless first half."

The storm retreated in the second half, and the sun came out, freeing up both offenses. TCU took a 6-0 lead, but halfback Don Watson hit Crow for a touchdown with nine minutes to play. Loyd Taylor's kick made the difference in the 7-6 Aggie win.

Asked afterward if The Hurricane Game went according to plan, Bryant replied, "It went according to prayer."

A thunderstorm washes away your golf game or the picnic with the kids. Lightning knocks out the electricity just as you settle in at the computer. A tornado interrupts your Sunday dinner and sends everyone scurrying to the hallway. Oppressive heat keeps you from doing that yardwork you wanted to.

For all our technology and our knowledge, we are still at the mercy of the weather, able only to get a little more advance warning than in the past. The weather answers only to God. Rain and hail will fall where they want to, totally inconsiderate of something as important as a Texas A&M football game.

We stand mute before the awesome power of the weather, but we should be even more awestruck at the power of the one who controls it, a power beyond our imagining. Neither, however, can we imagine the depths of God's love for us, a love that drove him to die on a cross for us.

The wind was blowing so hard you could hardly breathe.
— TCU's Jim Swink on 'The Hurricane Game'

The power of the one who controls the weather
is beyond anything we can imagine,
but so is his love for us.

PRACTICE SESSION

Read 2 Peter 1:3-11.

"For if you do these things, you will never fail, and you will receive a rich welcome into the eternal kingdom of our Lord and Savior Jesus Christ" (vv. 10b-11).

After an unusual day at practice, A&M safety Trent Hunter perhaps should have seen what was coming in the Nebraska game.

Hunter was a Freshman All-America in 2008, finishing third on the team with 65 tackles. He had three interceptions that season, including two against Colorado on Nov. 1. As a sophomore in 2009, he started at strong safety and led the team with 95 tackles. He was a second-team All-Big 12 selection.

During that 13-game 2009 season, however, Hunter didn't get a single interception. As the games of the 2010 season unfolded week after week, he still didn't have a pick. The drought stretched over 26 games and more than two years until the Nebraska game of Nov. 20 came along. In the grueling 9-6 upset of the ninth-ranked Cornhuskers, Hunter twice turned Nebraska back with interceptions.

The first theft came on a sideline pass intended for the Husker tight end. In perfect position to make the play, Hunter grabbed the ball and planted his feet quickly to stay in bounds. When head coach Mike Sherman asked Hunter if he were in bounds, his safety responded, "Coach, I can't look down when I'm catching the ball." The score was tied 3-3 in the second half when Hunter

grabbed his second interception of the game on yet another pass aimed at the tight end.

Since Hunter so rarely got interceptions, the two thefts came as something of a surprise. Maybe, though, a practice session during the week foreshadowed Hunter's game. In that practice, he had three interceptions. As Sherman put it, "It was like an omen that he was going to get a pick."

Imagine a football team that never practices. A play cast that doesn't rehearse. A preacher who never reads or studies the Bible. When the showdown comes, they would be revealed as inept bumblers that merit our disdain.

We practice something so that we will become good at it, so that it becomes so natural that we can pull it off without even having to think about it. Interestingly, if we are to live as Christ wants us to, then we must practice that lifestyle — and showing up at church and sitting stoically on a pew once a week does not constitute practice. To practice successfully, we must participate; we must do repeatedly whatever it is we want to be good at.

We must practice being like Christ by living like Christ every day of our lives. For Christians, practice is a lifestyle that doesn't make us perfect — only Christ is perfect — but it does prepare us for the real thing: the day we meet God face to face and inherit Christ's kingdom.

I'm a firm believer in the 'practice makes perfect' mentality.
— Trent Hunter

Practicing the Christian lifestyle doesn't make us perfect, but it does secure us a permanent place beside the perfect one.

DAY 45

JUST IMPOSSIBLE!

Read Matthew 19:16-26.

*"Jesus looked at them and said, 'With man this is
impossible, but with God all things are possible'" (v. 26).*

Reason, logic, sanity, common sense, practicality — they all
dictated that the Aggies faced an impossible task. To even get a
chance to win the game they would have to pull off the largest
last-minute comeback in basketball history. So why not?

Coach Billy Kennedy's Aggies of 2015-16 went 28-9, were co-
champions of the SEC, and advanced to the Sweet 16 in the Big
Dance. On March 20, against Northern Iowa in the second round
of the NCAA Tournament, the team ensured its permanent place
in A&M athletic lore.

With 33 seconds left, A&M trailed the Panthers 69-57. Practi-
cally every team in the country would have perfunctorily closed
the game out to end what was by any definition a great season.
Only the Aggies didn't do that as impossible as it seems.

So here's what happened.

Guard Admon Gilder scored on a putback. Full court press and
turnover. Senior guard Danuel House, who had 22 points, scored
on a layup. 25 seconds left. Press, bad pass. Forward Jalen Jones
picked up the loose ball and dunked. 21.7 seconds. Inbounds pass
thrown out of bounds. Turnover. SEC Defensive Player of the Year
Alex Caruso inbounded to House, who nailed a trey. 19.6 seconds.

Now wait a minute. Only three points behind? Was the impos-

sible suddenly possible? Maybe. Until the Panthers dunked the ball with 17.9 seconds left. Nice try, guys, but it was impossible.

Or not. Caruso dribbled the floor, shot, hit it, was fouled and nailed the free throw. 11.8 seconds. Gilder forced a turnover, got the ball, and scored with 1.8 seconds left. Game tied. "I was about to start crying on the court," Jones said.

The Aggies completed the impossible by winning 92-88 in two overtimes. "I've never been a part of a game like that," Kennedy said afterwards. "All I can do is say to God be the glory."

Like the Aggies that night, we stare into the face of the impossible every day. That's because any pragmatic person, no matter how deep his faith, has to admit we have turned God's beautiful world into an impossible mess. The only hope for this dying, sin-infested place lies in our Lord's return to set everything right.

But we can't just give up and sit around praying for Jesus' return, as glorious a day as that will be. Our mission in this world is to change it for Jesus. We serve a Lord who calls us to step out in faith into seemingly impossible situations. We serve a Lord so audacious that he inspires us to believe that we are the instruments through which God does the impossible.

Changing the world may indeed seem impossible. Changing our corner of it, however, is not. It is, rather, a very possible and doable act of faith.

By any common sense or statistical measure, the Aggies had virtually zero chance to come all the way back from a 12-point deficit.
— ESPN's *Jake Trotter on A&M's impossible task*

With God, nothing is impossible,
including changing the world for Jesus.

WHO, ME?

Read Judges 6:11-23.

"'But Lord,' Gideon asked, 'how can I save Israel? My clan is the weakest in Manasseh, and I am the least in my family'" (v. 15).

One of the Aggies' greatest players learned he was the team's quarterback as the second half of a game began.

John Heisman once called Texas A&M's Joel Hunt, "The best all-around back I've ever seen." The Aggies landed him quite literally for peanuts. When Hunt was a teenager, he saw A&M play for the first time by paying $2 to a concessionaire for apples and peanuts to hawk at an A&M-Baylor game. It didn't turn out to be a very good investment since he didn't sell a single apple or any peanuts. "I was too fascinated by the game," Hunt recalled. "I made up my mind that day where I wanted to go to college."

Hunt played for A&M from 1925-27 and was All-Southwest Conference all three seasons. The Aggies were 20-4-3 in that time and were conference champions in 1925 and '27. He ran, passed, punted, place-kicked, and played defense. His thirty career touchdowns were a school record that stood until Darren Lewis broke it in 1990. (Johnny Manziel is the current record-holder.) Hunt's 128 points in 1927 remain the A&M season record. In the 13-13 tie with TCU in 1926, the Frog defense had him trapped, so he responded by drop-kicking a 43-yard field goal on the dead run.

As his head coach, D.X. Bible, said years later, "Joel turned out

better in 1925 than we expected." In fact, Hunt's whole career at A&M was better than anybody expected. As a sophomore in '25, he weighed only 143 pounds, and Bible used him as a wingback.

Everything changed, though, when starting quarterback Bob Berry went down in the first half of the Baylor game. As the team left the locker room for the last half, Hunt reminded Bible, "Coach, you didn't name a quarterback." "You're it," Bible responded.

And so was born an A&M legend, much to Hunt's surprise.

You probably know exactly how Joel Hunt felt; you've experienced a moment of surprise with its sinking "who, me?" feeling when you're suddenly placed on the spot. How about that time the teacher called on you when you hadn't done a lick of homework? Or the night the hypnotist pulled you out of a room full of folks to be his guinea pig? You've had the wide-eyed look and the turmoil in your midsection when you found yourself in a situation you neither sought nor were prepared for.

You may feel exactly as Gideon did about being called to serve God in some way, quailing at the very notion of being audacious enough to teach Sunday school, coordinate a high school prayer club, or lead a small group study. Who, me? Hey, who's worthy enough to do anything like that?

The truth is that nobody is — but that doesn't seem to matter to God. And it's his opinion, not yours, that counts.

Your brain commands your body to 'Run forward! Bend! Scoop up the ball! Peg it to the infield!' Then your body says, 'Who, me?'
— Joe DiMaggio

You're right in that no one is worthy to serve God,
but the problem is that doesn't matter to God.

DAY 47

GIFT-WRAPPED

Read James 1:12-18.

"Every good and perfect gift is from above, coming down from the Father of the heavenly lights" (v. 17).

The gift was twenty-five years in the making.

Asked by writer Rusty Burson to name the greatest player he coached at A&M, legendary Aggie men's basketball coach Shelby Metcalf (See Devotion No. 73.) didn't even hesitate a moment to consider his answer. "Sonny Parker. He's the most talented player we ever had at A&M," said the man who led the Aggies from 1963-90 and holds the school record for wins. "I've never seen a player with that much talent work so hard."

Parker was a junior-college transfer who played two seasons for the Aggies, 1974-75 and 1975-76. He was first-team All-Southwest Conference and the league's Player of the Year both seasons. He averaged 20.7 points per game as a senior and led the Aggies to back-to-back conference championships.

Parker was inducted into the A&M Athletic Hall of Fame in 2000. The induction ceremony was the occasion for the giving of a one-of-a-kind gift that moved Parker to tears.

While he was still at A&M, Parker received a watch as the prize for being the Most Valuable Player of an all-star game. The watch was inscribed "Sonny P, MVP." He took it and had "To Coach Metcalf" inscribed on it and gave it to his coach. The gesture of affection deeply touched Metcalf. "It meant a lot to me that he did

that," the coach said. So much so that Metcalf kept the watch as the decades rolled by.

After twenty-five years, during Parker's induction ceremony, the coach gave the watch to Parker's son, Christian. "I told [Sonny] now that I'm such an old man that time just gets in my way. So I wanted his son to have it back," Metcalf said.

Receiving a gift is nice, but as was the case with Shelby Metcalf and the watch, giving has its distinct pleasures too, doesn't it? The children's excitement on Christmas morning. That smile of pure delight on your spouse's face when you came up with a really cool anniversary present. Your dad's surprise that time you didn't give him a tie or socks. There really does seem to be something to this being more blessed to give than to receive.

No matter how generous we may be, though, we are grumbling misers compared to God, who is the greatest gift-giver of all. That's because all the good things in our lives — every single one of them — come from God. Friends, love, health, family, the air we breathe, the sun that warms us, even our very lives are all gifts from a profligate God. And here's the kicker: He even gives us eternal life with him through the gift of his son.

What in the world can we possibly give God in return? Our love and our life.

To get the watch back [after] some 25 years, it just made me so thankful to be a part of the Aggie family.
— Sonny Parker on Shelby Metcalf's gift to his son

Nobody can match God when it comes to giving,
but you can give him the gift of your love
in appreciation of his gifts to you.

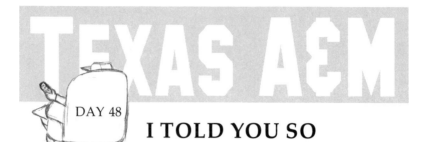

I TOLD YOU SO

Read Matthew 24:15-31.

"See, I have told you ahead of time" (v. 25).

All you've got to do is throw it up, and I'll go get it," Matt Bumgardner kept telling his quarterback, and finally he listened. The result was a win in the most emotion-laden game in Aggie football history.

Only eight days before the A&M-Texas game of Nov. 26, 1999, twelve A&M students were killed in the infamous collapse of the woodpile for the bonfire. The reaction 100 miles away in Austin was symbolized by what Texas defensive back Ahmad Brooks did when he heard of the tragedy: "I [got] on my knees and pray[ed] for the fans, the school, the friends, and families."

The night before the game, A&M quarterback Randy McCown and his roommate, junior wide receiver Matt Bumgardner, discussed game situations as they routinely did. Bumgardner's refrain this night was no different than any other pre-game talk; he was 6'2" tall, and if McCown would throw the ball high, he would go up and get it. What he repeatedly told his field general had pretty much been ignored throughout the season.

The Aggies trailed 16-13 in the fourth quarter when they took possession of the ball at the Texas 48. A&M quickly moved to the 14, the highlight a 24-yard pass from McCown to Chris Cole. At the line, McCown saw that his roommate had drawn single coverage. "I should have gone to [Cole] because he was on the wide side of

the field and had more room to work with," McCown said. "But what Bum told me went through my head, and I thought, 'OK, let's see what you got.'"

McCown threw it high. In the right corner of the end zone, Bumgardner did exactly what he had said he would do. He went up and pulled down the touchdown pass with 5:02 remaining. It was the game winner in the 20-16 Aggies victory.

Unless it's an Aggie saying exactly how he will perform in a game, don't you just hate it in when somebody says, "I told you so"? That means the other person was right and you were wrong; that other person has spoken the truth. You could have listened to that know-it-all in the first place, but then you would have lost the chance yourself to crow, "I told you so."

In our pluralistic age and society, many view truth as relative, meaning absolute truth does not exist. All belief systems have equal value and merit. But this is a ghastly, dangerous fallacy because it ignores the truth that God proclaimed in the presence and words of Jesus.

In speaking the truth, Jesus told everybody exactly what he was going to do: come back and take his faithful followers with him. Those who don't listen or who don't believe will be left behind with those four awful words, "I told you so," ringing in their ears and wringing their souls.

My last pass at A&M was to my roommate to beat our rival. It was a storybook ending for me.
— Randy McCown on the pass Matt Bumgardner said he would catch

Jesus matter-of-factly told us what he has planned:
He will return to gather all the faithful to himself.

FACING THE MUSIC

Read Psalm 98.

"Sing to the Lord a new song, for he has done marvelous things" (v. 1).

A shoemaker organized it, it does things that a computer has declared to be physically impossible, and it doesn't have a single music major. "It" is one of the most renowned marching musical groups in the country: the Fightin' Texas Aggie Band.

In 1885, Joseph F. Holick, 22, and his brother, Louis, hopped a ride on an empty boxcar to go work in a lumber mill in Orange. On the way, they stopped off in Bryan, and Joseph decided to stay. He found employment at a local boot shop and eventually was hired to make and repair boots at the new military college.

Shortly after Holick's arrival on campus, the commandant discovered the bootmaker had musical talents, so he was hired for $65 a month to play "Reveille" and "Taps." This was more money than Holick made as a cobbler, so he wanted to give the school "more than just two tunes for its money." He received permission to start a cadet band. The first group in 1894 had thirteen members.

The band derives it name from its method of selecting the early drum majors: They were chosen in physical combat. The candidates were placed in a locker room, and the cadet who walked out was the new drum major. The first drum major, H.A. "California" Morse, was, in fact, kicked out of school for fighting.

Today, the band is the largest military marching band in the

country, playing at all Aggie football games, in inaugural parades for presidents and governors, and at various university functions and special events. All the members are cadets; they live, eat, and are housed together as a unit of the corps. The band has no music majors for the simple reason that A&M doesn't offer that study.

The Aggie band is rightfully famous for its military precision and style. It performs marching maneuvers so complex that a computer has pompously claimed some of them can't be done because they require two people in the same place at the same time.

Maybe you can't play a lick or carry a tune in the proverbial bucket. Or perhaps you do know your way around a guitar or a keyboard and can sing "The Aggie War Hymn" on karaoke night without closing the joint down.

Unless you're a professional musician, however, how well you play or sing really doesn't matter. What counts is that you have music in your heart and sometimes you have to turn it loose.

Worshipping God has always included music in some form. That same boisterous and musical enthusiasm you exhibit when the Aggie band cranks up at football games should be a part of the joy you have in your personal worship of God.

When you consider that God loves you, he always will, and he has arranged through Jesus for you to spend eternity with him, how can that song God put in your heart not burst forth?

Good luck to dear old Texas Aggies. They are the boys who show the real old fight. That good old Aggie Spirit thrills us.
— from 'The Aggie War Hymn'

You call it music; others may call it noise;
sent God's way it's called praise.

STAR POWER

Read Luke 10:1-3, 17-20.

"The Lord appointed seventy-two others and sent them two by two ahead of him to every town and place where he was about to go" (v. 1).

John Kimbrough's journey to stardom took him all the way to Hollywood.

"Jarrin' John" Kimbrough is widely recognized as "the greatest player of Texas A&M's first 50 years of football." He was the star of the 1939 national championship team. In 1954, he became the first Aggie football player to be elected to the National Football Foundation Hall of Fame and was one of the five charter members of A&M's Athletic Hall of Fame in 1964.

Kimbrough got his first start against Baylor in 1938, and by the end of the season, it was clear to just about everybody that A&M had a star on its hands. In the 14-13 win over Tulane in the 1940 Sugar Bowl that clinched the national championship, Kimbrough rushed for 159 yards and scored both of A&M's touchdowns. He was All-America in both 1939 and '40, finishing second to Michigan's Tom Harmon in the voting for the 1940 Heisman Trophy.

Hollywood offered a different kind of stardom when Kimbrough's college football days were over. He starred in a pair of Westerns for 20th Century Fox in 1942 though he had never even been in a high school play. He also landed an advertising deal with Chesterfield cigarettes though he didn't smoke. "I didn't

know how to dangle the cigarette in my mouth," he said. "They took the picture and painted in the cigarette to make it look more natural." His face — with proper cigarette posture —appeared on billboards and in national magazines.

A stint as an army pilot during World War II interrupted Kimbrough's nascent Hollywood career and eventually ended it. After the war, he never went back to the silver screen, opting instead for stardom as a professional football player.

Football teams are like other organizations in that they may have a star such as John Kimbrough, but the star would be little or nothing without the supporting cast. It's the same in a private company, in a government bureaucracy, in a military unit, and just about any other team of people with a common goal.

That includes the team known as a church. It may have its "star" in the preacher, who is — like the quarterback or the company CEO — the most visible representative of the team. Preachers are, after all, God's paid, trained professionals.

But when Jesus assembled a team of seventy-two folks, he didn't have anybody on the payroll or any seminary graduates. All he had were no-names who loved him. And nothing has changed. God's church still depends on those whose only pay is the satisfaction of serving and whose only qualification is their love for God. God's church needs you.

Without the other men on the team, I would just be a nobody.
— John Kimbrough

**Yes, the church needs its professional clergy,
but it also needs those who serve as volunteers
because they love God; the church needs you.**

SWEET WORDS

Read John 8:1-11.

"'Then neither do I condemn you,' Jesus declared. 'Go now and leave your life of sin'" (v. 11).

A&M head coach Mark Turgeon tried several things to turn around his floundering basketball team. Most of all, he offered the players affirmation. It worked.

After a loss to Baylor on Feb. 14, 2009, their third straight, the Aggies were 3-7 in the conference. Just as his players were searching for answers, so was Turgeon. "He couldn't decide whether to kick his guys in the pants or wrap his arms around them."

The head coach told his players he "was going to spend a lot of time in church praying for answers. He wasn't kidding." He also shortened practices. But what Turgeon did most of all was offer his struggling team affirmation. He told them he believed in them, and because of that, they should believe too. "We're not going to fold," he added. "We can still make a run."

That's exactly what they did, stomping Texas 81-66 to start a six-game conference win streak. They ended the regular season with what was called "a near-perfect" 96-86 defeat of 15th-ranked Missouri that locked up a berth in the NCAA Tournament. In that game, the Aggies shot 61 percent from the field in the first half and led by as many as 22 points. They scored sixteen points off turnovers and completely controlled the tempo of the game, leading by as many as 26 in the last half before a late and meaningless

Missouri rally make the game look closer than it was.

"A lot of teams would have quit," Turgeon said about his squad that many fans and writers dismissed after the loss to Baylor. "We didn't. We're tough." They were indeed, coming from eighteen down to beat Nebraska and eight down to beat Colorado during the run. They then rolled past favored BYU 79-66 in the opening round of the Big Dance and finished the season at 24-10.

A little affirmation went a long way for the 2008-09 Aggies.

You make a key decision. All excited, you tell your best friend or spouse and anxiously await for a favorable reaction. "Boy, that was dumb" is the answer you get.

A friend's life spirals out of control into a total disaster. Alcohol, affairs, drugs, unemployment. Do you pretend you don't know that messed-up person?

Everybody needs affirmation in some degree. That is, we all occasionally need someone to say something positive about us, that we are worth something, and that God loves us.

The follower of Jesus does what our Lord did when he encountered someone whose life was a shambles. Rather than seeing what they were, he saw what they could become. Life is hard; it breaks us all to some degree. To be like Jesus, we must see past the problems of the broken and the hurting and envision their potential, understanding that not condemning is not condoning.

You can motivate football players better with kind words than you can with a whip.
— Legendary college football coach Bud Wilkinson

**The greatest way to affirm lost persons
is to lead them to Christ.**

GOOD TIMES

Read Psalm 30.

"You turned my wailing into dancing; you removed my sackcloth and clothed me with joy" (v. 11).

One gentlemanly Alabama fan wished four A&M fans a good time while they were in Tuscaloosa. Much to his distress, they had a very good time.

On Nov. 11, 2012, the consensus was that the Aggies were simply another speed break on the Tide's run to a second straight national title. True, 7-2 A&M was ranked 15th, but Alabama was undefeated and ranked No. 1. If there were any good times to be had in town that day, they would belong to the folks wearing crimson and white.

Instead, it turned into one of the grandest times A&M fans have had in a long time. When the game was over, the Aggies had a 29-24 upset, and the Fightin' Texas Aggie Band was blaring the War Hymn as loudly and as proudly as it could. Ryan Swope, the Aggies' all-time leading receiver, and cornerback Dustin Harris were standing on top of a gate and impersonating a conductor. They were joined by their teammates and thousands of fans who made the trip in generally having a blast.

The good times started for the Aggies almost as soon as the first whistle blew. A&M jumped on Bama for three touchdowns in the first quarter. Running back Christine Michael got in twice from the 1-yard line, and Johnny Manziel hit Swope for a 10-yard

TD. The Aggies amassed 200 yards of offense and put 20 points on the board.

Alabama threatened to halt A&M's good times, closing to within 29-24 and mounting a last-gasp drive to save itself. On fourth and goal with 1:36 to play, sophomore defensive back Deshazor Everett jumped on a quick out route and pulled down an interception to seal the upset. When the game ended minutes later, the Aggie good times began in earnest.

Here's a basic but distressing fact about the good times in our lives: They don't last. We may laugh in the sunshine today, but we do so while we symbolically glance over a shoulder. The Aggies pulled off the upset against Alabama but only after they had lost close ones to Florida and LSU. We know that sometime — maybe tomorrow — we will cry in the rain as the good times suddenly come crashing down around us.

Awareness of the certainty that good times don't endure often drives many of us to lose our lives and our souls in a lifestyle devoted to the frenetic pursuit of "fun." This is nothing more, though, than a frantic, pitiable, and doomed effort to outrun the bad times lurking around the corner.

The good times will come and go. Only when we quit chasing the good times and instead seek the good life through Jesus Christ do we discover an eternity in which the good times will never end. Only then will we be forever joyous.

I hope you all enjoy your time. Just don't enjoy it too much.
— Alabama fan to four A&M fans before 2012 game

Let the good times roll — forever and ever
for the followers of Jesus Christ.

DAY 53

LOST AND FOUND

Read Luke 15:11-32.

"This brother of yours was dead and is alive again; he was lost and is found" (v. 32).

Quite by accident, the Aggie football equipment manager discovered "arguably the most precious piece of metal associated with A&M football."

In the winter of 2004, Matt Watson was rummaging "deep in the musty bowels of Kyle Field, in a small storage room at the end of a long, dark hallway." He was looking for old trophies to fill out a glass case in the new athletic building. In the bottom of an old box, he found a dusty cup, buried among a bunch of other stuff, "artifacts from glory days long past and mostly forgotten."

This time, though, when Watson pulled the cup out and read the engraving, he could not believe what he had found. "I didn't even know that trophy existed," he said. Watson had stumbled upon the trophy that the Aggies had received after winning the 1940 Sugar Bowl that clinched the school's only football national championship. To his surprise and dismay, Watson read: "To the Brilliant Victor of the 1940 Sugar Bowl Classic. Texas A&M 14 Tulane 13. New Orleans. January 1, 1940."

How could such a treasure simply get lost and forgotten? The members of that championship team certainly knew it existed; they passed it around on the joyous and exuberant train ride home from New Orleans. "People had their minds on things other

than athletics" at the time, suggested Jim Sterling, a member of the '39 team. Those other things were Adolf Hitler and World War II, and the trophy – even football itself – became an afterthought.

And so, somehow, the trophy wound up at the bottom of a box at the back of a closet – until it was found. Lost no more, the cup was placed behind glass in the A&M lettermen's lounge.

From car keys to friendships, fortunes to reading glasses, loss is a feature of the unfolding panorama of our lives. We win some, we lose some; that's life.

Loss may range from the devastatingly tragic to the momentarily annoying. No loss, however, is as permanently catastrophic as the loss of our very souls. While "being lost" is one of Christianity's many complex symbols, the concept is simple. The lost are those who have chosen to separate themselves from God, to live without an awareness of God in an unrepentant lifestyle contrary to his commandments and tenets. Being lost is a state of mind as much as a way of life.

It's a one-sided decision, though, since God never leaves the lost; they leave him. In God's eyes, no one is a born loser, and neither does anyone have to remain lost. All it takes is a turning back to God; all it takes is a falling into the open arms of Jesus Christ, the good shepherd.

Coaches and athletic directors come and go, and somebody must have just forgotten about it.
— Roy Bucek of the '39 team on how the trophy was lost

**From God's point of view, we are all either lost
or found; interestingly, we — not God —
determine into which group we land.**

A ZEAL FOR GOD

Read Mark 12:28-34.

"Love the Lord your God with all your heart and with all your soul and with all your mind and with all your strength" (v. 30).

Perhaps the most incredible play in A&M football history generated so much excitement among the Cadet Corps that they poured onto the field to carry their heroes off even though the game wasn't over.

The search for a successor to Bear Bryant after the 1957 season was so divisive that the governor of Texas instituted an investigation. The ultimate choice was Jim Myers, the head coach at Iowa State. Aware of the dissension and wary of its implications, Myers originally turned down the job. A delegation of students, however, presented him with a petition bearing more than 2,000 names begging him to come to College Station, and he couldn't reject their plea.

Myers lasted four seasons before he was replaced in 1962 by Hank Foldberg. He had played with the Aggies in 1942 and went on to become an All-American end at West Point. He coached for three seasons before giving way to Gene Stallings.

Foldberg's first victory as a head coach provided A&M with a legendary gridiron moment. On Oct. 6, 1962, Texas Tech seemed to have wrapped up a win with a field goal with only 19 seconds left to play. The Red Raiders then kicked deep to Dan McIlhany,

who caught the ball in the end zone. He headed upfield, eluded two tacklers, and went 102 yards for a touchdown, crossing the goal line with only two seconds on the clock.

The exuberant cadets rushed onto the field to carry McIlhany and other players around on their shoulders. They paraded about for some fifteen minutes before officials managed to get them off the field so the game could continue. Their zeal cost the Aggies a 15-yard penalty, but nobody cared. A&M won 7-3.

What fills your life, your heart, and your soul so much that you sometimes just can't help what you do? We all have a zeal for something, whether it's Aggie football, sports cars, golf, family, scuba diving, or stamp collecting.

But do we have a zeal for the Lord? We may well jump up and down, scream, holler, even cry — generally making a spectacle of ourselves — when A&M scores. Yet on Sunday morning, if we go to church at all, we probably sit there showing about as much enthusiasm as we would for a root canal.

Of all the divine rules, regulations, and commandments we find in the Bible, Jesus made it crystal clear which one is number one: We are to love God with everything we have. All our heart, all our soul, all our mind, all our strength.

If we do that, our zeal and enthusiasm will burst forth. Like the cadets on that memorable October afternoon against Texas Tech, we just won't be able to help ourselves.

If you are not fired with enthusiasm, you will be fired with enthusiasm.
— Vince Lombardi

**The enthusiasm with which we worship God
reveals the depth of our relationship with him.**

DAY 55

TRUSTWORTHY

Read Psalm 25.

"To you, O lord, I lift up my soul. In you I trust, O my God" (vv. 1-2).

As Sharonda McDonald lay in the dust with a pain in her knee she had never experienced before, she knew two things immediately: That she was seriously injured and that she would have to trust in a power greater than herself to get back on the field.

The A&M softball program is a true powerhouse with three national titles including the AIAW championship in 1982 before the program joined the NCAA. McDonald is one of the Aggies' greatest players. An outfielder from 2004-07, she was All-Big 12 four times. She still holds Aggie career and single-season records for runs scored (195, 60) and stolen bases (153, 48). She is second all-time in career hits with 249.

Her 48 steals led the nation in 2005. Her total steals that season may have been phenomenal had she not torn an ACL in a game against Missouri. Her coach, Jo Evans, doubted she would be back before the season ended, but McDonald put her trust in God and determined to prove her coach wrong. "I knew the only way I could do it was through God," she said.

As a star athlete, she had always trusted her body and her abilities. Now, however, when even walking was hard, she had to take the difficult and challenging step of trusting in a higher power. That trust resulted in a calm throughout her rehab that

was so striking her teammates noticed. "There was something stronger inside of Sharonda that helped her work hard and get through it," said third baseman Jamie Hinshaw. "It was contagious and spread throughout the team."

Trusting in God throughout her recovery, McDonald was back on the team as a pinch runner in three weeks. Five days later, she was in the starting lineup in the super regional.

The benefits and boons our modern age has given us have not come without a price. Among those costs is the erosion of our trusting nature. Once upon a time in America we trusted until we saw a reason not to. Now, wariness is our first response to most situations.

It's not just outlandish claims on TV that have rendered us a nation of skeptics. We've come to accept hucksters as relatively harmless scam artists who are part of a capitalistic society.

No, the serious damage to our inherent sense of trust has been done in our personal relationships. With much pain, we have learned the truth: Many people just flat can't be trusted.

And then there's God, whom, as Sharonda McDonald learned through her injury, we can trust absolutely. He will not let us down; he is incapable of lying to us; he always delivers on his promises; he is always there when we need him.

In God we can trust. It sounds like a motto we might find on a coin, but it's a statement of absolute truth.

It was a huge struggle for me to get through it and rely on God.
— Sharonda McDonald

We look for the scam before surrendering our trust, but we can trust God without hesitation.

STORY TIME

Read Luke 8:26-39.

"'Return home and tell how much God has done for you.'
So the man went away and told all over town how much
Jesus had done for him" (v. 39).

From beating Texas twice in one season to preseason training at a fish camp to the wrong opponent showing up for a game, the A&M football teams of 1909 and 1910 had some real stories to tell. Along the way, they also went 15-1-1.

In 1910, Aggie head coach Charley Moran took his squad of forty would-be players to the Seabrook Hunting and Fishing Club for preseason practice. It wasn't a vacation. He rolled his boys out each morning at 6:00 for laps around a half-mile track, calisthenics, passing drills, dummy tackling, and wind sprints. Only then came breakfast. Later, Moran added blocking, tackling, and full-speed scrimmages to the marathon workouts. Moran was pleased with the results, and so were the Aggie fans. Rounded into superb playing shape, the squad went 8-1-0 and was formally named "Champions of the South."

The 1909 team pulled off a feat that has never been equalled. On Nov. 8, the 3-0-1 Aggies trounced Texas 23-0. The teams met again on Nov. 25, and, "to the utter amazement of the so-called experts," A&M beat Texas again, this time by a 5-0 score. During that second game, some Texas students displayed a sign that read, "Only once in seven years," referring to Texas' win streak that

stretched back to 1902. After the game, some A&M fans changed the sign to read, "Twice in three weeks."

In October 1910, the 3-0 Aggies were preparing for their game against the University of Kentucky when, to the surprise and embarrassment of everyone, Transylvania's team showed up. It seems the preseason invitation to Kentucky had mistakenly been mailed to Transylvania. The teams went on and played, and the Aggies, who apparently didn't really care whom they beat, won easily 33-0.

Like those early Aggie teams, you, too, have a story to tell; it's the story of your life and it's unique. No one else among the billions of people on this planet can tell the same story.

Part of that story is your encounter with Jesus. It's the most important chapter of all, but all too often believers in Jesus Christ don't tell it. Otherwise brave and daring Christian men and women who wouldn't think twice of skydiving or white-water rafting often quail when faced with the prospect of speaking about Jesus to someone else. It's the dreaded "W" word: witness. "I just don't know what to say," you sputter.

But witnessing is nothing but telling your story. No one can refute it; no one can claim it isn't true. You don't get into some great theological debate for which you're ill prepared. You just tell the beautiful, awesome story of Jesus and you.

To succeed in your sport or your life, you have to go out and write your own story.
— *Motivational-Quotes-for-Athletes.com*

We all have a story to tell, but the most important part of all is the chapter where we meet Jesus.

TEARS IN HEAVEN

Read Revelation 21:1-8.

*"[God] will wipe every tear from their eyes. There will be
no more death or mourning or crying or pain" (v. 4).*

It's the first time I've cried in twenty or thirty years," declared
Bear Bryant. "And believe me, I did."

Bryant's rare tears fell following the 1964 football season while
he was in New York for the Heisman Trophy dinner. A writer
walked into Bryant's hotel room to find the coach on the phone,
and "big ole tears were running down his cheek." The surprised
writer turned to Dude Hennessey, one of Bryant's assistant
coaches, who put a finger to his mouth to urge the writer to keep
his voice down. "What's wrong with Paul?" the reporter asked.
"He just lost one of his assistants," Hennessey responded. The
writer asked, "How old was he?" "Twenty-nine" was the answer.
"That's so young!" exclaimed the writer. "How did he die?" "Oh,
he didn't die," the coach explained. "He just went to Texas A&M."

The coach whom Bryant cried about losing was Gene Stallings,
one of the legendary "Junction Boys" of 1954. (See Devotion No.
12.) After he graduated, Stallings stayed on as a graduate assistant.
When Bryant moved to Alabama after the 1957 season, Stallings
went with him.

The A&M athletic committee made what was called a "bold,
dramatic, emotional decision" in calling one of their own back
home. At 29, Stallings would be the youngest coach in the country

AGGIES

to head up a major college team. The committee made such a dramatic move because A&M football needed a jolt. The program had gone through two head coaches in the seven seasons since Bryant had left. The Aggies had not won more than four games in a season during that spell.

And so, despite Bryant's warning that A&M was "the toughest recruiting job in America," Stallings left his coach bawling in a hotel room and came home to College Station.

When your parents died. When a friend told you she was divorcing. When you broke your collarbone. When you watch a sad movie. You cry. Crying is as much a part of life as are breathing and potholes on the highway. Usually our tears are brought on by pain, sorrow, or disappointment.

But what about when your child was born? When A&M pulls out a win in the last minute? When you discovered Jesus Christ? Those times elicit tears too; we cry at the times of our greatest, most overwhelming joy.

Thus, while there will be tears in Heaven, they will only be tears of sheer, unmitigated, undiluted joy. The greatest joy possible, a joy beyond our imagining, must occur when we finally see Christ. If we shed tears when A&M wins a game, can we really believe that we will stand dry-eyed and calm in the presence of Jesus?

What we will not shed in Heaven are tears of sorrow and pain.

I can't stop bawling. I'm so proud that A&M has hired [Gene Stallings], but I'm also sad because now I'll have to go back to work.
— Bear Bryant

**Tears in Heaven will be like everything else there:
a part of the joy we will experience.**

THE BIG TIME

Read Matthew 2:19-23.

"He went and lived in a town called Nazareth" (v. 23).

They once dressed in the men's locker room and practiced in an unheated gym. But the women of A&M's basketball program formally completed the move into the big-time on April 5, 2011, when they won the national championship.

Kelly Krauskopf, described as "most likely the biggest name of any former A&M player involved in women's hoops," was present at the creation. She transferred to A&M in 1980 after a year at Stephen F. Austin "and found a program in tatters." The head coach paid for paint out of her own pocket to renovate the locker room; the players did the painting. In the preseason, they went to J.C. Penney and purchased discounted travel bags. When the weather turned cold, the players put on extra clothing and practiced right on with no heat in their building.

The earliest players dressed in the men's locker rooms. Flowers were placed in the urinals to make the area "feminine." "We wore the same uniforms every year, and we used duct tape on our travel bags," Krauskopf remembered. They crammed thirteen players into a minivan to travel to games. Nobody sold tickets. Even so, Krauskopf recalled, a typical crowd at a home game in those early days numbered about fifty.

In 1986, Lynn Hickey, who doubled as the head coach and the women's athletic director, received a call from a Texas official

who asked about tickets for a game. An assistant athletic director by then, Krauskopf bought a roll of tickets "that looked like they came from the county fair," and charged the Horns $5 each. It was the first time the school had sold tickets to a women's game. Those hardscrabble days are long gone now. Instead, in 2011, the A&M women's basketball program made permanent reservations in the penthouse by winning the national championship.

Like the Aggie women have done, the move to the big time is one we often desire to make in our own lives.

Bumps in the road, communities with a single flashing light, and towns with only a convenience store, a church or two, and a voting place dot the American countryside. Maybe you were born in one of them and grew up in a virtually unknown village in a backwater county. Perhaps you started out on a stage far removed from the bright lights of Broadway, the glitz of Hollywood, or the halls of power in Washington, D.C.

Those original circumstances don't have to define or limit you, though, for life is much more than geography. It is about character and walking with God whether you're in the countryside or the city. Jesus knew the truth of that. After all, he grew up in a small town in an inconsequential region of an insignificant country ruled by foreign invaders.

Where you are doesn't matter. What you are does.

It takes your breath away.
— Kelly Krauskopf on the women's facilities and program in 2011

**Where you live may largely be
the culmination of a series of circumstances;
what you are is a choice you make.**

CALLING IT QUITS

Read Numbers 13:25-14:4.

"The men who had gone up with him said, 'We can't attack those people; they are stronger than we are'" (v. 13:31).

One of A&M's greatest players quit the team as a freshman.

Defensive tackle Charlie Krueger spent his freshman season of 1954 as a nondescript member of the team, buried six deep on the depth chart. Convinced he had no future under Bear Bryant at A&M, he decided to transfer to Texas A&I (now Texas A&M-Kingsville). Therefore, in the summer before the 1955 season, he wrote Bryant a letter telling the coach he was quitting. Krueger was so sure of his decision that he walked off his job in Houston so he could visit the A&I campus with a member of that school's coaching staff.

But teammate and friend Dennis Goehring convinced Krueger that Bryant not only valued him but wanted him back on the team. Despite his fear of facing his coach, Krueger asked Bryant to forget the letter and let him return to the squad. Bryant did, and Krueger started every game for three seasons.

In a squad meeting prior to the 1957 Missouri game, Bryant asked his senior leader, "Charlie, how does Coach [Jerry] Claiborne [of the Missouri staff] like to start a game?" "By running at the other team's strength," Krueger replied. "Then where will the first play come?" "At me," Krueger said.

He wasn't being boastful, just honest. Sure enough, on the first play of the game, Missouri ran a power play off tackle — right at Krueger. He played off two blockers and dropped the runner for a loss.

This player who had to be talked out of quitting was a two-time All-America and was inducted into the A&M Athletic Hall of Fame in 1972. He was one of the tackles named to the 50-year All-Southwest Team in 1969.

Remember that time you quit a high-school sports team? That night you bailed out of a relationship? Walked away from a job with the goals unachieved? Sometimes quitting is the most sensible way to minimize your losses, so you may well at times in your life give up on something or someone.

In your relationship with God, however, you should remember the people of Israel, who quit when the Promised Land was theirs for the taking. They forgot one fact of life you never should: God never gives up on you.

That means you should never, ever give up on God. No matter how tired or discouraged you get, no matter that it seems your prayers aren't getting through to God, no matter what — quitting on God is not an option.

He is preparing a blessing for you, and in his time, he will bring it to fruition — if you don't quit on him.

The first time you quit, it's hard. The second time, it gets easier. The third time, you don't even have to think about it.

— Bear Bryant

Whatever else you give up on in your life, don't give up on God; he will never ever give up on you.

DAY 60

PLAN AHEAD

Read Psalm 33:1-15.

"The plans of the Lord stand firm forever, the purposes of his heart through all generations" (v. 11).

Homer Norton had a plan that would lead to a national championship, but a reluctant banker had to make it happen.

The Aggies' head football coach stood firm in his conviction that for Texas A&M to win on the gridiron, he had to offer full scholarships to the state's best players. The problem was that the program was worse than broke; it was deep in debt. (See Devotion No. 9.) That didn't keep Norton in 1937 from devising a short-term plan to put his long-term plan into effect.

He drew up a list of the forty players he coveted and dubbed it the "Forty Most Wanted." Then — "here was the cute part" — he decided to go to the Dallas bank holding the athletic department's note and borrow an additional $25,000 to pay for the scholarships. He figured if he landed as many as twenty-five of these blue-chippers, the money would cover $250 per player for four years.

Norton knew he would need some assistance at the bank, so he called in some heavy artillery in the person of Bert Pfaff, a rich former student. Pfaff met Norton and his ace recruiter, Lil Dimmitt, at the bank. The banker must have been flabbergasted when he learned the men weren't there to make a payment but to request an additional loan. Norton explained that the money was necessary to "recruit a team that will win, and in winning [to]

attract a gate that will pay off our debt."

The Dallas banker listened and then deflected all their logical arguments, resisting until Pfaff threatened to close his account at the bank. By lunchtime, the Aggies had their money. By the fall, twenty-three of the "Forty Most Wanted" were Aggies. They included John Kimbrough, Tommie Vaughn, Marshall Robnett, Jim Thomason, and "virtually the entire team" that would go 11-0 and win the 1939 national championship.

Homer Norton's plan worked to perfection — literally.

Like success on the football field, successful living takes planning. You go to school to improve your chances for a good job. You use blueprints to build your home. You plan for retirement. You map out your vacation to have the best time. You even plan your children — sometimes.

Your best-laid plans, however, sometime get wrecked by events and circumstances beyond your control. The economy tanks; a debilitating illness strikes; a severe storm hits. Life is capricious, and thus no plans — not even your best ones — are foolproof.

But you don't have to go it alone. God has plans for your life that guarantee success as God defines it if you will make him your planning partner. God's plan for your life includes joy, love, peace, kindness, gentleness, and faithfulness, all the elements necessary for truly successful living for today and for all eternity. And God's plan will not fail.

A man without a plan doesn't have a future.
— *TCU head coach Gary Patterson*

Your plans may ensure a successful life;
God's plans will ensure a successful eternity.

DAY 61

IT'S YOUR CHOICE

Read Deuteronomy 30:15-20.

"I have set before you life and death, blessings and curses. Now choose life, so that you and your children may live" (v. 19).

Mark Thurmond had a choice to make, and when he made it, he became the answer to an A&M trivia question.

Thurmond is one of the greatest pitchers in Aggie baseball history. He arrived on campus in the fall of 1975 and started in the outfield as a freshman. He entered practice the following year as the team's No. 4 pitcher for coach Tom Chandler. As a junior, he got his first start in the second conference series of the season and pitched a shutout. He was on his way.

In 1977 and '78, Thurmond teamed with fellow ace Mark Ross to lead the Aggies to back-to-back conference titles. He was first-team All-SWC and first-team All-America both seasons. He won 34 games (tied with Ross for the most in school history), tossed 11 shutouts including a no-hitter against Texas Tech, and had a miniscule 2.29 career ERA.

Thurmond originally planned to follow the path blazed by his older brother, Al, who, from 1973-75, played safety for football coach Emory Bellard and the outfield for Chandler. In fact, Mark signed a football scholarship with the Aggies as a quarterback.

While he was playing in a summer baseball league after his high school graduation, however, Thurmond realized he had to

make a choice that could very well determine the course of his life. He figured his football career would never go past the collegiate level, but he thought he was good enough to have a real shot at a pro career in baseball. Thurmond chose.

He called Bellard and told the head Aggie that he had decided to play baseball exclusively. Bellard respected the decision and honored the scholarship for a year, thereby bringing up the trivia question: What player on a full football scholarship at Texas A&M played baseball and not football?

That would be Mark Thurmond.

Your life, too, is the sum of the choices you've made. That is, you have arrived at this moment and this place in your life because of the choices you made in your past. Your love of the Aggies. Your spouse. Your children. Mechanic, teacher, or beautician. Condo in downtown Houston or ranch home in Dallas. Dog, cat, or goldfish. You chose; you live with the results.

That includes the most important choice you will ever have to make: faith or the lack of it. That we have the ability to make decisions when faced with alternatives is a gift from God, who allows that faculty even when he's part of the choice. We can choose whether or not we will love him.

God reminds us that this particular choice has rather extreme consequences. Choosing God's way is life; choosing against him is death. Life or death. What kind of choice is that?

The choices you make in life make you.

— *John Wooden*

God gives you the freedom to choose: life or death; what kind of choice is that?

CONFIDENCE MEN

Read Micah 7:5-7.

"As for me, I will look to the Lord, I will wait for the God of my salvation" (v. 7 NRSV).

Texas A&M was 5-4; Oklahoma was unbeaten and ranked No. 1. And the Aggies were confident headed into the game? Well, they had reason to be — several of them, in fact.

R.C. Slocum's 2002 team got off to a good start before injuries decimated the squad. "We had more injuries than any team I'd ever been around," the head coach said. The beaten-up Aggies thus limped to a 5-4 record with Oklahoma on deck. The experts predicted the mighty Sooners would blow past A&M with ease.

But the underdogs entered the game surprisingly confident. For one thing, they had had the eventual national champions on the ropes in 2000 before a late interception return bailed the Sooners out. As a result of that encounter, said Slocum, "We had confidence we could play with them."

The Aggies were also as healthy as they had been all season. The return of several starters boosted their confidence, which was also bolstered by a Slocum psychological ploy. He assembled a highlight tape of big plays from the season and showed it to his team right before they took the field.

OU jumped out to an early 10-0 lead, but the Aggies remained confident. In large part that was because Slocum inserted a secret weapon into the game: freshman quarterback Reggie McNeal,

who had played little. The blowout became a shootout. McNeal threw a 61-yard bomb to Terrence Murphy and a 40-yard TD to tight end Greg Porter to tie the game at 13 at halftime.

His third touchdown pass, this one to Bethel Johnson, gave A&M its first lead at 20-13. A fourth scoring toss — again to Murphy — sent A&M ahead 27-23. The teams swapped field goals after that, and a surprisingly confident bunch of Aggies strode off the field with a memorable 30-26 upset.

You need confidence in all areas of your life. You're confident the company you work for will pay you on time, or you wouldn't go to work. You turn the ignition confident your car will start. When you flip a switch, you expect the light to come on.

Confidence in other people and in things is often — indeed, usually — misplaced. Companies go broke; car batteries die; light bulbs burn out. Even the people you love the most and have confidence in sometimes let you down.

So where can you place your trust with absolute confidence you won't be betrayed? In the promises of God.

Confidence is easy, of course, when everything's going your way, but what about when you cry as Micah did, "What misery is mine!" As Micah declares, that's when your confidence in God must be its strongest. That's when you wait for the Lord confident that God will not fail you, that he will never let you down.

I knew he could play, but I didn't know if he was ready yet.
— R.C. Slocum on having the confidence to play Reggie McNeal

People, things, and organizations will let you down; only God can be trusted absolutely and confidently.

THE SIMPLE LIFE

Read 1 John 1:5-10.

"If we confess our sins, he is faithful and just and will forgive us our sins and purify us from all unrighteousness" (v. 9).

In what was called at the time "the school's most monumental victory" in the modern era of Texas A&M football, the Aggies completed only two passes. That, however, was right in keeping with the simple plan head coach R.C. Slocum cooked up.

"We can't play like we've been playing and stay on the field with Nebraska," Slocum moaned as he prepared his squad for the match-up on Oct. 10, 1998. The Aggies were doing all right at 4-1. It's just that the Cornhuskers were unbeaten and riding a 19-game winning streak, were ranked second in the country, and were the defending national champions. Only the season before, the champs had waxed the Aggies in the Big 12 championship game. A&M didn't even have the full benefit of its intimidating home-field advantage. Because of construction in the north end zone, only two-thirds of Kyle Field's seating capacity was available.

But Slocum had a surprise for the Huskers: no surprise at all. A&M didn't do anything remarkable or unusual. The Aggies simply lined up and beat Nebraska 28-21. "We controlled the line of scrimmage on both sides of the ball," Slocum said. "Our plan was to run the ball," which explains the two pass completions.

Not that one of them wasn't right big. Early in the game, junior

quarterback Randy McCown hit wide receiver Chris Taylor for an 81-yard touchdown bomb. After that, though, the Aggies pretty much settled into Slocum's simple plan of running from tackle to tackle. A 71-yard romp by tailback Ja'Mar Toombs in the second quarter set up the touchdown that put A&M up for good.

Perhaps the simple life in America was doomed by the arrival of the programmable VCR, itself subsequently rendered defunct by more sophisticated technology. Since then, we've been on an inevitably downward spiral into ever more complicated lives. The once simple phone now does everything but brew coffee, and clothes dyers have more lights, bells, and whistles than cockpits.

But we might do well in our own lives to mimic the simple formula R.C. Slocum cooked up to beat favored Nebraska in 1998. That is, we should approach our lives with the keen awareness that success requires simplicity, a sticking to the basics: Revere God, love our families, honor our country, do our best.

Theologians may make what God did in Jesus as complicated as quantum mechanics and the infield fly rule, but God kept it simple for us: believe, trust, and obey. Believe in Jesus as the Son of God, trust that through him God makes possible our deliverance from our sins into Heaven, and obey God in the way he wants us to live.

It's simple, all right, but it's the true winning formula, the way to win for all eternity.

I think God made it simple. Just accept Him and believe.
— *Bobby Bowden*

**Life is complicated, but God made it simple
for us when he showed up as Jesus.**

YOUNG BLOOD

Read Jeremiah 1:4-10.

*"The Lord said to me, 'Do not say, 'I am only a child' . . .
for I am with you and will rescue you" (vv. 7a, 8).*

After Myles Garrett's brother took him to a Dallas Mavericks practice, a Mavs official said he couldn't do that again. The suit was worried Garrett might hurt some of his guys; he was 16.

Garrett arrived at A&M in 2014 as "the highest-ranked prospect the Aggies [had] signed in more than a decade." He started at defensive end as a freshman for a squad that beat third-ranked Auburn and defeated West Virginia 45-37 in the AutoZone Liberty Bowl. The latter win came on the day Garrett turned 19. He led the team with 11 sacks, a total that shattered the SEC freshman record of eight set by South Carolina's Jadeveon Clowney. He also made the All-SEC freshman team and *ESPN*'s Freshman All-America squad, earned All-SEC Second-Team honors, and won the team's defensive MVP award.

He had no trouble picking a major when he arrived at A&M; he chose geology. That's because he had fallen in love with paleontology — when he was 3 years old.

Obviously, being young has never stood in Garrett's way.

He got into sports early, but his primary interest at first was basketball. He didn't give football a serious try until his freshman year of high school. "I didn't know what to think," he said when the coaches moved him from offense to defense after two days of

practice.

Naturally, the youngster figured it out and was moved up to the varsity as a sophomore. That was the year he discovered the benefits of weightlifting and demonstrated a work ethic beyond his years. He asked his mother for weights as a gift; the result was a physical transformation. "It's like he went into his room and came out Mr. Olympia," said his mom.

That's when Myles' brother, Sean, who spent four seasons in the NBA, took him to a Mavericks workout. So much for that.

While our media do seem obsessed with youth, most aspects of our society value experience and some hard-won battle scars. Life usually requires us to spend time on the bench as a reserve, waiting for our chance to play with the big boys and girls. Unlike Myles Garrett, you probably rode some pine in high school. You entered college as a freshman. You started out in your career at an entry-level position.

Paying your dues is traditional, but that should never stop you from doing something bold and daring right away. Nowhere is this more true than in your faith life.

You may assert that you are too young and too inexperienced to really do anything worthwhile for God. Those are just excuses, however, and God won't pay a lick of attention to them when he issues a call.

After all, the younger you are, the more time you have to serve.

They thought he was a grown man.
— *Myles Garrett's mom on the Dallas Mavericks*

**Youth is no excuse for not serving God;
it just gives you more time.**

DAY 65

HERO WORSHIP

Read 1 Samuel 16:1-13.

"Do not consider his appearance or his height, for . . . the Lord does not look at the things man looks at. . . . The Lord looks at the heart" (v. 7).

On a day full of offensive heroes and heroics, a defensive player emerged as the biggest hero of all.

On Oct. 21, 2006, 23rd-ranked A&M (6-1) and Oklahoma State pulled off a thrilling overtime shoot-out. The Cowboys looked like winners when they struck for a 60-yard touchdown run and a 27-20 lead with only 3:24 to play. A&M still had some heroics of its own left, however.

After the kickoff, the Aggies went 65 yards in eleven plays to force overtime. On the way, though, they faced a fourth-and-13 at their 32. Quarterback Stephen McGee couldn't find an open receiver and dumped an outlet pass to tailback Jorvorskie Lane. The throw was slightly behind him, but Lane made like a hero, twisting around and making the catch with one hand. He then rumbled for 17 yards to the Aggie 49 for the first down.

Six plays later, McGee found another hero, hitting tight end Joey Thomas with a 2-yard touchdown pass with only three ticks on the clock. The PAT tied the game at 27; it was on to overtime.

The Aggies had pulled off heroics all game long, rallying three times for ties, largely behind McGee. He completed 17 of 26 passes for 192 yards and two touchdowns and rushed for 86

yards on 17 carries.

Lane continued to play the hero when he bulled his way in from a yard out to put A&M up 34-27 in overtime. Oklahoma State responded with a 15-yard touchdown pass, setting up what appeared to be a second overtime.

But a new kind of Aggie hero emerged. On the extra-point try, defensive tackle Red Bryant used his right arm to deflect the low kick. With all their late heroics, the Aggies had a 34-33 win.

In sports, heroes are those who make amazing or clutch plays to help their team win. In everyday living, heroes are commonly thought of as those who perform brave and dangerous feats that save or protect someone's life. You figure that excludes you.

But ask your son about that when you show him how to bait a hook, or your daughter when you show up for her softball game. Look into the eyes of those Little Leaguers you coach or those teenagers you teach Sunday school to.

Ask God about heroism when you're steady in your faith. For God, a hero is a person with the heart of a servant. And if a hero is a servant who acts to save others' lives, then the greatest hero of all is Jesus Christ.

God seeks heroes today, those who will proclaim the name of their hero — Jesus — proudly and boldly, no matter how others may scoff or ridicule. God knows heroes when he sees them — by what's in their hearts.

Heroes and cowards feel exactly the same fear; heroes just act differently.
— Former boxing trainer Cus D'Amato

God's heroes are those who remain steady
in their faith while serving others.

DAY 66

HOW YOU SEE IT

Read John 20:11-18.

"Mary stood outside the tomb crying" (v. 11).

Depending on one's view of life, you could say I was either part of the dead wood or part of building something special." So spoke an Aggie who pulled off one of the most famous plays in A&M football history.

Linebacker Scott Polk signed with Tom Wilson's Aggies in 1980. He started a few games as a freshman and then played enough as a sophomore to letter before a hamstring tear ended his season. He was granted a medical redshirt, and when he played the next three years, he became a rarity: a five-year letterman.

Thirty years or so after the fact, Polk still meets people who remember a play that one writer said "changed A&M football." It came in the 1984 win over Texas. After the 1983 game, Texas had won twelve of the last sixteen meetings between the two. In the '84 game, though, the Aggies jumped out to a 20-0 halftime lead. Then Texas started the last half with a drive.

The defense held, forcing a 27-yard field-goal attempt. Defensive back Domingo Bryant sailed in and blocked the kick. Polk picked up the loose ball and took off. He managed to cover 76 yards to the Texas 7 before he was tackled. "I don't think I had run that far since two-a-days," Polk said. "I was good for the first 40 yards, but after, that I started to lose ground."

Nevertheless, "the fat lady began singing, while Texas fans

began exiting." Eric Franklin kicked a field goal, and the Aggies went on to win 37-12. They rolled to six straight wins over Texas and won ten of the next eleven games.

Polk once noted that after he left A&M, the team went to three straight Cotton Bowls, so, he observed, depending upon one's perspective, he was part of the problem or part of a glorious turnaround. Aggie fans generally have one perspective: Scott Polk was part of a foundation that changed the pecking order in the A&M-Texas series.

Your perspective goes a long way toward determining whether you slink through life amid despair, anger, and hopelessness or stride boldly through life with joy and hope. Mary Magdalene is an excellent example. On that first Easter morning, she stood by Jesus' tomb crying, her heart broken, because she still viewed everything through the perspective of Jesus' death. But how her attitude, her heart, and her life changed when she saw the morning through the perspective of Jesus' resurrection.

So it is with life and death for all of us. You can't avoid death, but you can determine how you perceive it. Is it fearful, dark, fraught with peril and uncertainty? Or is it a simple little passageway to glory, the light, and loved ones, an elevator ride to paradise?

It's a matter of perspective that depends totally on whether or not you're standing by Jesus' side when it arrives.

For some people it's the end of the rainbow, but for us it's the end of the finish line.

— *Rower Larisa Healy*

Whether death is your worst enemy or
a solicitous chauffeur is a matter of perspective.

DAY 67

TEN TO REMEMBER

Read Exodus 20:1-17.

*"God spoke all these words: 'I am the Lord your God
You shall have no other gods before me'" (vv. 1, 3).*

The Aggies have played football since 1894, so many games in their storied history are memorable. Few, however, can match the collection of ten games that made up the regular season of 1939, the year the Aggies won their only national championship.

In the opener, A&M blasted Oklahoma A&M (now State) 32-0. Centenary fell 14-0 with fullback John Kimbrough scoring twice.

The third game of the season was crucial. Santa Clara had won the last two Sugar Bowls, was favored on its home turf, and led 3-0 heading into the fourth quarter. But junior tailback Marion Pugh hit Jim Thomason — who was primarily a blocking back and rarely saw the ball come his way — with a 19-yard touchdown pass for the 7-3 win. It would be Santa Clara's only loss of the season. "When we beat Santa Clara, we realized we might go all the way," said junior end William "Dog" Dawson.

Win number four was a 33-7 blasting of a Villanova team that was unbeaten in 22 straight games. Number five was a big one, a 20-6 whipping of TCU, the defending national champions. The Frogs' touchdown was the only one a Southwest Conference foe managed all season against an A&M defense that set a national record that still stands by allowing only 1.71 yards per play.

Ranked fifth nationally, the Aggies thumped Baylor 20-0 for

win number six. In the first minute, senior end Herb Smith, once called "pound for pound the greatest end football ever saw," ripped the ball out of a Bear's hands and ran 29 yards to score.

The Aggies buried Arkansas 27-0 to go 7-0 and then edged once-beaten SMU 6-2. Kimbrough scored the game's only touchdown after Tommie Vaughn recovered a fumble at the Mustang 11. Win number nine was a 19-0 conquest of Rice, which managed only eight total yards; number ten was a 20-0 romp over Texas.

The 10-0 Aggies finished the season ranked No. 1. For Texas A&M fans, these are indeed ten to remember for the ages.

You've got your list and you're ready to go: a gallon of paint and a water hose from the hardware store; chips, peanuts, and sodas from the grocery store for watching tonight's football game; the tickets for the band concert. Your list helps you remember.

God also made a list once of things he wanted you to remember; it's called the Ten Commandments. Just as your list reminds you to do something, so does God's list remind you of how you are to act in your dealings with other people and with him.

A life dedicated to Jesus is a life devoted to relationships, and God's list emphasizes that the social life and the spiritual life of the faithful cannot be sundered. God's relationship to you is one of unceasing, unqualified love, and you are to mirror that divine love in your relationships with others.

In case you forget, you have a list.

National champions? What is that, exactly?
 — Center Tommie Vaughn on hearing the Aggies were champs

God's list is a set of instructions on how you are to conduct yourself with other people and with him.

DAY 68

THE PRIZE

Read Philippians 3:10-16.

"I press on toward the goal to win the prize for which God has called me heavenward in Christ Jesus" (v. 14).

College football's biggest award was actually little more than a consolation prize for John David Crow.

On a November afternoon in 1957, Velma Crow took a phone message for her son. When he came home, she told him the president of Texas A&M had called with news that he had won something called the Heisman Trophy. "It's a big award," his mother said. She knew that because "they're flying me and your dad and you and Carolyn [his wife] to New York." That trip wasn't anything special to Crow. He had been to New York the year before and had met Bob Hope as part of the Associated Press All-America team. Meeting Bob Hope — now *that* was a big deal.

The banquet at the Downtown Athletic Club's gymnasium didn't impress A&M's senior running back either. It just reminded him of the sports banquets at dear old Springhill High School, his alma mater. Maybe he didn't notice that about 500 people were at this one; maybe he also didn't realize that they were all there just to see him pick up his trophy.

Only when Crow began his acceptance speech behind a cluster of microphones and saw one from the Movietone News did he appreciate just how big a deal this was. He thought, "They're going to put me in the theater in Springhill," population 1,500.

AGGIES

So why wasn't the first Texas A&M player to win the Heisman Trophy more impressed with it all? Through his football, he had already won two awards that were more special to him. "I just wanted to make Coach [Bear] Bryant happy," he said. "And I tried to always do something to please my father."

For John David Crow, those were prizes worth winning.

Even the most modest and self-effacing among us can't help but be pleased by prizes and honors. They symbolize the approval and appreciation of others, whether it's a Heisman Trophy, an Employee of the Month citation, a plaque for sales achievement, or the sign declaring yours as the neighborhood's prettiest yard.

Such prizes, honors, and awards are usually the culmination of the pursuit of personal achievement and accomplishment, whether intentional or not. Thus, they represent accolades and recognition from the world. Nothing is inherently wrong with any of that as long as we keep them in perspective.

That is, we must never let awards become such idols that we worship or lower our sight from the greatest prize of all and the only one truly worth winning. It's one that won't rust, collect dust, or leave us wondering why we worked so hard to win it in the first place. The ultimate prize is eternal life, and it's ours through Jesus Christ.

A gold medal is a wonderful thing, but if you're not enough without it, you'll never be enough with it.
— *John Candy in* Cool Running

The greatest prize of all doesn't require competition to claim it; God has it ready to hand to you through Jesus Christ.

DAY 69

CELEBRATION TIME

Read Luke 15:1-10.

"There is rejoicing in the presence of the angels of God over one sinner who repents" (v. 10).

Nothing like celebrating a national title with a visit to Steak 'n Shake. Ah, but when the Aggie women got home, the celebration really began.

After the Texas A&M women's basketball team won the NCAA Tournament by beating Notre Dame 76-70 on April 5, 2011, the whole bunch naturally celebrated. They wrapped up the long day — and started another wild one — at 2 a.m. with a long-delayed meal at an Indianapolis Steak 'n Shake. Even there the celebration continued as they "chatted with fans, shook hands with workers and caught a few highlights of the win on *ESPN.*"

But the party really started when the bleary-eyed team that set a school record with its 33 wins pulled into College Station the next afternoon. At Reed Arena, thousands of cheering and excited fans met them and threw an hour-long party. The band played, Reveille strolled around, and banners surrounded a stage assembled on the court. University president R. Bowen Loftin called it "a great day in Aggieland." Head coach Gary Blair and his players addressed the crowd of celebrants that included head football coach Mike Sherman and some of his players.

Danielle Adams, A&M's first All-America, received a standing ovation and thanked the school for recruiting her. Later, she could

only shake her head at the crowd that lined up for her autograph. Senior point guard Sydney Colson told the crowd that the Aggies had shown that "women's basketball isn't all that bad. It can be pretty good."

Blair recalled the week he was hired in 2003 when a fan told him, "Everybody loves us; we're lovable losers." Blair responded, "That's not what I want to be a part of. I'm here to build champions."

He did just that. And so, the Aggies celebrated.

A&M just won a close one. You got that new job or that promotion. You just held your newborn child in your arms. Life has those grand moments that call for celebration. You may jump up and down and scream in a wild frenzy at Kyle Field or share a quiet, sedate candlelight dinner at home — but you celebrate.

Consider then a celebration that is quite literally beyond our imagining, one that fills every niche of the very home of God and the angels. Imagine — if you can even begin to — a celebration in Heaven, which also has its grand moments.

Those grand moments are touched off when someone comes to faith in Jesus. Heaven itself rings with the joyous sounds of the singing and dancing of the celebrating angels. Even God rejoices when just one person — you or someone you have introduced to Christ? — turns to him.

When you said "yes" to Christ, you made the angels dance.

It's amazing to come back and see all these fans here.
— Danielle Adams at the champs' homecoming party

God himself joins the angels in heavenly celebration when even a single person turns to him through faith in Jesus.

THE RIGHT THING

Read Galatians 6:7-10.

"Let us not grow weary in doing what is right, for we will reap at harvest time, if we do not give up" (v. 9 NRSV).

Texas A&M head football coach Homer Norton did the right thing — even though it ultimately may have cost him his job.

Until R.C. Slocum came along with his fourteen seasons and 123 wins, Norton was A&M's winningest coach with 82 wins in his 14 seasons (1934-47). He was the head man of the '39 national champions. Norton was once described as "a gentle and unselfish man with a quiet sense of humor and an absolute horror of offending anyone." He had bedrock faith in the old-fashioned virtues. In other words, Homer Norton always believed in doing the right thing.

By 1943, World War II had decimated his squad, but still Norton kept winning. Only when the war ended and the veterans returned did the alumni begin to turn on him.

"When my boys went off to war," Norton recalled, "they knew they could come back and I would honor those scholarships." But when they started trickling back in 1946, they were all older, some with families, some disabled. Some had lost their desire to play football. Nevertheless, Norton honored every one of the commitments he had made to the men before they went off to war.

The head coach explained that the scholarships weren't just for football; rather "they were meant to enable them to get an

education. There was never a thought to not keeping those commitments. They were entitled to them."

Sadly, the results were predictable. Norton didn't have enough scholarships left to pursue the recruits that he needed to win. "It got me in trouble with the alumni," the head coach admitted. In 1946, the Aggies went 4-6. When they went 3-6-1 in 1947, Norton consented to having his contract bought out.

He left Texas A&M "heartbroken," but knowing he had done the right thing by his players and the nation's veterans.

Doing the right thing is easy when it's little stuff. Giving the quarter back when the cashier gives you too much change, helping a lost child at the mall, or putting a few bucks in the honor box at your favorite fishing hole.

But what about when the cost is dear as it was for Homer Norton? Every day you have multiple chances to do the right thing; in every instance, you have a choice: right or wrong. The factors that weigh into your decisions — including the personal cost to you — reveal much about your character.

Does your doing the right thing ever depend upon your calculation of the odds of getting caught? In the world's eyes, you can't go wrong doing wrong when you won't get caught. That passes for the world's slippery, situational ethics, but it doesn't pass muster with God.

In God's eyes, you can't go wrong doing right. Ever.

I knew what I was doing. But it was the right thing to do.
— Homer Norton on honoring his veterans' scholarships

**As far as God is concerned,
you can never go wrong doing right.**

A LONG SHOT

Read Matthew 9:9-13.

"[Jesus] saw a man named Matthew sitting at the tax collector's booth. 'Follow me,' he told him, and Matthew got up and followed him" (v. 9).

If bets were made about where [Michael Hodges'] football career would go after graduation, Texas A&M would have been put at 1,000:1, and that's being generous." And yet, this long shot not only wound up at A&M, he became a star.

Only the Air Force Academy offered Hodges a scholarship out of high school, so he took it. From Helotes, Texas, he was never happy so far from home. He said his goal some days was simply "to wake up, go through the day then hit his head against the pillow to repeat the process."

Hodges stuck it out for two years, decided to make a change, and came home in the summer of 2007. His football prospects were limited; after all, he hadn't played any in Colorado. In his mind, his only choices were Texas A&M and Texas State. One day, though, his mother said to him, "When it comes to it, you're always going to wonder if you could've played at the Division One level." Hodges made his decision; it was Texas A&M.

He walked on in the spring of 2008 and sat out the season because of the transfer rules. He used the time to hit the weights and prepare. He went into the spring of 2009 as a second-string linebacker but was soon promoted to starter.

AGGIES

The long shot thus started in 2009 and 2010. He was honorable mention All-Big 12 as a junior and second-team All-Big 12 as a senior. In the 2010 season, he led the Aggies in tackles and was twice the Big 12 Defensive Player of the Week. He was also a first-team *ESPN* Academic All-America.

At the football banquet in April 2011, this long shot to ever play in a game won the team's highest honor, The Aggie Heart Award. That formally named him the heart and soul of the defense of the 9-4 team that was co-champion of the Big 12's South Division.

Matthew the tax collector was another long shot, an unlikely person to be a confidant of the Son of God. While we may not get all warm and fuzzy about the IRS, our government's revenue agents are nothing like Matthew and his ilk. He bought a franchise, paying the Roman Empire for the privilege of extorting, bullying, and stealing everything he could from his own people. Tax collectors of the time were "despicable, vile, unprincipled scoundrels."

And yet, Jesus said only two words to this lowlife: "Follow me." Jesus knew that this long shot would make an excellent disciple.

It's the same with us. While we may not be quite as vile as Matthew was, none of us can stand before God with our hands clean and our hearts pure. We are all impossibly long shots to enter God's Heaven. That is, until we do what Matthew did: get up and follow Jesus.

Overcoming challenges should never be considered a long shot.
— Mother of disabled child on MightyMikeBasketball.com

**Only through Jesus does our status change
from being long shots to enter God's Kingdom
to being heavy favorites.**

WHAT A SURPRISE!

Read 1 Thessalonians 5:1-11.

"But you, brothers, are not in darkness so that this day should surprise you like a thief" (v. 4).

Life was just full of surprises for Thomas Carriger.

He was surprised that Texas A&M recruited him at all. He grew up in tiny Skidmore in the Rio Grande Valley. "No stoplight, just two blinkers," he said about his hometown of about 700 people. In high school, he played defensive end and tight end and was the kicker. A&M recruited him as a defensive lineman.

Thus, when he arrived at College Station in the summer of 2001, Carriger expected to be redshirted as a defensive lineman. To his surprise, he wasn't. Still another surprise came toward the end of summer practice when he was switched to tight end "in case of emergency." The biggest surprise of all was yet to come.

Senior Lonnie Madison, who was to share playing time at tight end with junior Michael de la Torre, suffered a knee injury on the first day of fall practice; he was lost for the season. The back-ups, Fred Spiller and Joey Perot, soon went down with injuries. Six games into the season, doctors told de la Torre his football career was over because of a herniated disk in his back. Much to his surprise, two months after showing up in College Station as a defensive lineman, Thomas Carriger was the starting tight end.

He knew he was primarily a blocker and not a receiver. After all, quarterback Mark Farris said of him, "He catches the ball really

good for a defensive lineman." To his surprise, Carriger caught four passes that 2001 season, including one for a touchdown.

Described as "the accidental tight end," Carriger never did go back to the defensive line, starting eight games at tight end as a sophomore and five as a junior before chronic shoulder problems ended his career.

Surprise birthday parties are a delight. And what's the fun of opening Christmas presents when we already know what's in them? Some surprises in life provide us with experiences that are both joyful and delightful.

Generally, though, we expend energy and resources to avoid most surprises and the impact they may have upon our lives. We may be surprised by the exact timing of a baby's arrival, but we nevertheless have the bags packed beforehand and the nursery all set for its occupant. Paul used this very image (v. 3) to describe the Day of the Lord, when Jesus will return to claim his own and establish his kingdom. We may be caught by surprise, but we must still be ready.

The consequences of being caught unprepared by a baby's insistence on being born are serious indeed. They pale, however, beside the eternal effects of not being ready when Jesus returns. We prepare ourselves just as Paul told us to (v. 8): We live in faith, hope, and love, ever on the alert for that great, promised day.

Thus, what happens to us after that will be no surprise at all.

I try to concentrate, try to relax and try not to mess up too bad.
— Thomas Carriger on playing his surprising position

**The timing of Jesus' return will be a surprise;
the consequences should not be.**

DAY 73

WINNER'S CIRCLE

Read 1 John 5:1-12.

*"Who is it that overcomes the world? Only he who
believes that Jesus is the Son of God" (v. 5).*

He was known as "A&M's witty basketball wizard," renown for
his snappy one-liners but also for his coaching prowess, which
led to wins.

Dr. Shelby Metcalf was the head coach of the men's basketball
team at Texas A&M for 26 1/2 seasons, from 1963-90. He won 438
games as a head coach, including 239 conference wins, the most
in Southwest Conference history. His 26 teams had 23 winning
seasons; six of his teams won 20 or more games. He was inducted
into the Texas Sports Hall of Fame in 1994 and the A&M Hall of
Fame in 1998.

Among his teams' greatest achievements was winning the
1987 Southwest Conference Tournament. The Aggies were seeded
eighth in the tournament after a 14-13 season with only a 6-10
conference record. But they surprised top-seeded TCU 81-70 in
the opening round and defeated Texas Tech 68-60 to advance to
the championship game against Baylor.

The magic carpet ride continued as the Aggies "systematically
rip[ped] apart a good Baylor team" in a game "that was over after
only 12 minutes." A&M jumped out to a 20-10 lead, and Baylor
never got closer. The Aggies recorded one of the most lopsided
wins in league championship history, stomping the Bears 71-46.

Guard Darryl McDonald led all scorers with 17 points. Senior forward Winston Crite had 16 points and 11 rebounds and was named the tournament's Most Valuable Player. Metcalf quipped, "This was the Aggie version of Cinderella. That's when you get a bunch of good guys together, they work hard and then turn a pumpkin into a coach."

As the record shows, this coach was no pumpkin. For Texas A&M, Shelby Metcalf was first and foremost a winner.

Life itself, and not just athletic events, is a competition. You vie against other job or college applicants. You compete against others for a date. Sibling rivalry is real; ask your brother or sister.

Inherent in any competition or in any situation in which you strive to win is the involvement of an antagonist. You always have an opponent to overcome, even if it's an inanimate video game, a golf course, or even yourself.

Nobody wants to be numbered among life's losers. We recognize them when we see them, and maybe mutter a prayer that says something like, "There but for the grace of God go I."

But one adversary will defeat us: Death will claim us all. We can turn the tables on this foe, though; we can defeat the grave. A victory is possible, however, only through faith in Jesus Christ. With Jesus, we have hope beyond death because we have life.

With Jesus, we win. For all of eternity.

I'm gonna go out and buy some underwear. I hadn't planned on being in Dallas this long.
— Shelby Metcalf on how he would celebrate the '87 tournament wins

Death is the ultimate opponent;
Jesus is the ultimate victor.

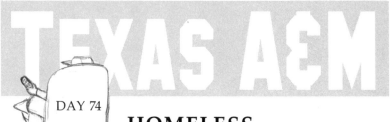

DAY 74

HOMELESS

Read Matthew 8:18-22.

"Jesus replied, 'Foxes have holes and birds of the air have nests, but the Son of Man has no place to lay his head'" *(v. 20).*

The Aggies once had a scout-team player who was homeless.

Ben Bitner is something of an Aggie legend. He appeared at open football tryouts in the fall of 2005, standing all of 5-foot-3 and weighing almost 150 pounds. He achieved his legendary status one day on the practice field when he knocked 280-pound running back Jorvorskie Lane unconscious during kickoff drills.

When he first showed up, Bitner, who stayed with it through his senior season of 2007 and got in on a few kickoffs, had more than twenty inches of long hair that hung from his helmet in a ponytail. It wasn't a fad, though. The hair was a promise Bitner made when his grandmother died of cancer. He grew it to donate to Locks for Love, which he did after the 2006 Holiday Bowl.

For more than a year, though, Bitner's campus lifestyle was probably the most unusual in Aggie football history. By choice, he was homeless. A spat with roommates led him to decide to live on the streets starting in January 2005. He actually had a plan, complete with hammock, sleeping bag, and hiking backpack. Originally, he expected to live outside for only a few days.

Ultimately, his dual lifestyle — student-athlete by day and free-spirit wanderer at night – became a choice. "When I got tired, I

would seek out a dark spot and hang up my hammock," he said. "It wasn't bad at all. I slept good. I'm not going to say I liked it." But he saved more than $3,000, he wasn't living off anyone, and the only thing he missed was watching TV any time he wanted to.

Even when teammates learned he was homeless and offered him shelter, Bitner declined. Each morning when the coaches arrived at the Bright Complex, they found Bitner already there, taking a shower and heading out for class.

Rock bottom in America has a face: the bag lady pushing a shopping cart or the scruffy guy with a beard and a backpack at the interstate exit holding a cardboard sign. Look closer at that bag lady or that scruffy guy, though, and you may see desperate women with children fleeing violence, veterans haunted by their combat experiences, or sick or injured workers.

Few of us are indifferent to the homeless when we're around them. They often raise quite strong passions, whether we regard them as a ministry or an odorous nuisance. They trouble us, perhaps because we realize that we're only one catastrophic illness and a few paychecks away from joining them. They remind us of just how tenuous our hold upon the material success we value so highly really is.

But they also stir our compassion because we serve a Lord who — like them — had no home, and for whom, the homeless, too, are his children.

He was really homeless and no one knew it.
— Aggie safety Melvin Bullitt on Ben Bitner

Because they, too, are God's children,
the homeless merit our compassion, not our scorn.

ANGER MANAGEMENT

Read James 1:19-27.

"Everyone should be quick to listen, slow to speak and slow to become angry, for man's anger does not bring about the righteous life that God desires" (vv. 19-20).

In an incident later recalled as one of the most bizarre football-related events of the century, angry Aggie fans once threatened the safety and well-being — of the Rice band.

In the 1970s, Rice's combination of a small alumni base and a cavernous stadium meant that when the Owls hosted Texas A&M, Aggie fans filled the place. "It was as if Kyle Field was somehow relocated for one day."

The Rice band — which called itself the Marching Owl Band or MOB — was a nontraditional outfit. They didn't march but rather presented revues that poked fun at anything they could think of. Their target on Nov. 17, 1973, was the Aggies.

A&M fans were in a surly mood at halftime since Rice led 17-0; their disposition quickly worsened. To "honor" A&M, the Rice band goose-stepped onto the field in its best Nazi imitation. Then the MOB formed a giant fire hydrant and played "Oh, Where Has My Little Dog Gone?" while a band member wandered around and pretended to be pulled by a dogless leash.

Insulting Reveille was just too much. The Aggies "hurled trash, insults, and threats at the MOB as it returned to the bleachers." After Rice won the game 24-20, several hundred angry fans went

after the band again until the students had to hide beneath the stadium bleachers. School officials then had to figure out a way to get the band safely out of the stadium. They commandeered the bread trucks used to haul hamburger and hot dog buns to the concession stands and rode the MOB members to safety past the unknowing but still irate Aggie fans.

Our society today is well aware of anger's destructive power because all too many of us don't manage our anger. Anger is a healthy component of a fully functional human being until — like other normal emotions such as fear, grief, and worry — it escalates out of control. Anger abounds when the Aggies lose; the trouble comes when that anger intensifies from annoyance and disappointment to rage and destructive behavior.

Anger has both practical and spiritual consequences. Its great spiritual danger occurs when anger is "a purely selfish matter and the expression of a merely peevish vexation at unexpected and unwelcome misfortune or frustration" as when A&M fumbles on first down at the other team's 5-yard line. Under those circumstances, anger interferes with the living of the righteous, Christlike life God intends for us.

Our own anger, therefore, can incur God's wrath. Making God angry can never be anything but a perfectly horrendous idea.

Still seething, an Aggie crowd estimated at 500 gathered outside the stadium, wanting to settle the issue with the MOB once and for all.
— Olin Buchanan on the anger at the 1973 Rice game

Anger becomes a problem when it escalates into rage and interferes with the righteous life God intends for us.

ON CALL

Read 1 Samuel 3:1-18.

*"The Lord came and stood there, calling as at the other
times, 'Samuel! Samuel!' Then Samuel said, 'Speak, for
your servant is listening'" (v. 10).*

King Gill answered the call, and thus was born one of college
football's most inspiring traditions.

On Jan. 2, 1922, the Aggies played the Praying Colonels of
Centre College in the Dixie Classic in Dallas. Centre was "unde-
feated, untied and virtually unchallenged" and a heavy favorite
over the 5-1-2 Aggies, champions of the Southwest Conference.
But A&M played a strong first half and led 2-0 at the break after
Fred Wilson tackled a Centre punt returner in the end zone for a
safety.

Coach Dana X. Bible had a serious problem, though. Six A&M
players had been knocked out of the game. With only one sub-
stitute available to play, the Aggies were running out of warm
bodies. In the dressing room, Bible remembered Gill, who had
left the football team to concentrate on basketball. Bible had asked
Gill to assist with spotting the players for journalists.

He sent Gill a message to come down to the bench. As Gill
recalled it, "It was not until I arrived on the field that I learned
Coach wanted me to put on a uniform and be ready to play if he
needed me." Gill never hesitated. The stadium didn't have any
dressing rooms, so Heinie Weir, one of the injured players, and

AGGIES

Gill went under the stands and swapped clothes.

The Aggies pulled off the upset 22-14, winning what Bible called "the biggest game A&M had ever had." Gill wasn't needed in the game, but he "won immortality simply by being at the right place at the right time and merely by climbing into a uniform."

Yell leader Harry W. Thompson, the man Bible had sent to fetch Gill, organized a rally to celebrate the win. There he referred to Gill as The Twelfth Man. And so it has been ever since for the Aggie student body, standing throughout the games to signify their readiness to answer the call for the sake of Texas A&M.

A team player is someone who does whatever the coach calls upon him to do for the good of the team. Something quite similar occurs when God places a specific call upon a Christian's life.

This is much scarier, though, than standing up during a football game. The way many folks understand it is that answering God's call means going into the ministry, packing the family up, and moving halfway around the world to some place where folks have never heard of air conditioning, fried chicken, cell phones, or the Aggies. Zambia. The Philippines. Cleveland even.

Not for you, no thank you. And who can blame you?

But God usually calls folks to serve him where they are. In fact, God put you where you are right now, and he has a purpose in placing you there. Wherever you are, you are called to serve him.

'It looks like we may not have enough players to finish the game. You may have to go in and stand around for a while.' 'Yes, sir.'
— Dana X. Bible to King Gill and Gill's response

God calls you to serve him right now right where he has put you, wherever that is.

FOOD FOR THOUGHT

Read Genesis 9:1-7.

"Everything that lives and moves will be food for you. Just as I gave you the green plants, I now give you everything" *(v. 3).*

Wieners in a glove, a restaurant revolt, and a swearing off of chocolate and sodas — A&M athletes have their food stories.

A&M's Olsen Field was famous for 25-cent hot dog night, and the baseball players, always long on appetites and short on money, would load up. One night, as shortstop Richard Petru (1994-97) trotted out to his position, he stuck his fingers in his glove — only to find them blocked by some foreign substance. Upon a closer inspection, he found five wieners stuck up his glove's finger holes. He had to scramble to toss them around the infield and get his glove on before the inning started.

Longtime A&M softball coach Bob Brock (See Devotion No. 26.) always preferred to eat in a cafeteria when his team was on the road. That was not what his players particularly desired. On one trip to Louisiana, the bus pulled up to a cafeteria, and an excited Brock hopped off the bus. But, as pitcher Shawn Andaya (See Devotion No. 87.) put it, "We refused to budge." After finding himself alone in the cafeteria, a livid Brock returned to the bus. "Later on, we ate at Chili's," Andaya said, adding, "It's that type of strong will that makes you win!"

The softball national champions of 1987 demonstrated that

strong will in no uncertain terms. "There was a lot of drug testing going on at that time," Andaya recalled. "We were so paranoid [about] testing positive for anything that we stopped eating chocolate and drinking sodas" before the College World Series. After the championship had been won and all the tests had been run, before the champs left the stadium, their parents handed over bags of M&M's and Snickers and cans of soda. The deprived players ate and drank them on the spot.

Belly up to the buffet, boys and girls, for barbecue, fried catfish with hush puppies, sirloin steak, grilled chicken, and a lobster or two. Rachael Ray's a household name; hamburger joints, pizza parlors, and taco stands lurk on every corner; and we have television channels devoted exclusively to food. We love our chow.

Food is one of God's really good ideas, but consider the complex divine plan that begins with a seed and ends with beans. The creator of all life devised a system in which living things are sustained and nourished physically through the sacrifice of other living things in a way similar to what Christ underwent to save us spiritually. Whether it's fast food or home-cooked, everything we eat is a gift from God secured through a divine plan in which some plants and animals have given up their lives.

Pausing to give thanks before we dive in seems the least we can do.

I cut down to six meals a day.

— *Charles Barkley on losing weight*

**God created a system that nourishes us
through the sacrifice of other living things;
that's worth a thank-you.**

SIZE MATTERS

Read Luke 19:1-10.

"[Zacchaeus] wanted to see who Jesus was, but being a short man he could not, because of the crowd. So he ran ahead and climbed a sycamore-fig tree to see him (vv. 3-4).

By all accounts, he is still the biggest Vietnamese person any-body in south Texas — or all of Texas for that matter — has ever seen. He is also one of the most popular and one of the greatest players in A&M football history.

Linebacker Dat Nguyen was the first Vietnamese-American to play in the NFL, his career with the Dallas Cowboys cut short in 2005 by a neck injury. From 1995-98, he started every game of his Aggie career, all 51 of them. He still holds the A&M record for tackles in a career (517) and is the only Aggie ever to lead the team in tackles four straight seasons. He was All-America and the Big 12 Defensive Player of the Year in 1998, the same year he won the Lombardi award as the nation's most outstanding lineman and the Bednarik Award as college football's Defensive Player of the Year. He returned to College Station in 2010 as the inside linebackers coach, staying on the staff through the 2011 season.

Nguyen has always figured he got his work ethic from his father and his good manners from his mother. No one, however, can account for his size. At 5'11", he weighed in at 234 pounds with the Cowboys and towered over everyone in his family. His father, Ho, blames it on a whole lot of milk. His mother, Tarn,

has long suspected that her son's unusual size resulted from the consumption of way too much fried rice and broccoli, which she believes was a major factor in the failure of the family's Chinese restaurant several years ago. Nguyen suggests a lifelong acquaintance with his favorite food: hamburgers.

Growing up, as he kept getting bigger, Nguyen wanted to play for Michigan because he liked their helmets. A&M won out, however. "I just woke up one day and said, 'I'm an Aggie,'" he said.

And he's been a big man on campus ever since.

Bigger is better! Such is one of the most powerful mantras of our time. We expand our football stadiums. We augment our body parts. Hey, make that a triple cheeseburger and a large order of fries! My company is bigger than your company. Even our church buildings must be bigger to be better. About the only exception to our all-consuming drive for bigness is our waistlines.

But size obviously didn't matter to Jesus. After all, salvation came to the house of an evil tax collector who was so short he had to climb a tree to catch a glimpse of Jesus. Zacchaeus indeed had a big bank account; he was a big man in town even if his own people scorned him. But none of that — including Zacchaeus' height — mattered. Zacchaeus received salvation because of his repentance, which revealed itself in a changed life.

The same is true for us today. What matters is the size of the heart devoted to our Lord.

It is not the size of a man but the size of his heart that matters.
— Evander Holyfield

**Size matters to Jesus, but only the size of the heart
of the one who would follow Him.**

DAY 79

THE FAME GAME

Read 1 Kings 10:1-10, 18-29.

*"King Solomon was greater in riches and wisdom than
all the other kings of the earth. The whole world sought
audience with Solomon" (vv. 23-24).*

Over the years, Dave South has achieved local fame as the long-
time radio voice of the Aggies, but one single event propelled him
to national fame and cult status: He was thrown out of a basket-
ball game.

As the Voice of Aggieland, South has for years broadcast A&M
football, basketball, and baseball games over the 60-plus stations
of the A&M radio network. During the 1993 Southwest Conference
basketball tournament game between A&M and Houston, he had
a run-in with a ref that made him a national celebrity.

During a time out in the second half, one of the refs, who had
apparently overheard some of South's less-than-kind critiques
as he trotted by the courtside press row during the game, stood
and stared directly at South. The broadcaster smiled, toasted the
ref with his soft drink, and then put his left hand to his throat
in the worldwide symbol for choking. The official went berserk,
rounding up a security guard and screaming, "You're out of here"
repeatedly. The security guard escorted South off the floor.

South said the incident took on a life of its own. *ESPN* featured
it that evening; John Madden lambasted it on his national radio
show. It had its own page on the "Sports Hall of Shame" calendar,

and the sports-themed comic strip *Tank McNamara* managed to get a week's worth of fun out of it. The artists framed the original artwork and sent it to South.

The conference fired the referee at season's end. In a rather wry aside to the incident, the security guard later showed his appreciation for South's fame by posing with him for a picture.

Have you ever wanted to be famous? Hanging out with other rich and famous people, having folks with microphones listen to what you say, throwing money around like toilet paper, meeting adoring and clamoring fans, signing autographs, and posing for the paparazzi before you climb into your imported sports car?

Many of us yearn to be famous, well-known in the places and by the people that we believe matter. That's all fame amounts to: strangers knowing your name and your face.

The truth is that you are already famous where it really does matter, which excludes TV's talking heads, screaming teenagers, rapt moviegoers, or D.C. power brokers. You are famous because Almighty God knows your name, your face, and everything else there is to know about you.

If a persistent photographer snapped you pondering this fame — the only kind that has eternal significance — would the picture show the world unbridled joy or the shell-shocked expression of a mug shot?

It is very funny now, and I tell the story all the time.

— *Dave South*

**You're already famous because
God knows your name and your face,
which may be either reassuring or terrifying.**

UNEXPECTEDLY

Read Matthew 24:36-51.

*"No one knows about that day or hour, not even the
angels in heaven, nor the Son, but only the Father" (v. 36).*

The Aggie comeback was so sudden and so unexpected that a
reporter on his way to the dressing room for his post-game inter-
views missed the whole thing.

On Nov. 12, 1955, Bear Bryant's second Aggie team was in the
unusual position of being favored over Rice. The Owls had beaten
A&M ten straight times, but in 1955, they had won only two games
when they met the 6-1-1 Aggies.

Nevertheless, the Rice team "solemnly had collected for its one
great effort of 1955." The result was a 12-0 lead with less than five
minutes to play. Halfback Loyd Taylor put some life into the Aggie
cause by taking a pitch around right end 58 yards to the Owl 3
behind a clearing block from Jack Pardee. He then scored from
the 2 to cut Rice's lead to 12-7 with 3:18 on the clock.

Rice expected an onside kick and lined up for it, but Pardee
placed it perfectly, and Gene Stallings recovered for A&M at the
Rice 43. Jim Wright immediately hit Taylor with a strike that car-
ried to the Rice 5. Once again, Taylor got in, and suddenly A&M
led 14-12.

In desperation, Rice threw the ball, and Pardee nabbed an inter-
ception and returned it to the Owl 8. Don Watson scored from
there with 1:09 on the clock to complete the unexpected come-

back. The Aggies won 20-12, having scored all their points in two minutes and nine seconds. One wag noted the unexpected win "terminated a Rice winning streak of 10 years and 56 minutes."

A reporter had headed for the A&M dressing room to talk with Bryant and some Aggies about what he expected to be a loss. He got stuck in an elevator for several minutes and did not learn that A&M had won the game until he arrived in the exuberant winners' locker room.

Just like the Rice Owls in 1955, we think we've got everything figured out and under control, and then something unexpected happens. About the only thing we can expect from life with any certainty is the unexpected.

God is that way too, suddenly showing up to remind us he's still around. A friend who calls and tells you he's praying for you, a hug from your child or grandchild, a lone lily that blooms in your yard — unexpected moments when the divine comes crashing into our lives with such clarity that it takes our breath away and brings tears to our eyes.

But why shouldn't God do the unexpected? The only factor limiting what God can do in our lives is the paucity of our own faith. We should expect the unexpected from God, this same deity who caught everyone by surprise by unexpectedly coming to live among us as a man, and who will return when we least expect it.

Rice outplayed us and deserved to win. We were very, very lucky.
— Bear Bryant on the sudden and unexpected win in 1955

God continually does the unexpected,
like showing up as Jesus,
who will return unexpectedly.

DAY 81

PRESSURE POINT

Read 1 Kings 18:16-40.

"Answer me, O Lord, answer me, so these people will know that you, O Lord, are God" (v. 37).

All the pressure of 22 years of Aggie history was wrapped up in one swing, and Bronson Burgoon was in real trouble.

There Burgoon stood, hands on his hips, eyeballing his next shot in the final round of the 2009 NCAA men's golf championships. The senior golfer and second-team All-America had just finished blowing a four-hole lead against a buddy and occasional golf partner from the University of Arkansas. The championship was match play; Aggies Andrea Pavan and John Hurley had won their matches, but the Razorbacks had also won twice. Thus, the match was deadlocked.

Talk about pressure. If Burgoon won this final hole, a par four, the Aggies were national champions. If Burgoon lost the hole, a drought that had lasted 22 years would continue. Not since the 1987 softball team had the Aggies won an NCAA national title.

Burgoon was not in very good shape to have all that pressure on his shoulders. His tee shot wound up far to the right in deep rough 120 yards from the pin. His Arkansas opponent drove right down the heart of the fairway. "Bronson's a great player, first off," said coach J.T. Higgins. "He had no problem all day getting out of the rough. I figured he'd get it on the green."

Burgoon's shots all day, though, had not come with this much

pressure. The Razorback was looking at an easy par, so the next shot out of the rough and into the wind would probably determine the national championship. Burgoon let loose with "one mighty hack." His ball landed on the green and rolled to within three inches of the hole. "I couldn't have drawn it up any better," he said. His opponent conceded the tap-in for birdie, then missed a 35-foot putt to tie.

The Aggies were national champions. The pressure was off.

You live every day with pressure. As Elijah did so long ago and as Bronson Burgoon did in Toledo in 2009, you lay it on the line with everybody watching. Your family, coworkers, or employees – they depend on you. You know the pressure of a deadline, of a job evaluation, of taking the risk of asking someone to go out with you, of driving in rush-hour traffic.

Help in dealing with daily pressure is readily available, and the only price you pay for it is your willingness to believe. God will give you the grace to persevere if you ask prayerfully.

And while you may need some convincing, the pressures of daily living are really small potatoes since they all will pass. The real pressure comes when you stare into the face of eternity because what you do with it is irrevocable and forever. You can handle that pressure easily enough by deciding for Jesus. Eternity is then taken care of; the pressure's off — forever.

Pressure is for tires.

— *Charles Barkley*

**The greatest pressure you face in life
concerns where you will spend eternity,
which can be dealt with by deciding for Jesus.**

GOAL ORIENTED

Read 1 Peter 1:3-12.

"For you are receiving the goal of your faith, the salvation of your souls" (v. 9).

Shut down Darren Sproles. Achieve that goal and a win over the defending conference champions was possible. Mark that one down as mission accomplished.

The week of the game against Kansas State on Oct. 2, 2004, the A&M coaches laid out one goal for the defense: Don't let Sproles, the Wildcats' star running back, get loose. Stop him and they just might upset the 2003 champs. It was a pretty ambitious goal. Sproles was coming off a 292-yard game the week before and had rushed for 220 or more yards in four of his last six games.

The game started out as though Sproles would have another field day. On K-State's first possession, the Wildcats chewed up more than seven minutes and took a 7-0 lead. The star rushed for 36 yards on the drive.

After that — well, Aggie defensive coordinator Carl Torbush summed up how the A&M defense fared against the Heisman-Trophy candidate. "We talked a lot about slowing [Sproles] down," Torbush said. "I think we did better than that."

The defense just flat stopped Sproles. After that opening drive, he gained a grand total of 25 yards rushing the rest of the game. His longest run was ten yards. To make his long night even longer, he fumbled twice, setting up a pair of A&M touchdowns.

AGGIES

On paper, the game looks like a K-State rout. The Cats ran 90 plays to A&M's 43 and held the ball for more than 40 minutes. But while the Aggie defense was nailing Sproles, the Wildcat defense couldn't stop the Aggies. The offense scored six touchdowns on drives that totaled 7 minutes, 15 seconds.

With 1:34 left and A&M leading only 35-30, the defense had one last insult to throw Sproles' way. Linebacker Keelan Jackson nailed him short of a first down on fourth down. A&M scored one last time and won 42-30.

Put a check mark beside the goal for the night.

What are your goals in life? Have you ever thought them out? Or do you just shuffle along living for your paycheck and whatever fun you can seek out instead of pursuing some greater purpose?

Now try this one: What is the goal of your faith life? You go to church to worship God. You read the Bible and study God's word to learn about God and how God wants you to live. But what is it you hope to achieve? What is all that stuff about? For what purpose do you believe that Jesus Christ is God's son?

The answer is actually quite simple: The goal of your faith life is your salvation, and this is the only goal in life that matters. Nothing you will ever seek is as important or as eternal as getting into Heaven and making sure that everybody you know and love will be there too one day.

We did a great job on Sproles.

— *A&M head coach Dennis Franchione*

**The most important goal of your life
is to get to Heaven and to help as many people
as you can to get there one day too.**

DAY 83

PEACEKEEPERS

Read Hebrews 12:14-17.

"Make every effort to live in peace with all men and to be holy" (v. 14).

Joe Routt was so mad he was determined to beat up his coach. What happened turned his life around.

Routt transferred to A&M from Blinn Junior College in 1933 and soon became academically ineligible. His football coach, the legendary Homer Norton, at times "had as much trouble with [Routt] as his professors [did]." "Joe was unruly, pugnacious, and hard to handle when he first came to A&M," Norton said.

When he regained his eligibility, Routt became an A&M legend. Not before, however, he had a showdown with his head coach in a hotel dining room. In the 1936 game against Centenary, Norton benched the junior guard — and Routt didn't like it one bit. The team went back to the hotel for supper, and Routt and Norton were the last two people left in the dining room. "I knew he was mad and was going to whip me," Norton said, "because he was accustomed to having his own way."

Finally, Norton forced the issue, telling Routt, "Go ahead, Joe; do what you want, but I'm going to run this ball club my way." They talked some more, and eventually Routt came around. "I talked him out of whipping me, and from then on he was easy to handle," Norton said.

Routt was so easy to handle, in fact, that he became an honor-

roll student and A&M's first football All-America (1936 and '37). He won the school heavyweight boxing championship as a senior and then turned pro upon graduation. His career lasted only one fight; when he lost he said, "If I can't beat this guy, I'm giving up boxing." He did.

Routt died fighting — but as an American hero. An infantry captain, he was killed in 1944 during the Battle of the Bulge. In 1962, Routt was elected to the College Football Hall of Fame. Joe Routt Boulevard in College Station honors him.

Perhaps you've never been particularly interested in beating up your coach. But maybe you retaliated when you got one elbow too many in a pickup basketball game. Or maybe you and your spouse or your teenager get into it occasionally, shouting and saying cruel things. Or road rage may be a part of your life.

While we do seem to live in a more belligerent, confrontational society than ever before, fighting is still not the solution to a problem. Rather, it only escalates the whole confrontation, leaving wounded pride, intransigence, and simmering hatred in its wake. Actively seeking and making peace is the way to a solution that lasts and heals broken relationships and aching hearts.

Peacemaking is not as easy as fighting is, but it is much more courageous and a lot less painful. It is also exactly what Jesus would do.

[Joe Routt] was mean, cantankerous, and opinionated until Homer [Norton] straightened him out.
— Former A&M sports publicist H.B. McElroy

Making peace instead of fighting takes courage and strength; it's also what Jesus would do.

DAY 84

WILD AND CRAZY

Read Acts 4:1-22.

"When they saw the courage of Peter and John and realized that they were unschooled, ordinary men, they were astonished" (v. 13).

Cedric Ogbuehi was a key part of a play so wild and crazy that it may have won Johnny Manziel the Heisman Trophy.

Texas A&M has had many big wins in its long and storied football history. Few — if any — of those wins, however, will be remembered as fondly and as avidly as the 29-24 win over top-ranked Alabama on Nov. 11, 2012. (See Devotion No. 52.)

Manziel and his fellow Aggies jumped all over the Tide with three touchdowns in the first quarter for a 20-0 lead. They then held off a ferocious Alabama comeback for the win.

One of those first-quarter touchdown plays was so wild and crazy — well, you have to see it to believe it. The Aggies were up 7-0 and faced a third-and-goal at the Alabama 10-yard line. Manziel took the snap in the shotgun formation, dropped back a step or two, and looked to his left.

Not liking what he saw, he started to scramble as he so often did throughout his Aggie career. He stepped up into the pocket and looked to his right for a way out of the Alabama pressure.

That's when the play turned wild and crazy. Manziel slipped and bumped into Ogbuehi, a star tackle who would be first-team All-SEC and first-team All-America. The collision with Ogbuehi's

backside caused Manziel to lose his balance and the ball. "With waves of Tide rushers crashing around him," he somehow found his feet and the ball and scrambled. He spied wide receiver Ryan Swope open in the end zone and threw a touchdown pass.

As writer Richard Croome put it, "Thanks to Manziel's composure and ability . . . Ogbuehi became part of [A&M] folklore."

Part of the lure of sports is how the games sometimes lapse into the wild and crazy, such as the play against Alabama that used Cedric Ogbuehi's backside. But ponder a moment the notion that Jesus calls each one of us to a wild, crazy, and adventuresome life, something like that of Peter and John. If this is true, then why is it that church and faith life often seem so boring to many of us? Why don't Christians lead lives of adventure and excitement?

Many do. Heading into the uncharted waters of the mission field is certainly exciting. Helping the homeless turn their lives around isn't dull at all. Neither is working with youth, teaching Sunday school, entering the chaplaincy for the military, or riding with a Christian biker gang.

The truth is too many of us play it safe. We prefer to do what we want to do rather than what God calls us to do. As a result, we pass on the chance for our lives to be a great adventure story. We may just be common, ordinary folks, but if we truly follow Jesus, there is nothing common or ordinary about our lives.

That kind of made him the Heisman winner because every Heisman winner needs that one play, one game, and that was it.
— Cedric Ogbuehi on the fanny play vs. Alabama.

We are a bunch of wild and crazy guys and gals when we truly surrender our lives to Jesus.

MIDDLE OF NOWHERE

Read Genesis 28:10-22.

"When Jacob awoke from his sleep, he thought, 'Surely the Lord is in this place, and I was not aware of it'" (v. 16).

If you hadn't been there before, you couldn't find it the first time." So declared Texas A&M recruiter and assistant coach Elmer Smith about the place far out in the boondocks where he found one of the Aggies' greatest quarterbacks.

Fortunately for the history of A&M football, Smith had been "there" before. In late 1959 and early 1960, he traveled the "farm-to-market road back into the woods" out "in the Cass County boondocks of East Texas." He was in the woods to round up "a stubby halfback with quickness and a tough disposition" named George Hargett. Hargett went on to play football and baseball for A&M from 1961-63, distinguishing himself as a pass receiver, a kick returner, and a defensive back.

On one of those trips off the main road somewhere close to the small town of Linden, Smith spotted George's 12-year-old brother, Edd. He was "a little old timid boy," Smith recalled. "I bent down and put my arm around his shoulder and said, 'Edd, I'll be back here someday to sign you, too.'"

Sure enough, six years later, Smith made his way down what was now a familiar if "winding, bumpy" road to that same house back in the woods. He wasn't alone this time; a lot of recruiters were scrambling to find the Hargett house. Little 12-year-old Edd

had grown into quite a quarterback. But Elmer Smith had gotten there first.

The younger Hargett missed the 1965 football season with a knee injury that required surgery. Once he was healthy, though, nothing stopped him again. By the time Hargett wound up his playing days at A&M in 1968, he held 21 school records, was a two-time All-SWC quarterback, and had led the Aggies to the 1967 conference title. His 418 yards of total offense against SMU in 1968 was a school record.

Edd Hargett went from the backwoods to the big-time.

Ever been stuck in Lodi? Picked any fruit in Pear Valley? Found happiness in Joy? Or joy in Happy?

They are among the many small communities, some of them nothing more than crossroads, that dot the Texas countryside. Not on any interstate highway or major road, they seem to be in the middle of nowhere, the type of place Edd Hargett could have been found growing up with a football in his hand. They're just hamlets we zip through on our way to somewhere important.

But don't be misled; those villages are indeed special and wonderful. That's because God is in Pumpville and Cee Vee just as he is in College Station, Dallas, and Amarillo. Even when you are far off the roads well traveled, you are with God. As Jacob discovered one rather astounding morning, the middle of nowhere is, in fact, holy ground — because God is there.

If you could walk and chew gum in Linden, you played football.
— Edd Hargett on his small hometown

No matter how far off the beaten path you travel,
you are still on holy ground because God is there.

DAY 86

CHEAP TRICKS

Read Acts 19:11-20.

"The evil spirit answered them, 'Jesus I know, and I know about Paul, but who are you?'" (v. 15)

Tricks and pranks are such a part of Von Miller's life that he even got his start in football by playing a trick on his dad — with a little help from his mom.

As a senior in 2010, Miller became A&M's first major award winner in more than a decade when he won the Butkus Award as the nation's most outstanding linebacker. He was a two-time All America, A&M's first to be so honored since Jason Webster in 1999.

Growing up in DeSoto, Texas, Miller earned a reputation as an indomitable trickster. He once put a live turtle in a teammate's football helmet. He also stashed a dead snake under his brother's bed just to see if his mom would scream when she found it.

That inclination followed him to College Station. At a summer retreat, Miller set his mind on tossing strength and conditioning coach Dave Kennedy into a swimming pool. He made up a story about losing his cell phone and asked Kennedy to call his number. "The moment Kennedy whipped out his own cell, he was toast." An accomplice swiped the phone, and before Kennedy figured out what was happening, he was sailing into the drink.

A penchant for tricks runs in the family. Von's mom, Gloria, helped him deceive his dad so he could first play football. It wasn't that the senior Von didn't want junior to play; he just wanted him

to wait for his body to mature some. But little Von pestered his mom until she enrolled him in fifth-grade Pee Wee football.

She aided the deception by stashing her son's pads in her van and washing his jerseys in the garage late at night to protect their secret. Dad caught on some time later when he took the SUV out for a rare washing. "By then," senior said, "he was entrenched. I wasn't gonna take football away from him."

A&M fans are still grateful this particular trick worked.

Scam artists are everywhere — and they love trick plays. An e-mail encourages you to send money to some foreign country to get rich. That guy at your front door offers to resurface your driveway at a ridiculously low price. A TV ad promises a pill to help you lose weight without diet or exercise.

You've been around; you check things out before deciding. The same approach is necessary with spiritual matters, too, because false religions and bogus Christian denominations abound. The key is what any group does with Jesus. Is he the son of God, the ruler of the universe, and the only way to salvation? If not, then what the group espouses is something other than the true Word of God.

The good news about Jesus does indeed sound too good to be true, but the only catch is that there is no catch. When it comes to salvation through Jesus Christ, there's no trick lurking in the fine print. There's just the truth, right there for you to see.

As soon as you think you're safe, he'll come up with something else.
— Gloria Miller on her son's pranks

God's promises through Jesus sound too good to be true, but the only catch is that there is no catch.

DAY 87

JUST PERFECT

Read Matthew 5:43-48.

"Be perfect, therefore, as your heavenly Father is perfect"
(v. 48).

With the national championship on the line, Texas A&M softball legend Shawn Andaya was perfect.

On May 24, 1987, the Aggies faced a daunting challenge in their quest to win the school's second NCAA softball title. (1983 was the other; they also won the AIAW title in '82.) They had to beat a UCLA team twice that hadn't given up a single run the entire College World Series. "It seemed like the impossible dream," Andaya said. "I remember riding over in the team van, and just thinking, 'This is crazy.'"

But Andaya gave the Aggies a real shot. From 1984-87, she was a three-time All-America. As a senior in 1987, she led the nation in strikeouts (326) and in wins (36). Her career ERA was infinitesimal at 0.43.

She couldn't have been better than she was on this day, especially in the first game when she was perfect. With palpable pressure riding on every pitch, she threw a perfect game at the Bruins and won that initial game 1-0 to set up a one-game showdown.

Andaya got the starting nod from coach Bob Brock in the second game despite pulling a muscle running out a ground ball in the first game. Brock had another pitcher ready to go, but Andaya told him, "Hey, I can go." End of discussion.

Her single in the first inning drove in the game's first run. For a while, it looked as though she might pitch a second perfect game before she made a fielding error in the fourth inning. She went on to pitch a two-hitter, and the Aggies won 4-1 on a day when their ace pitcher was about as perfect as she could be.

Except perhaps for Shawn Andaya when she's pitching a softball, nobody's perfect; we all make mistakes every day. We botch our personal relationships; at work we seek competence, not perfection. To insist upon personal or professional perfection in our lives is to establish an impossibly high standard that will eventually destroy us physically, emotionally, and mentally.

Yet that is exactly the standard God sets for us. Our love is to be perfect, never ceasing, never failing, never qualified – just the way God loves us. And Jesus didn't limit his command to only preachers and goody-two-shoes types. All of his disciples are to be perfect as they navigate their way through the world's ambiguous definition and understanding of love.

But that's impossible! Well, not necessarily, if to love perfectly is to serve God wholeheartedly and to follow Jesus with single-minded devotion. Anyhow, in his perfect love for us, God makes allowance for our imperfect love and the consequences of it in the perfection of Jesus.

Practice does not make you perfect as nobody is perfect, but it does make you better.
— *Soccer coach Adrian Parrish*

**In his perfect love for us, God provides a way
for us to escape the consequences
of our imperfect love for him: Jesus.**

THE NIGHTMARE

Read Mark 5-1-20.

"What do you want with me, Jesus, Son of the Most High God? Swear to God that you won't torture me!" (v. 7)

The A&M women's basketball team once played a strange game that was remembered "as a nightmarish day for the three referees and for one official on the scorer's table."

On Feb. 20, 2010, play between 18-6 A&M and 19-6 Texas was stopped in the last half for the referees to huddle. Neither head coach knew what was going on, but they knew "something bad was going to happen to one of them." It did, something neither one of them had ever seen in their combined 43 years of coaching.

A&M led 47-42 with only 3:45 remaining in the nationally televised game when the refs were summoned to the scorer's table. For fourteen excruciating minutes, they huddled to watch video replays while everyone else in the building wondered what in the world was going on.

When it was all over, the Longhorns had two points taken off the scoreboard and lost possession of the ball. The official scorekeeper had awarded the Longhorns what were called "unmerited free throws." After the game, the head referee said it was the first time in her twenty years as an official that she had seen this particular mistake made.

What happened is that the official scorekeeper inadvertently recorded an A&M team foul that occurred in the first half as

happening in the last half. As a result, Texas went into the bonus in the last half a foul early. The player made both shots.

Some time passed before the error was caught. The refs were then notified at the next dead ball. That's when the long delay came, followed by the loss of the two points. The Aggies went on an 11-4 run when play resumed and beat the Longhorns for the seventh straight time 58-44.

Falling. Drowning. Standing naked in a room crowded with fully dressed people. They're nightmares, dreams that jolt us from our sleep in anxiety or downright terror.

The film industry has used our common nightmares to create horror movies that allow us to experience our fears vicariously. This includes Hollywood's formulaic "evil vs. good" movies in which demons and the like render good virtually helpless in the face of their power and ruthlessness.

The spiritual truth, though, is that it is evil that has come face to face with its worst nightmare in Jesus. We seem to understand that our basic mission as Jesus' followers is to further his kingdom and change the world through emulating him in the way we live and love others. But do we appreciate that in truly living for Jesus, we are daily tormenting the very devil himself?

Satan and his lackeys quake helplessly in fear before the power of almighty God that is in us through Jesus.

I can't have a nightmare tonight. I've just lived through one.
— Darrell Imhoff, the opposing center the night Wilt Chamberlain
scored 100 points in an NBA game.

As the followers of Jesus Christ,
we are the stuff of Satan's nightmares.

THE ANSWER

Read Colossians 2:2-10.

"My purpose is that they . . . may know the mystery of God, namely, Christ, in whom are hidden all the treasures of wisdom and knowledge" (vv. 2, 3).

ESPN had a problem; the answer lay in an unprecedented contract with Texas A&M.

In 1985, the sports network began its first season of expanded college football coverage with night games. The contests late in the season required a Southern school because of the cold weather. Texas A&M was the solution to the problem. In a move unheard of at the time, *ESPN* agreed to televise the Aggies' last three home games, a deal that gave the university unprecedented access to the power of prime-time television. "It was a deal made in [H]eaven. *ESPN* used the Aggies to build its Saturday night ratings, while the Aggies used *ESPN* to spread the word . . . that A&M football was a force to be reckoned with."

ESPN certainly got its money's worth. Against SMU in the first game, Eric Franklin kicked a 47-yard field goal with 1:48 left to push A&M to a 19-17 win. "I didn't send Eric Franklin out there to miss," stated head coach Jackie Sherrill. Another tight game followed as the Aggies upped their record to 7-2 and stayed in the hunt for the conference title by slipping past Arkansas 10-6.

After the Aggies bombed TCU 53-6 in Fort Worth, *ESPN* found itself with a lot more than just an answer to a problem: It had a big

game with national appeal on its plate. No. 15 A&M and No. 18 Texas played Thanksgiving night for the conference title and the berth in the Cotton Bowl.

Though the game was the most hyped of the three, it was the only one that wasn't close. A&M bombed the Horns 42-10 — and it happened right there on national television in an age before the proliferation of prime-time games.

Experience is essentially the uncovering of answers to some of life's questions, both trivial and profound. You often discover to your dismay that as soon as you learn a few answers, the questions change. Your children get older, your health worsens, your financial situation changes, A&M's teams struggle unexpectedly — all situations requiring answers to a new set of difficulties.

No answers, though, are more important than the ones you seek in your search for God and the meaning of life because they determine your fate for all eternity. Since a life of faith is a journey and not a destination, the questions do indeed change with your circumstances. The "why" or the "what" you ask God when you're a teenager is vastly different from the quandaries you ponder as an adult.

No matter how you phrase the question, though, the answer inevitably centers on Jesus. And that answer never changes.

When you're a driver and you're struggling in the car, you're looking for God to come out of the sky and give you a magical answer.
— NASCAR's Rusty Wallace

It doesn't matter what the question is;
if it has to do with life, temporal or eternal,
the answer lies in Jesus.

GOD'S WRATH

Read Romans 2:1-11.

"Because of your stubbornness and your unrepentant heart, you are storing up wrath against yourself for the day of God's wrath, when his righteous judgment will be revealed" (v.5).

Even a future Heisman-Trophy winner feared the wrath of Bear Bryant.

A&M halfback John David Crow won college football's highest and most coveted award as a senior in 1957. While the Heisman balloting was going on, Bryant, his head coach, actively lobbied for Crow, declaring, "If John David doesn't get it, they ought to quit giving it." In return, Crow said after his football career was over, "When I think of football, I think of Coach Bryant."

All that warm and cuddly stuff, however, didn't exempt the superstar from fearing the wrath of his intimidating head coach. In the 13-2 win over SMU in 1955 when Crow was a sophomore, he fielded a punt around the Aggie 40 and tried to get outside the coverage and bust a big play. Instead, he was tackled around the 10, thus losing some 30 yards on the return.

The two teams swapped possessions, and Crow was back in on offense. The first-down play was an end run, and Crow gave ground to get around the cornerback. He lost five yards. As he got to his feet, he saw Bill Dendy, his back-up, trotting onto the field.

"Uh-oh, here's where I catch it," Crow thought. He was careful

not to look at Bryant as he came off the field and went to the end of the bench as far from his coach as he could get. He refused to look up until "all of a sudden I saw Coach Bryant's shoes. I kinda braced myself" and looked up when Bryant put his hand on Crow's knee. The coach pointed toward the field; all he said, though with great vehemence, was, "John, our goal is THATAWAY!"

God is love, mercy, and grace; that aspect of God we embrace. The Bible is clear, however, that God's character also includes justice, wrath, and judgment. We don't like that part. So to escape accountability and responsibility in and for our lives, we arrogantly declare with our spiritual fingers crossed that a real God of love could *never* condemn anyone to Hell.

Though with a glance it may not seem like it, the wrath of God is in reality another example of his abiding love for us. Judgment Day is in effect a sorting day, sort of like a divine bunk assignment at summer camp. God dispenses to those who deny Jesus and God in their lives exactly what they have said they desired: eternity without God. Those who have lived their lives in service to Christ get what they desire: eternity with God.

God doesn't condemn anyone to Hell because he doesn't make that decision. We do. God just provides the means for each of us to get to where our lifestyle has said we always wanted to go, be it Heaven or Hell.

I was scared to death and knew what was coming.
— John David Crow, facing the wrath of Bear Bryant against SMU

God's wrath ultimately reveals itself
in sacrificial love, giving those who have denied
him what they wish for: eternity without him.

A DOG'S LIFE

Read Genesis 6:11-22; 8:1-4.

"God remembered Noah and all the wild animals and the livestock that were with him in the ark" (v. 8:1).

Life in the A&M Cadet Corps is no picnic — unless your name happens to be Reveille.

Reveille, of course, is the official mascot of Texas A&M. The tradition began in 1931 when some cadets hit a small black and white dog with their car and brought her back to school to care for her. When the bugler sounded "Reveille" the next morning, the startled puppy barked and thereby earned her name. She became a regular in the Corps area.

The following football season she became the school's official mascot when she led the band onto the field during a halftime performance. During World War II, she was made a general in the K-9 Corps. To this day, Reveille is the highest ranking member of the Corps of Cadets.

That first Reveille died in 1944 and was given a formal military funeral in Kyle Field. She was buried at the north entrance to the field as subsequent mascots have been. Several other unofficial mascots, such as Tripod, Spot, and Ranger, followed before Reveille II, a Shetland shepherd, appeared in 1952. Reveille III was the first collie as all mascots have been since.

Today, Reveille IX is the most revered dog on campus and is perhaps the most pampered canine in the country. Corps com-

AGGIES

pany E-2 is the official mascot company, charged with taking care of the general. If she is sleeping on a cadet's bed, that cadet must sleep on the floor. Tradition says professors must dismiss their classes if Reveille barks during them. She can attend classes because she has her own student ID card (and a cell phone). A must for every Aggie fan is a visit to the Reveille Cemetery. When a stadium expansion sealed off the mascots' line of sight to the stadium scoreboard, the Reveille Scoreboard was installed near the burial sites so the dogs could keep track of the score.

Do you have a dog or two around the place? How about a cat that passes time staring longingly at your caged canary? Kids have gerbils? Maybe you've gone more exotic with a tarantula or a ferret. Americans love our pets; in fact, more households in this country have pets than have children. We not only share our living space with animals we love and protect but also with some — such as roaches and rats — that we seek to exterminate.

None of us, though, has the problems Noah faced when he packed God's menagerie into one boat. God saved all his varmints from extinction, including the fish and the ducks, who must have been quite delighted with the whole flood business.

The lesson is clear for we who strive to live as God would have us: All living things are under God's care. God doesn't call us to care for and respect just our beloved pets; we are to serve God as stewards of all of his creatures.

Reveille is a highly cherished mascot and receives only the best.
— *'Aggie Traditions'*

**God cares about all his creatures,
and he expects us to respect them too.**

LESSON LEARNED

Read Psalm 143.

"Teach me to do your will, for you are my God" (v. 10).

On one of the darkest nights of his young life, Tony McGinnis learned perhaps the most important lesson of his whole life; he discovered firsthand the awesome power of prayer.

McGinnis was a four-year letterman for the Aggies men's basketball team (1991-95). A forward, he averaged ten points a game as a junior and 15.2 points as a senior. He led the 19-11 team of 1993-94 in blocked shots and led his team in steals as a senior. He was named to the All-SWC Defensive Team in 1993-94.

But McGinnis was struggling early in his freshman year. His head coach, Tony Barone, "just went crazy on me," he recalled. "He was trying to see who was tough enough to cut it." But after weeks of hard times, the freshman "was thinking I couldn't take it any more." One night in his dorm room, he "was crying and thinking I was just going to go home and get a regular job."

Before he gave up, though, McGinnis rather uncertainly got down on his knees and prayed. He asked God to send someone who could give him a little comfort. "I was so specific," McGinnis said, "that I prayed for God to send somebody into my room that night if it was meant for me to stay at Texas A&M."

God was listening. "Almost immediately," McGinnis' academic advisor knocked on his door for a chat. That wasn't enough for the skeptical freshman, though, who dismissed the visit as a mere

coincidence because the advisor "was going to come by anyway." McGinnis prayed again, "asking God to send me a real sign." God was still listening. Shortly thereafter, Dave South, the Voice of Aggieland, (See Devotion No. 79.) stuck his head in the room and said, "Tony, I was just thinking about you. Keep your head up, son. You're going to make it."

That did it. South had never been to the room before. McGinnis said, "God, I believe it now. I'm staying." He had learned his lesson about the power of prayer.

Learning anything in life requires a combination of education and experience. Education is the accumulation of facts that we call knowledge. Experience is the acquisition of wisdom and discernment, which add depth and relevance to our knowledge in the form of purpose and understanding.

The most difficult way to learn is trial and error: dive in blindly and mess up. The best way to learn is through example coupled with a set of instructions: Someone has gone ahead of you and has written down all the information you need to follow.

In teaching us the way to live godly lives, God chose the latter method. He set down in his book the habits, actions, and attitudes that make for a way of life in accordance with his wishes. He also sent us Jesus to explain and to illustrate.

God teaches us not only how to exist but how to live. We just need to be attentive students.

Sports remain a great metaphor for life's more difficult lessons.
— *Author Susan Casey*

To learn from Jesus is to learn what life is all about and how God means for us to live it.

DAY 93

DOWN AND DIRTY

Read Isaiah 1:15-20.

"Though your sins are like scarlet, they shall be as white as snow; though they are red as crimson, they shall be like wool" (v. 18).

Even playing in the mud couldn't stop the A&M drive toward the 1939 national championship, but it came mighty close.

When the 7-0 Aggies met once-defeated SMU on Nov. 11, they also faced the great equalizer: mud. It had rained all night and all morning in College Station. The rain ceased for a while in the third quarter, but the damage had long since been done to the field and what had been its turf.

In perhaps what could be considered more than a wee bit of hyperbole, the contest was described as "the greatest wet weather game in the history of man" and "the greatest football game waged under adverse circumstances that this country has ever seen." It was certainly a thriller.

Not surprisingly, both teams played conservatively, waiting for the break the muddy conditions would inevitably offer. The Aggies got it in the second quarter when SMU fumbled and A&M defensive captain Tommie Vaughn fell on the wet ball at the SMU 10. To no one's surprise, All-American fullback John Kimbrough got the call three straight times. The third run wound up in the muddy end zone.

That 6-0 lead stood up, but just barely. In the fourth quarter,

SMU blocked an Aggie punt in the end zone, but Bill Conatser "proved the better bird dog in the mud." He recovered the ball for a safety, thus preventing a tying touchdown.

In desperation, the Ponies went to the air late in the game and nearly pulled it out. With time running out, they hit a pass to the Aggie 20. The last SMU throw came with one minute to play and was into the end zone, but the A&M defense batted it away.

The Aggies won the mud battle 6-2.

Maybe you've never slopped any hogs. You may not be a fan of mud boggin'. Still, you've worked on your car, planted a garden, played touch football in the rain, sat through a rainy football game, or endured some military training. You've been dirty.

Dirt, grime, and mud aren't the only sources of stains, however. We can also get dirty spiritually by not living in accordance with God's commands, by doing what's wrong, or by not doing what's right. We all experience temporary shortcomings and failures; we all slip and fall into the mud.

Whether we stay there or not, though, is a function of our relationship with Jesus. For the followers of Jesus, sin is not a way of life; it's an abnormality, so we don't stay in the filth. We seek a spiritual bath by expressing regret and asking for God's pardon in Jesus' name. God responds by washing our soul white as snow with his forgiveness.

Each churning step caused moisture to spring from the wet turf.
— *Writer Jinx Tucker on the 1939 A&M-SMU game*

**When your soul gets dirty, a powerful
and thorough cleansing agent is available
for the asking: God's forgiveness.**

MEMORY LOSS

Read 1 Corinthians 11:17-29.

"[D]o this in remembrance of me" (v. 24).

Grady Allen gave up his most precious memory of A&M football, one he had cherished for more than twenty-five years. Under the circumstances, he was more than glad to let it go.

Allen was an All-Southwest Conference defensive end in 1967 and was one of the key players in A&M's win over Alabama in the Cotton Bowl. He went on to a pro career as a linebacker.

For most of his adult life, Allen carried with him one memory that was his favorite among them all. A senior captain in the fall of '67, Allen was on the field when Buster Adami intercepted a pass at the A&M 8-yard line to preserve the Aggies' 10-7 win over Texas. The victory clinched the conference championship and sent the team to that Cotton-Bowl showdown against the Crimson Tide. "That particular play is etched in my mind," Allen said.

And, so, that precious memory lingered and even grew stronger as the years passed by. Until suddenly one day in the fall of 1993, it was replaced when his son, Dennis, "turned in a play that left his dad's definition of ecstasy positively time-warped."

The situation was remarkably similar to that of the senior Allen twenty-six years before. This time, though, he was in the stands when his son intercepted a goal-line Longhorn pass that clinched an 18-9 win. Again, the victory wrapped up the conference title and sent the Aggies to the Cotton Bowl.

AGGIES

According to those around the senior Allen, the junior Allen's theft "launched his delirious dad into the laps of spectators sitting [in] the row below him." "I don't think there's much that can compare in athletics to the big play he made in the Texas game," dad Allen later said about his son. "To see him step up and make that play was very exciting."

And memorable.

Memory helps shape us into us who we are. Whether they are dreams or nightmares, our memories to a large extent determine both our actions and our reactions. Alzheimer's is so terrifying because it steals our memory from us, and in the process we lose ourselves. We disappear.

The greatest tragedy of our lives is that God remembers. In response to that memory, he condemns us for our sin. On the other hand, the greatest joy of our lives is that God remembers. In response to that memory, he came as Jesus to wash even the memory of our sins away.

Through memory, we encounter revival. At the Last Supper, Jesus instructed his disciples and us to remember. In sharing this unique meal with fellow believers and remembering Jesus and his actions, we meet Christ again, not just as a memory but as an actual living presence.

To remember is to keep our faith alive.

I guess he's kind of reliving his youth through me, and that makes me feel good.
— Dennis Allen on making new memories for his dad

**We remember Jesus,
and God will not remember our sins.**

IMPRESSIONS

Read Mark 6:1-6.

"And [Jesus] was amazed at their lack of faith" (v. 6).

Bear Bryant's initial impression of Texas A&M was decidedly an unfavorable one. That changed right away when the students made quite an impression on him.

"At first glance, Texas A&M looked like a penitentiary," he said. "No girls. No glamour. A lifeless community." Such was Bryant's first impression of the place when he arrived at Easterwood Airport the night of Feb. 8, 1954, to unofficially launch his brief career as A&M's head football coach.

Bryant's flight was five hours late, but that didn't deter more than 3,000 students and fans from waiting patiently for the new coach's appearance at the Grove outdoor theater. When he finally showed up, the crowd cheered wildly and escorted him to the student center where he signed the register. They then led him back to the theater's center stage.

Bryant later said that publicity director Jones Ramsey had coached him on what to do when he faced those thousands of frenzied Aggies. As he proved throughout his career, though, not even a fire-and-brimstone preacher could work a crowd better than Bryant could. He set about "deliver[ing] some of that old-time religion to the adoring masses."

He first dramatically took off his coat, flung it to the stage, and stomped on it. Then he yanked off his tie, tossed it down, and

gave it a stomping. As he approached the microphone, Bryant rolled up his sleeves. He hadn't even said a word yet and already the crowd was bonkers, "the swelling noise sweeping across campus like a prairie fire."

The crowd wasn't the only one impressed by the whole scene, though. It worked both ways. Bryant said, "It was like voodoo. . . . I was awed, I'll tell you. Ten Aggies can yell louder than a hundred of anybody else."

You bought that canary convertible mainly to impress the girls; a white sedan would transport you more efficiently. You seek out subtle but effective ways to gain the boss' approval. You may be all grown up now, but you still want your parents' favor. You dress professionally but strikingly and take your prospective clients to that overpriced steak house.

In our lives we constantly seek to impress someone else so they will remember us and respond favorably to us. That's exactly the impression we should be making upon Jesus because in God's scheme for salvation, only the good opinion of Jesus Christ matters. On the day when we stand before God, our fate for eternity rests upon Jesus remembering and responding favorably to us.

We don't want to be like the folks in Jesus' hometown. Oh, they impressed him all right: with their lack of faith in him. This is not the impression we want to make.

This place will grow on you.
— A&M Chancellor Dr. Thom Harrington to Bear Bryant

Jesus is the only one worth impressing,
and it is the depth of your faith
— or the lack of it — that impresses him.

NOTES
(by Devotion Day Number)

1 In 1894, 18-year-old Milt Sims talked . . . "Fists, elbows, knees, anything.": Gene Schoor, *The Fightin'*
 Texas Aggies (Dallas: Taylor Publishing Company, 1994), p. 6.

1 "a hodgepodge of players of all ages from the Galveston Sports Association.": Homer Jacobs, *The*
 Pride of Aggieland (New York City: Silver Lining Books, 2002), p. 36.

1 Another record simply calls them Galveston High School.: Wilbur Evans and H.B. McElroy, *The*
 Twelfth Man (Huntsville, AL: The Strode Publishers, 1974), p. 274.

1 "We beat them so easy we got to . . .permission to make the trip: Schoor, p. 6.

1 the first intercollegiate football game in the state's history.: Evans and McElroy, p. 26.

1 the writer covering the game was . . . referring to the visitors only as "Bryan.": Evans and McElroy,
 p. 26.

2 "The two powers tonight were the two that earned it,": Doug Feinberg, "Adams Totes A&M on Her
 Back to Title," *statesman.com*, April 6, 2011, http://www.statesman.com/sports/aggies/adams-
 totes-a-m-on-her-back-to-1378976.html.

2 He "dipped, bounced, swayed and wiped his hand across his forehead to music": Alberta Phillips,
 "Big Dance Clearly Shows How A&M's Blair Is in Step with His Players," *Austin American-*
 Statesman, April 9, 2011, p. A14.

3 Enclosed please find one railroad ticket.": Mickey Herskowitz, *The 1939 Texas Aggies* (Houston:
 Halcyon Press Ltd., 2006), p. 69.

3 he made his high-school squad as a seventh grader.: Evans and McElroy, p. 164.

3 Norton earnestly pitched the advantages . . . membership in the Cadet Corps.: Herskowitz, p. 69.

3 It took only two weeks on the Tulane . . . "Enclosed please find one railroad ticket.": Herskowitz,
 p. 69.

3 "the marquee player on what . . . the greatest generation ever knew.: Herskowitz, p. 70.

4 After a string of heartaches, . . . she was in the room with me.: Brent Zwerneman, *More Tales from*
 Aggieland (Champaign, IL: Sports Publishing L.L.C., 2005), p. 9.

4 "He's a devout Christian, . . . wanted him to get his degree.: Zwerneman, *More Tales from Aggieland*,
 p. 11.

4 I told her I'd never disappoint her.: Zwerneman, *More Tales from Aggieland*, p. 9.

5 A&M's Marty Karow was the only coach . . . he had never seen the school.: Rusty Burson, *Texas*
 A&M: Where Have You Gone? (Champaign, IL: Sports Publishing L.L.C., 2004), p. 204.

5 After Ogletree graduated from . . . stuck with his commitment.: Burson, p. 206.

5 Gov. Buford Jester got into the act, inviting . . . that was good enough for him.: Burson, pp. 206-07.

5 "to a place no A&M team had been before": Burson, p. 207.

6 "The doctors didn't know if I was . . . wouldn't know where he was.: Burson, p. 133.

6 'She wouldn't stop praying,": Burson, p. 133.

6 He later had a CAT scan . . . released him to play football.: Burson, p. 133.

6 It was nothing short of a miracle from God.: Burson, p. 133.

7 [The win over Oklahoma] was the culmination of a season that no one could have possibly imag-
 ined.: Richard Croome, " 'Journey has Been Like a Dream for the Aggies," *theeagle.com*, Feb.
 8, 2013, www.theeagle.com/news/local/article_c1ff2fc3-6d74-5d3e-90f0-3282da8f3a21.html.

8 "cheered the punters in warm-ups as if they were rock stars,": Jacobs, p. 92.

8 the "electricity in the stands remained palpable.": Jacobs, p. 92.

8 sending "the already rocking stadium . . . by waiting to snap the ball.': Jacobs, p. 92.

8 I remember coming out of . . . The 12th Man towels were everywhere.: Jacobs, p. 92.

9 "and it must have occurred to him . . . and he had less money.: Herskowitz, p. 35.

9 During the coach's first two seasons, . . . a note at a Dallas bank.: Herskowitz, p. 36.

9 the school's "first real star,": Schoor, p. 19.

9 railroaded a special bill through . . . to pick from, he needed scholarships.; Herskowitz, p. 36.

9 The team was on its way by train . . . would they play the game?: Herskowitz, p. 37.

9 Because A&M received a nice guarantee . . . rather than in hotel rooms.: Herskowitz, p. 38.

9 [Texas A&M] was a proud school reduced to barnstorming for a payday.; Herskowitz, p. 38.

10 the first Aggie in history to return a kickoff for a TD in successive games.: David Harris, "No. 19
 Aggies Just Keep Fighting," *The Battalion*, Nov. 14, 2010, http://www.thebatt.com/news/no-
 19-aggies-just-keep-fighting-1.1775906.

10 "We had the will to win and never gave up.": Harris, "No. 19 Aggies Just Keep Fighting."

10 "This is not a time to; . . . should not have lost to.": Harris, "No. 19 Aggies Just Keep Fighting."

10 We have fighters on this team who will do anything to win.: Harris, "No. 19 Aggies Just Keep

Fighting."

11 Aggie head coach G Guerrieri knew . . . club player before high school.: Patrick Hayslip, "Continuing the Aggie Legacy," *The Battalion*, March 1, 2010, http://www.thebatt.com/2.8485/continuing-the-aggie-legacy-l.l181180.

11 Growing up, she regularly visited . . . that "didn't really click": Hayslip, "Continuing the Aggie Legacy."

11 "I was like, 'What am I doing?' I want to go to A&M,": Hayslip, "Continuing the Aggie Legacy."

11 I started thinking about all the . . . any other place in the country.: Hayslip, "Continuing the Aggie Legacy."

12 "When we reported for fall practice, . . . because we were going on a trip.": Evans and McElroy, p. 186.

12 he expected to find at least . . . He didn't.: Evans and McElroy, p. 186.

12 on a parched, baked plot of land, . . . three grueling practice sessions each day: Olin Buchanan, *Stadium Stories: Texas A&M Aggies* (Guilford, CN: The Globe Pequot Press, 2004), p. 34.

12 heat that routinely reached 110 degrees.: John D. Forsyth, *The Aggies and the 'Horns* (Austin: Texas Monthly Press, Inc., 1981), p. 94.

12 Bryant didn't allow any water breaks, equating water with weakness.: Buchanan, *Stadium Stories*, p. 35.

12 "pushed to the brink of extinction," . . . as opposed to quitting.": Brent Zwerneman, "Junction Boys the Stuff of A&M Football Legends," *chron.com*, April 28, 2010. http://www.chron.com/disp/story.mpl/sports/college/texasam/6980725.html.

12 "most of the players couldn't — or wouldn't — take it,": Buchanan, p. 36.

12 With the Junctions boys, . . . know they have to meet.: Evans and McElroy, p. 188.

13 In 1993, a band of thirty University . . . they kidnapped Reveille.: Buchanan, p. 24.

13 They staked out the home of . . . sign during the Cotton Bowl: Buchanan, p. 25.

13 University officials didn't treat the theft . . . that did this should be expelled.": Buchanan, p. 26.

13 telephoned a local radio station, . . . She received a raucous welcome.: Buchanan, p. 27.

13 I'd probably end up in something like a witness protection program [if Reveille were stolen].: Buchanan, p. 24.

14 Travis Labhart didn't have a . . . wanted to play football.": Robert Cessna, "Labhart's Journey to Field for Texas A&M a Long, Winding One," *The Eagle*, Oct. 17, 2013, http://www.the eagle.com/aggie_sports/football/labhart-s-journey-to-field-for-texas-a-m-a/article.

14 He developed a close bond . . . counselor at a Christian camp.: Cessna, "Labhart's Journey to Field for Texas A&M."

14 It's been a very interesting . . . It's been a blessing.: Cessna, "Labhart's Journey to Field for Texas A&M."

15 She confessed she was confused about . . . know to believe in God,": Sean Lester, "Overcoming Obstacles," *The Battalion*, March 9, 2011, http://www.thebatt.com/news/overcoming-obstacles-1.2085126.

15 Her car went airborne and flipped . . . started marking the scene for a death.: Lester, "Overcoming Obstacles."

15 "major carpet burn.": Lester, "Overcoming Obstacles."

15 The roof of the car . . . injury required four surgeries: Sarah Grimmer, "Texas A&M Student-Athlete Spotlight: Meagan May," *Big12 Sports.com*, April 7, 2011, http://www.big12sports.com/ViewArticle.dbml?DB_OEM_ID=10410&ATCLID=205131.

15 That she lived, that she suffered such . . . knows none of that was luck.: Lester, "Overcoming Obstacles."

15 "I found God through that . . . has a plan for [my life.].: Grimmer, "Texas A&M Student-Athlete Spotlight."

15 I'm extremely glad it all happened. It may not have been the way I expected, but I got my answer.": Lester, "Overcoming Obstacles."

15 It's just a reminder that there are bigger things out there than just me.: Lester, "Overcoming Obstacles."

16 Sherman figured that for his players . . . "came out swinging": Brent Zwerneman, "Texas A&M 52, Texas Tech 30," *Houston Chronicle*, Oct. 25, 2009, http://www.chron.com/CDA/archives/archive.mpl?id=2009_4804978.

16 On one play, tight end Jamie . . . to their fat little girlfriends,": Zwerneman, "Texas A&M 52, Texas Tech 30."

17 "We had [linebackers] Aaron Wallace . . . wreck something else this week.'": Buchanan, p. 78.

17 Players wore hard hat and carried tools . . . patented it to market it.: Buchanan, p. 80.

193

TEXAS A&M

17 Crew members developed a special handshake;: Buchanan, p. 81.
17 coveted Crew baseball caps were presented to players who excelled.: Buchanan, p. 80.
17 At game's end, the fans honored the . . . of A&M nicknames: "Wrecking Crew.": "Texas A&M Postgame Quotes: Texas A&M 33, (#11) Oklahoma 19," *KBTX.com*, Nov. 7, 2010, http://www.kbtx.com/sports/headlines/Texas _AM_Postgame_Quotes.
17 Hearing the fans chanting 'Wrecking . . . the fans screaming that for us.: "Texas A&M Postgame Quotes."
18 her "somewhat disturbing . . . she was in the second grade.: Zwerneman, *More Tales from Aggieland*, p. 15.
18 Bozo even made road trips with . . . of Bozo with her on road trips.: Zwerneman, *More Tales from Aggieland*, p. 17.
18 "a raging beauty with a phenomenal vertical jump and a lion's heart.": Zwerneman, *More Tales from Aggieland*, p. 16.
18 Sykora was always careful . . . were a little different, too.": Zwerneman, *More Tales from Aggieland*, p. 17.
18 Among its features were . . . fellow eccentric Dennis Rodman.": Zwerneman, *More Tales from Aggieland*, p. 16.
18 "The team fed off her," . . . and needed to call someone.: Zwerneman, *More Tales from Aggieland*, p. 17.
18 There are a lot of people who think I'm weird.: Zwerneman, *More Tales from Aggieland*, p. 17.
19 Bryant sent in a sub with instructions for . . . a touchdown. Osborne was running for his life.": Herskowitz, p. 8.
19 It was as if God raised my arm.: Herskowtiz, p. 8.
20 "He's really just one of those . . . "Nothing else matters.": Terrance Harris, "The Horrific Scenes of 9/11 Remain Etched in the Mind of A&M's Mark Dodge," *Houston Chronicle*, Sept. 11, 2006, http://www.chron.com/CDA/archives/archive.mpl?id=2006_4188322.
20 "I get to play football while . . . It's not that big of a deal,": Harris, "The Horrific Scenes of 9/11."
20 He acts like he's real young, . . . in a mature type of way.: Harris, "The Horrific Scenes of 9/11."
21 In his office at Texas A&M, Slocum . . . for his lack of talent,: Kevin Sherrington, "A Shining Career," *The Dallas Morning News*, Oct. 28, 1992, http://nl.newsbank.com/nl-search/we/Archives?p_action=doc&p_docid=0ED3D2755DD5.
21 He had a lot of pride. That's why he worked so hard at [football].: Sherrington, "A Shining Career."
22 Ray never doubted where he . . . from several smaller schools,: John P. Lopez, "No. 12 Fits Perfectly on A&M's Ray," *Houston Chronicle*, Nov. 23, 2005, http://www.chron.com/CDA/archives/archive.mpl?id=2005_4014323.
22 class of '72. His mother . . . since day one, an Aggie,": Lopez, "No. 12 Fits Perfectly on A&M's Ray."
22 before the Oklahoma game, . . . the 12th man is like a blessing.": Lopez, "No. 12 Fits Perfectly on A&M's Ray."
22 the most a player had ever . . . thirteen — by Blake Kendrick: Lopez, "No. 12 Fits Perfectly on A&M's Ray."
22 He had worn that No. 12 . . . a lot of pride in my heart,": Lopez, "No. 12 Fits Perfectly on A&M's Ray."
22 It's goose bumps for us . . . out there playing for the Aggies.': Lopez, "No. 12 Fits Perfectly on A&M's Ray."
23 "It was the most magnificent building,": Zwerneman, *More Tales from Aggieland*, p. 94.
23 Former women's basketball coach and . . . those squirrels back outside.": Zwerneman, *More Tales from Aggieland*, p. 93.
23 A&M assistant sports information . . . Marquardt took a knee.: Zwerneman, *More Tales from Aggieland*, p. 94.
23 He recalled that the packed gym . . . Grab somebody and guard 'em.": Zwerneman, *More Tales from Aggieland*, p. 94.
23 The gym wasn't a bad place to play. . . . leave the gym where it is.: Zwerneman, *More Tales from Aggieland*, p. 95.
24 As part of the broadcasts during . . . a ride with a state trooper.: Zwerneman, *More Tales from Aggieland*, p. 111.
24 "Were you interviewing one of the . . . how much I want to hit [him].": Zwerneman, *More Tales from Aggieland*, p. 112.
25 decided to take the school's unique Twelfth Man tradition out of the bleachers and onto the field.: Buchanan, p. 9.
25 He reasoned such a step . . . the team wanted to win for them.": Buchanan, p. 10.
25 Sherrill's plan was to assemble a unit . . . cover kickoffs at home games.: Schoor, p. 156.

25 "You couldn't do that anywhere but [here]," he said. "Some people thought I was crazy.":
Buchanan, p. 12.

25 He could see only that the opponents . . . in the student newspaper and distributed flyers,:
Buchanan, p. 12.

25 "spark[ing] pandemonium on campus.": Schoor, p. 156.

25 Two hundred and fifty-two students . . . in the 1983 opener against California.: Buchanan, p. 12.

25 Though uncertain about the whole idea, . . . the kickoff coverage as the Twelfth Man.: Buchanan,
p. 14.

25 I knew there were enough kids on campus crazy enough to do it.: Buchanan, 12.

26 showed up 45 minutes late for practice. . . . some time that season.": Zwerneman, More Tales from
Aggieland, p. 79.

26 Third baseman Cindy Cooper once . . . for the day's doubleheader.: Zwerneman, More Tales from
Aggieland, p. 80.

27 Steve Kragthorpe could only fall to his knees and whisper, "Thank you, Jesus.": Jacobs, p. 119.

27 Starting A&M quarterback Randy McCown had . . . Stewart's knee recovered quickly,: Jacobs,
pp. 113-14.

27 He was tackled at the pylon,: Jacobs, p. 119.

27 It was a miracle — a miracle finish.: Jacobs, p. 119.

28 the first scout in Southwest football history,: Evans and McElroy, p. 31.

28 the faculty decided athletics . . . from playing other Texas colleges.: Evans and McElroy, p. 30.

28 When the students rose up . . . for head football coach James E. Platt.: Evans and McElroy, p. 30.

28 the surprising notion of preseason . . . introduced calisthenics and rugged scrimmages.: Schoor,
p. 11.

28 in midseason he went to Austin . . . pounding the left side of the Texas line: Evans and McElroy,
p. 31.

28 The explanation of the unexpected is that College had the best team.: Evans and McElroy, p. 33.

29 with the cry "The Aggies Are Back.": Evans and McElroy, p. 236.

29 "The Aggies Are Way Back.": Evans and McElroy, pp. 237-38.

29 "one of the most miraculous comebacks of all time.": Schoor, p. 125.

30 A&M's improbable run to . . . coming to an abrupt halt.": David Harris, "One Miracle Gives Aggies
Shot at Title," The Battalion, April 4, 2011, http://www.thebatt.com/news/david-harris-one-
miracle-gives-aggies-shot-at-title-1.2139661.

30 Colson took the inbounds pass, . . . a perfect bounce pass to White,: Harris, "One Miracle Gives
Aggies Shot at Title."

30 They just fight. They scratch. They claw. Foremost, they don't panic.: Harris, "One Miracle Gives
Aggies Shot at Title."

31 I don't know what it was, . . . was a football player.": Evans and McElroy, p. 197.

31 "wasn't much of a player . . . He hadn't really hit anybody,": Evans and McElroy, p. 197.

31 a bunch of the football players, . . . made us a football player.": Evans and McElroy, p. 197.

31 You can't tell when a boy . . . The next day he is.": Evans and McElroy, p. 197.

32 The 1940 Aggies were so devastated . . . vote to accept the invitation.: Aggies: A Century of Football
Tradition (New York City: Professional Sports Publications, 1994), p. 53.

32 In the locker room before the . . . and broke into laughter.": Herskowitz, p. 94.

32 "I didn't know there was . . . "It's a unique call,": David Barron, "One-Point Safety Catches Both
Teams by Surprise," Houston Chronicle, Nov. 27, 2004, http://www.chronc.om/CDA/archives/
archive.mpl?id=2004_3822508.

33 That first week, he opened his . . . ;Give it to us,'": Rusty Burson, Texas A&M: Where Have You Gone?
(Champaign, IL: Sports Publishing LLC, 2004), p. 218.

33 he was part of a group . . . a part of the Aggie family.: Burson, p. 220.

33 I just wanted to be an Aggie, and those students just wanted me to be an Aggie.: Burson, p. 220.

34 Free substution was unheard of, . . . helmets without a face mask.; Herskowitz, p. 54.

34 Texas A&M had a running back the pundits compared to Red Grange and Jim Thorpe.: Hers-
kowitz, p. 53.

34 only fifteen players saw most of . . . nothing to do there except win.: Herskowitz, p. 54.

34 "holler guy" Tommie Vaughn said . . . "twenty years ahead of his time.": Herskowitz, p. 53.

34 "glamorous, mysterious, important." . . . were the latter called "bombs.": Herskowitz, p. 56.

34 they often kicked on first down: Herskowitz, p. 57.

34 College State had no real main street, . . . White Way Cafe with its plate lunch.: Herskowitz,
p. 54.

34 Practically everything seemed better than it does today, except air conditioning.:
Herskowitz, p. 55.

35 Then Reveille led the rest of . . . and he hugged his mom.: Joshua Siegel, "Manziel

TEXAS A&M

	Leaves Kyle Field Crowd with One Last Show," *The Eagle*, Nov. 10, 2013, http://www.theeagle. com/aggie_sports/football/manziel-leaves-kyle-field-crowd-with-one-last-show/article.
35	One writer noted that . . . took less than two minutes.: Robert Cessna, "Fast-Pace Offense Strikes Again," *The Eagle*, Nov. 10, 2013, http://www.theeagle.com/aggie_sports/football/fast-pace-offense-strikes-again-leads-texas-a-m-past/article.
35	Throughout the last half, . . . they sang the "Aggie War Hymn.": Siegel, "Manziel Leaves Kyle Field Crowd with One Last Show."
35	For our seniors, it was a long-lasting memory.: Cessna, "Fast-Paced Offense Strikes Again."
36	the TV announcers didn't know his name: Burson, p. 115.
36	In a survey conducted by the . . . most memorable moment in Aggie history.: Burson, p. 112.
36	An artist even created a limited-edition painting of it.: Burson, p. 115.
36	"I probably talk about it five times . . . you name it — bring it up.": Burson, p. 114.
36	Defensive back Chet Brooks, who came up . . . "Chet said that would drive him crazy.": Burson, p. 115.
36	After A&M took a 28-10 lead in the fourth . . . He never has known, though, what happened to that towel.: Burson, p. 115.
36	I just never figured that people would still remember me.: Burson, p. 117.
37	It's been called "The Night That Changed Everything,": Beau Holder, "The Night That Changed Everything," *The Battalion*, March 27, 2010, http://www.thebatt.com/2.8484/the-night-that-changed-everything-1.1283271.
37	"Allen Fieldhouse is crazy," declared. . . arenas you will ever play in.": Holder, "The Night that Changed Everything."
37	"I remember the court shaking . . . the game during tip-off.": Holder, "The Night that Changed Everything."
37	"It was so loud you couldn't hear . . . a program was born": Holder, "The Night That Changed Everything."
38	Quite a few Aggies showed up . . . them as their homecoming game.: Neil Hohlfeld, "A&M Dims Lights on Iowa State's Party," *Houston Chronicle*, Oct. 10, 2004, http://www.chron.com/CDA/archives/archive.mpl?id=2004_3808518.
38	"Schools look for a homecoming . . . the land the last two years.": Hohlfeld, "A&M Dims Lights."
38	A&M quarterback Reggie McNeal was . . . the Cyclones' night by winning.: Hohlfeld, "A&M Dims Lights."
38	We'll be [Oklahoma State's] homecoming . . . another chance to kiss the queen.: Hohlfeld, "A&M Dims Lights."
39	This is the greatest day ever.": Fran Blinebury, "Style, Success Passing Notre Dame By," *Houston Chronicle*, Sept. 30, 2001, http://www.chron.com/CDA/archives/archive.mpl?id=2001_3338203.
39	largest crowd ever to watch a football game in Texas.: Blinebury, "Style, Success Passing Notre Dame By."
39	they hadn't been ahead . . . sometime during the 2000 season.: Blinebury, "Style, Success Passing Notre Dame By."
39	Notre Dame looked like "it's playing blindfolded.": Blinebury, "Style, Success Passing Notre Dame By."
39	the first true freshman to start at . . . he responded pretty well,": Neil Hohlfeld, "Notre Dame-Texas A&M Summary," *Houston Chronicle*, Sept. 30, 2001, http://www.chron.com/CDA/archives/archive.mpl?id=2001_3338206.
39	despite the loss of nose . . . freshman Marcus Jasmine stepped in.: Hohlfeld, "Notre Dame-Texas A&M Summary."
40	I thought he was done.": Sam Kahn, Jr., "A&M's Kennedy the Heart of Receiving Corps," *ESPNcom*, Oct. 1, 2014, http://espn.go.com/blog/sec/post/_/id/89890/ams-kennedy-the-heart-of-receiving-corps.
40	"really the heart and soul of our team and a great leader.": "Malcome Kennedy Named Aggie Heart Award Winner," *12thman.com*, Dec. 12, 2014, http://www.12thman.com/news/2014/12/12/209806688.aspx?path=football.
40	Kennedy told Sumlin he had . . . than anything I can say.": Khan, "A&M's Kennedy the Heart of Receiving Corps."
40	"When the game's on the line, Malcome's the guy we're going to,": Khan, "A&M's Kennedy the Heart of Receiving Corps."
40	[The trainers] asked me if I was done. I said, 'No. I've got to go.': Khan, "A&M's Kennedy the Heart of Receiving Corps."
41	"so tantilizingly close to clinching a Final Four spot,": Suzanne Halliburton, "Aggies Lack Title But Not Feeling That They Belong," *Austin American-Statesman*, March 31, 2011, p. C01.

41 He told them not to dogpile on the floor. "Act like you've been there before,": Halliburton, "Aggies Lack Title."

41 Why do you want to ruin your . . . whole thing, I'll be on top of that dogpile.: Halliburton, "Aggies Lack Title."

42 it was featured by *Ripley's Believe it or Not.: Aggies: A Century of Football Tradition*, p. 27.

42 As A&M lined up to receive the . . . "Everything we tried thereafter turned out right.": Evans and McElroy, pp. 73-74.

42 He entered A&M in 1911 as a 15-year-old . . . down on the varsity football field.": Evans and McElroy, p. 72.

43 Oct. 20, 1956, dawned sunny and beautiful at College Station.: Jacobs, p. 66.

43 The Aggies were somewhat surprised when . . . at a football game in College Station.": Jacobs, p. 66.

43 Torrential rain drove most of the spectators . . . "to an alarming degree.": Evans and McElroy, p. 202.

43 More than 150 planes were overturned . . . "became 100 yards of pig slop": Jacobs, p. 66.

43 a "stormy, muddy scoreless first half.": Evans and McElroy, p. 202.

43 "It went according to prayer.": Jacobs, p. 67.

43 The wind was blowing so hard you could hardly breathe.: Jacobs, pp. 66-67.

44 The first theft came on a sideline . . . another pass aimed at the tight end.: Kyle Cunningham, "Safety Saves the Game with Key Picks," *The Battalion*, Nov. 22, 2010, http://www.thebatt. com/sports/safety-saves-the-game-with-key-picks-1.1788415.

44 In that practice, he had three . . . he was going to get a pick,": Cunningham, "Safety Saves the Game."

44 I'm a firm believer in the 'practice makes perfect' mentality.: Cunningham, "Safety Saves the Game."

45 the largest last-minute comeback in basketball history.: Andy Staples, "Texas A&M's Prayers Answered," *SI.com*, March 21, 2016, http://www.si.com/college-basketball/2016/03/21/ncaa-tournament-texas-am-aggies-comeback.

45 "I was about to start crying on the court,": Staples, "Texas A&M's Prayers Answered."

45 "I've never been a . . . to God be the glory.": Staples, "Texas A&M's Prayers Answered."

45 By any common sense . . . from a 12-point deficit.: Jake Trotter, "'We Weren't Ready to Be Done,': How Texas A&M Managed Their Comeback," *ESPN.go.com*, March 21, 2016, http://.espn. go.com/blog/collegebasketballnation/post/_/id/113628/texas-am-aggies-kept-on-believing.

46 "The best all-around back I've ever seen.": Evans and McElroy, p. 112.

46 When Hunt was a teenager, he saw A&M . . . that day where I wanted to go to college.: Evans and McElroy, p. 108.

46 the Frog defense had him trapped . . . a 43-yard field goal on the dead run.: Evans and McElroy, p. 110.

46 "Joel turned out better in 1925 than we expected.": Evans and McElroy, p. 109.

46 As a sophomore in '25, . . . "You're it,": Evans and McElroy, p. 108.

47 Asked by writer Rusty Burson . . . we ever had at A&M,": Burson, p. 230.

47 "I've never seen a player with that much talent work so hard.": Burson, p. 230.

47 Parker received a watch as the prize . . . wanted his son to have it back,": Burson, p. 235.

47 To get the watch back . . . to be a part of the Aggie family.: Burson, p. 235.

48 All you've got to do is throw it up, and I'll go get it.": Buchanan, p. 115.

48 "I [got] on my knees and pray[ed] for the fans, the school, the friends, and families.": Buchanan, p. 114.

48 The night before the game, . . . pretty much been ignored throughout the season.: Buchanan, p. 115.

48 McCown saw that his roommate . . . let's see what you got.": Buchanan, p. 119.

48 My last pass at A&M was . . . a storybook ending for me.: Buchanan, p. 122.

49 In 1885, 22-year-old Joseph F. Holick . . . kicked out of school for fighting.: Donald B. Powell and Mary Jo Powell, *The Fightin' Texas Aggie Band* (College Station: Texas A&M University Press, 1994), as quoted in "Fightin' Texas Aggie Band," *Wikipedia, the free encyclopedia*, http:// en.wikipedia.com/wiki/Fightin'_Texas_Aggie_Band.

49 a computer has pompously claimed . . . same place at the same time.: "The Fightin' Texas Aggie Band," *Texas A&M University Corps of Cadets*, http://corps.tamu.edu/the-corps-experience/ the-fightin-texas-aggie-band.html.

50 "the greatest player of Texas A&M's first 50 years of football.": *Aggies: A Century of Football Tradition*, p. 36.

50 though he had never been in a high school play.: Herskowitz, p. 49.

50 He also landed an advertising . . . billboards and in national magazines.: Herskowitz, p. 50.

50 Without the other men on the team, I would just be a nobody.: *Aggies: A Century*

of Football Tradition, p. 37.

51 "He couldn't decide whether to kick . . . "We can still make a run.": Richard Justice, "After 3-7 League Start, A&M Decides to Fight," *Houston Chronicle*, March 8, 2009, http://www.chron. com/CDA/archives/archive.mpl?id-=2009_4709520.

51 a "near-perfect" 96-86 defeat: Justice, "After 3-7 League Start."

51 "A lot of teams would have quit," . . . "We didn't. We're tough.": Justice, "After 3-7 League Start."

52 One gentlemanly Alabama fan . . . they were in Tuscaloosa.: David Harris, "Texas A&M Stuns No. 1 Alabama in Upset," *theeagle.com*, Nov. 11, 2012, www.theeagle.com/news/local/ article_779933e9-e9e0-5271-89dc-2940de8de7d6.html.

52 Ryan Swope and cornerback Dustin . . . impersonating a conductor.: Harris, "Texas A&M Stuns No. 1."

52 Deshazor Everett jumped on a quick out route: Harris, "Texas A&M Stuns No. 1."

52 I hope you all enjoy your time. Just don't enjoy it too much.: Harris, "Texas A&M Stuns No. 1."

53 "arguably the most precious piece of metal associated with A&M football.": Zwerneman, *More Tales from Aggieland*, p. 96.

53 In the winter of 2004, . . . long past and mostly forgotten.": Zwerneman, *More Tales from Aggieland*, p. 95.

53 he could not believe what he had found. "I didn't even know that trophy existed.": Zwerneman, *More Tales from Aggieland*, p. 96.

53 "To the brilliant victor . . . New Orleans. January 1, 1940.": Zwerneman, *More Tales from Aggieland*, p. 95.

53 The members of that championship . . . things other than athletics,": Zwerneman, *More Tales from Aggieland*, p. 96.

53 Coaches and athletic directors come and go, and somebody must have just have forgotten about it.: Zwerneman, *More Tales from Aggieland*, p. 96.

54 The search for a successor to Bear . . . governor of Texas instituted an investigation.: Evans and McElroy, p. 222.

54 Aware of the dissension, he originally . . . he couldn't reject their plea.: Evans and McElroy, p. 222.

54 with only two seconds on the clock.: Mervin Hyman, "Football's Week," *Sports Illustrated*, Oct. 15, 1962, http://sportsillustrated.cnn.com/vault/article/magazine/MAG1074204/index.htm.

54 They paraded about for some fifteen minutes: Schoor, p. 116.

54 Their zeal cost the Aggies a 15-yard penalty,: Evans and McElroy, p. 227.

55 Her coach, Jo Evans, doubted she would be back . . . could do it was through God": Susie Magill, "Speedy Recovery," *Sharing the Victory Magazine*, June/July 2006, http://www.sharingthe victory.com/vsItemDisplay.lsp?method=display&objectid=5B45AB.

55 That trust resulted in a calm throughout. . . and spread throughout the team.": Magill, "Speedy Recovery."

55 It was a huge struggle for me to get through it and rely on God.: Magill, "Speedy Recovery."

56 In 1910, head coach Charley Moran took . . . Moran was pleased with the results,: Schoor, p. 19.

56 formally named "Champions of the South.": Schoor, p. 21.

56 "to the utter amazement of the so-called experts,': Schoor, p. 16.

56 During that second game, some . . . "Twice in three weeks.": Schoor, p. 16.

56 the 3-0 Aggies were preparing for their . . . mistakenly mailed to Transylvania.: Schoor, p. 20.

57 It's the first time I've cried . . . "He just went to Texas A&M.": The account given here is an amalgam of the story as told by Mickey Herskowitz in *The 1939 Texas Aggies* (p. 11) and Eli Gold, *Crimson Nation* (Nashville, Rutledge Hill Press, 2005), p. 197.

57 "bold, dramatic, emotional decision" . . . to head up a major college team.: Herskowitz, p. 10.

57 "the toughest recruiting job in America,": Herskowitz, p. 11.

57 I can't stop bawling. . . . I'll have to go back to work.: Herskowitz, p. 10.

58 "most likely the biggest name . . . involved in women's hoops,": Gabe Bock, "TexAgs Talks Texas A&M Women's Hoops with Kelly Krauskopf," *TexAgs.com*, April 4, 2011, http://v4.texags. com/Stories/1868.

58 She transferred to A&M in . . . with no heat in their building.: "Former Player Says Texas A&M Basketball Has Come a Long Way," *The Dallas Morning News*, April 4, 2011, http:// www.dallasnews.com/sports/college-sports/texas-aggies/20110404.

58 The earliest players dressed . . . to make the area "feminine.": Ann Killion, "Once Unthinkable, Texas A&M Crowned Champions for First Time," *Sports Illustrated*, April 6, 2011, http:// sportsillustrated.cnn.com/2011/writers/ann_killion/04/06/texas.am.baylor/index.html.

58 "We wore the same uniforms every . . . sold tickets to a women's game.": "Former Player Says Texas A&M Has Come."

58 It takes your breath away.: Bock, "TexAgs Talks Texas A&M Women's Hoops."

198

59 Defensive tackle Charlie Krueger spent his . . . that school's coaching staff.: Evans and McElroy, p. 218.

59 teammate and friend Dennis Goehring convinced . . . every game for three seasons.: Evans and McElroy, pp. 218-19.

59 In a squad meeting prior to the 1957. . . and dropped the runner for a loss.: Evans and McElroy, p. 220.

60 The Aggies' head football coach stood . . . to the state's best players.: Herskowitz, p. 39.

60 He drew up a list of the forty . . . deflected all their logical arguments,.: Herskowitz, p. 39.

60 resisting until Pfaff threatened to close his account at the bank.: Herskowitz, pp. 39-40.

60 By lunchtime, the Aggies had their . . . "Forty Most Wanted" were Aggies.: Herskowitz, p. 40.

60 "virtually the entire team": Herskowitz, p. 39.

61 Thurmond originally planned to follow . . . at A&M never played football?: Burson, p. 239.

62 "We had more injuries than any team I'd ever been around,": Buchanan, p. 129.

62 "We had confidence we could play with them.": Buchanan, p. 131.

62 He assembled a highlight tape of . . . right before they took the field.: Buchanan, p. 132.

62 I knew he could play, but I didn't know if he was ready yet.: Buchanan, p. 137.

63 "the school's most monumental victory" in the modern era: Jacobs, p. 111.

63 "We can't play like we've been playing and stay on the field with Nebraska,": Jacobs, p. 106.

63 Because of construction in the north . . . seating capacity was available.: Jacobs, p. 107.

63 "We controlled the line of scrimmage . . . was to run the ball,": Ivan Maisel "College Football," *Sports Illustrated*, Oct. 19, 1998, http://sportsillustrated.cnn.com/vault/article/magazine/ MAG1014359/index.htm.

63 I think God make it simple. Just accept him and believe.: Jim & Julie S. Bettinger, *The Book of Bowden* (Nashville: TowleHouse Publishing, 2001), p. 47.

64 "the highest-ranked prospect the Aggies [had] signed in more than a decade.": Sam Kahn, Jr., "Myles Garrett's Path to Greatness Off to Strong Start," *ESPN.co*m, Dec. 15, 2014, http://espn. go.com/blog/sec/post/_id/95469;myles-garretts-path-to-greatness-off-to-strong-start.

64 He chose geology. . . . when he was 3 years old.: Kahn, "Myles Garrett's Path to Greatness."

64 his primary interest at first was . . . and came out Mr. Olympia,": Kahn, "Myles Garrett's Path to Greatness."

64 They thought he was a grown man.: Kahn, "Myles Garrett's Path to Greatness."

65 and dumped an outlet pass . . . making the catch with one hand.: Terrance Harris, "Late Heroics Net A&M Win," *Houston Chronicle*, Oct. 22, 2006, http://www.chron.com/CDA/archives/ archive.mpl?id=2006_4214751.

65 Red Bryant used his right arm to deflect the low kick.: Harris, "Late Heroics Net A&M Win."

66 Depending on one's point of view, . . . part of building something special.": Burson, p. 85.

66 a play that one writer said "changed A&M football.": Burson, p. 85.

66 "I don't think I had run that far . . . while Texas fans began exiting.": Burson, p. 82.

66 Polk once noted that after he left . . . the pecking order of the A&M-Texas series.: Burson, p. 85.

67 "When we beat Santa Clara, we realized we might go all the way,": Evans and McElroy, p. 149.

67 "pound for pound the greatest end football ever saw,": Herskowitz, p. 250.

67 National champions? What is that, exactly?: Herskowitz, p. 103.

68 On a November afternoon in 1957, . . . president of Texas A&M had called: Buchanan, p. 45.

68 with news that he had won something . . . to see him pick up his trophy.: Buchanan, p. 46.

68 Only when Crow began his acceptance . . . in the theater in Springhill," population 1,500.: Buchanan, p. 48.

68 "I just wanted to make Coach [Bear[Bryant . . . always do something to please my father.": Buchanan, p. 59.

69 at 2 a.m. with a long-delayed meal . . . highlights of the win on ESPN.": Kristie Rieken, "National Champion Aggies Welcomed Home," *SI.com*, April 6, 2011, http://sportsillustrated.cnn.com/ wcbk/story.

69 At Reed Arena, thousands of cheering . . . I'm here to build champions." Rieken, "National Champion Aggies."

69 It's amazing to come back and see all these fans here.: Rieken, "National Champion Aggies."

70 "a gentle and unselfish man . . . absolute horror of offending anyone.": Herskowitz, p. 71.

70 He had bedrock faith in the old-fashioned virtues.: Herskowitz, p. 74.

70 "When my boys went off to war," . . . "They were entitled to them.": Herskowitz, p. 77.

70 "It got me in trouble with the alumni,": Herskowitz, p. 77.

70 He left A&M "heartbroken,": Herskowitz, p. 78.

70 I knew what I was doing. But it was the right thing to do.: Herskowitz, p. 77.

71 If bets were made about where . . . and that's being generous.": Kyle Cunning-ham, "An Unlikely Superstar," *The Battalion*, Nov. 23, 2010, http://www.

thebatt.com/sports/an-unlikely-superstar-1.1795020?.

71 Only the Air Force Academy offered . . . played at the Division One Level.": Cunningham, "An Unlikely Superstar."

71 "despicable, vile, unprincipled scoundrels.": John MacArthur, *Twelve Ordinary Men* (Nashville: W Publishing Group, 2002), p. 152.

72 He was surprised that A&M recruited . . . "in case of emergency.": Neil Hohlfeld, "Lonesome End," *Houston Chronicle*, Oct. 24, 2001, http://www.chron.com/CDA/archives/archive. mol?id=2001_3343576.

72 Senior Lonnie Madison, who was . . . really good for a defensive lineman.": Hohlfeld, "Lonesome End."

72 "the accidental tight end,": Hohlfeld, "Lonesome End."

72 I try to concentrate, try to relax and try not to mess up too bad.: Hohlfeld, "Lonesome End."

73 "A&M's witty basketball wizard,": "Legendary Aggie Hoops Coach Shelby MetCalf Passes Away," *AggieAthletics.com*, Feb. 8, 2007, http://www.aggieathletics.com/sports/m-baskbl/spec-rel/020807aab.html.

73 "systematically rip[ped] apart a good . . . over after only 12 minutes": Mitch Lawrence, "Aggies Rise from Depths with a Splash," *The Dallas Morning News*, March 9, 1987, http://nl.news bank.com/nl-search/we/Archives?p_action=doc&p_docid=0ED3CF2158254.

73 "This was the Aggie version . . . a pumpkin into a coach.": Lawrence, "Aggies Rise from Depths."

74 He appeared at open football . . . weighing almost 150 pounds.: "The Tower of Big Ben," *Aggie Athletics.com*, Sept. 1, 2007, http://www.aggieathletics.com/sports/m-footbl/spec-rel/090107aaa.html.

74 when he knocked 280-pound running . . . after the 2006 Holiday Bowl.: Terrance Harris, "At Just 5-3, Ben Bitner Has Made a Name for Himself," *Houston Chronicle*, Dec. 25, 2006, http://www. chron.com/CDA/archives/archive.mpl?id=2006_4254389.

74 A spat with roommates led him . . . and offered him shelter, Bitner declined.: Harris, "At Just 5-3, Ben Bitner Has Made a Name for Himself."

74 Each morning when the coaches . . . and heading out for class.: "The Tower of Big Ben."

74 He was really homeless and no one knew it.: Harris, "At Just 5-3, Ben Bitner Has Made a Name for Himself."

75 an incident later recalled as one of the most bizarre football-related events of the century: Buchanan, p. 23.

75 In the 1970s, Rice's combination of a small . . . poked fun at anything they could think of.: Buchanan, p. 22.

75 A&M fans were in a surly mood . . . pulled by a dogless leash.: Buchanan, pp. 22-23.

75 The Aggies "hurled trash, insults, and threats . . . unknowing but still irate Aggie fans.: Buchanan, p. 23.

75 "a purely selfish matter . . . misfortune or frustration": Bruce T. Dahlberg, "Anger," *The Interpreter's Dictionary of the Bible* (Nashville: Abingdon Press, 1962), Vol. 1, p. 136.

75 Still seething, an Aggie crowd . . . with the MOB once and for all.: Buchanan, p. 23.

76 "undefeated, untied and virtually unchallenged" and a prohibitive favorite: *Aggies: A Century of Football Tradition*, p. 23.

76 Six A&M players had been knocked out of the game;: Schoor, p. 2.

76 with only one substitute available to play,: Evans and McElroy, p. 16.

76 In the dressing room, Bible remembered . . . spotting the players for journalists.: Schoor, pp. 2-3.

76 He sent Gill a message . . . the stands and swapped clothes.: Evans and McElroy, p. 16.

76 "the biggest game A&M had ever had.": Evans and McElroy, p. 14.

76 he "won immortality simply by being . . . merely by climbing into a uniform.": Evans and McElroy, p. 16.

76 Yell leader Harry W. Thompson, . . . referred to Gill as The Twelfth Man.: Evans and McElroy, p. 18.

76 'It looks like we may not have . . . 'Yes, sir.': Evans and McElroy, p. 16.

77 A&M's Olsen Field was famous for . . . before the inning started.: Zwerneman, *More Tales from Aggieland*, p. 88.

77 always preferred to eat in a cafeteria . . . will that makes you win!": Zwerneman, *More Tales from Aggieland*, p. 79.

77 "There was a lot of drug testing . . . were consumed on the spot.": Zwerneman, *More Tales from Aggieland*, p. 80.

78 Nguyen has always figured he got . . . and said, 'I'm an Aggie,'": Kelli Anderson, "Dat Nguyen," *Sports Illustrated*, Aug. 29, 1994, http://sportsillustrated.cnn.com/vault/article/magazine/MAG1005592/index.htm.

79 During a time out in the second half, . . . escorted South off the floor.: Al Pickett, *The Greatest Texas*

Sports Stories You've Never Heard (Abilene: State House Press, 2007), p. 192.

79 South said the incident took on . . . and sent it to South.: Pickett, p. 193.

79 The conference fired the referee at season's end,: Pickett, p. 192.

79 the security guard later showed his appreciation for South's fame by posing with him for a picture.: Pickett, p. 193.

79 It is very funny now, and I tell the story all the time.: Pickett, p. 193.

80 "solemnly had collected for its one great effort of 1955.": Evans and McElroy, p. 193.

80 behind a clearing block from Jack Pardee.: Evans and McElroy, p. 193.

80 Rice expected an onside kick . . . but Pardee placed it perfectly.: Evans and McElroy, p. 194.

80 "terminated a Rice winning .streak . . in the exuberant winners' locker room.: Evans and McElroy, p. 194.

80 Rice outplayed us and deserved to win. We were very, very lucky.: Evans and McElroy, p. 194.

81 There Burgoon stood, hands on his hips,: "Texas A&M Wins School's First Men's NCAA Golf Championship," *USA Today*, May 30, 2009, http://www.usatoday.com/sports/college/golf/2009-05-30-ncaa-mens-golf-championship.

81 His tee shot wound up far . . . he'd get it on the green.: "Texas A&M Wins School's First."

81 "one mighty hack." . . . missed a 35-foot putt to tie.: "Texas A&M Wins School's First."

82 The week of the game against . . . just might upset the 2003 champs.: Neil Hohlfeld, "Texas A&M 42, Kansas State 30: A&M Stops Sproles," *Houston Chronicle*, Oct. 3, 2004, http://www.chron.com/CDA/archives/archive.mpl?id=2004_3807326.

82 "We talked a lot about . . . we did better than that.": Hohlfeld, "Texas A&M 42, Kansas State 30: A&M Stops Sproles."

82 The offense scored six . . . that totaled 7 minutes, 15 seconds.: Hohlfeld, "Texas A&M 42, Kansas State 30: A&M Stops Sproles."

82 We did a great job on Sproles.: Hohlfeld, "Texas A&M 42, Kansas State 30: A&M Stops Sproles."

83 "had as much trouble with [Routt] as his professors [did].": Evans and McElroy, p. 134.

83 "Joe was unruly, pugnacious, and hard to handle when he first came to A&M,": Evans and McElroy, p. 133.

83 In the 1936 game against Centenary, . . . from then on he was easy to handle.": Evans and McElroy, p. 134.

83 when he lost, he said, "If I can't beat this guy, I'm giving up boxing." He did.: Evans and McElroy, p. 136.

83 [Joe Routt] was mean, cantankerous, . . . [Norton] straightened him out.: Evans and McElroy, pp. 134-35. 84 The Aggies were up 7-0 and . . . out of the Alabama pressure.: Chris Greenberg, "Johnny 'Football' Touchdown: Manziel Fumbles, Scrambles, Throws TD vs. Alabama," *The Huffington Post*, Nov. 10, 2012, http://www.huffingtonpost.com/2012/11/10/johnny-football-manziel-touchdown-alabama-fumble_n_2110706.html.

84 "With waves ot Tide rushers crashing around him,": Greenberg, "Johnny 'Football' Touchdown.'"

84 "Thanks to Manziel's composure . . . part of [A&M] folklore.": Richard Croome, "Texas A&M's Ogbuehi Remembers Crazy Manziel Play," *The Eagle*, Sept. 11, 2013, http://www.theeagle.com/aggie_sports/football/texas-a-m-s-ogbuehi-remembers-crazy-manziel-play/article.

84 That kind of made him the . . . one game, and that was it.: Croome, "Texas A&M's Ogbuehi Remembers Crazy Manziel Play."

85 If you hadn't been there before, you couldn't find it the first time.": Evans and McElroy, p. 247.

85 the "farm-to-market road back . . . and a tough disposition": Evans and McElroy, p. 247.

85 He was "a little old timid boy," . . . familiar if "winding, bumpy" road: Evans and McElroy, p. 247.

85 If you could walk and chew gum in Linden, you played football.: Zwerneman, Brent, *Game of My Life* (Champaign, IL.: Sports Publishing L.L.C., 2003), p. 63.

86 He once put a live . . . sailing into the drink.: Andrew Lawrence, "Locked Out and Loaded," *Sports Illustrated*, April 18, 2011, http://sportsillustrated.cnn.com/vault/article/magazine/MAG1184409/index.htm.

86 It wasn't that the senior Von . . . gonna take football away from him.": Lawrence, "Locked Out and Loaded."

86 As soon as you think you're safe, he'll come up with something else.: Lawrence, "Locked Out and Loaded."

87 "It seemed like the impossible dream," . . . This is crazy.'": Zwerneman, *More Tales from Aggieland*, p. 78.

87 pulling a muscle running out a . . . "Hey, I can go.": Robyn Norwood, "College Softball World Series," *Los Angeles Times*, May 25, 1987, http://articles.latimes.com/1987-05-25/sports/sp-1513_1_college-world-series-game.

88 "as a nightmarish day for the three referees and for one official on the scorer's

table.: Rick Cantu, "Aggies Defeat Horns After Score Reversal," *Austin American-Statesman*, Feb. 21, 2010, p. C05.

88 Neither head coach knew what was . . . an 11-4 run when play resumed: Cantu, "Aggies Defeat Horns."

89 In 1985, the sports network began . . . was a force to be reckoned with.": Jacobs, pp. 89-90.

89 "I didn't send Eric Franklin out there to miss,": Jacobs, p. 90.

90 "If John David doesn't get it, they ought to quit giving it.": Evans and McElroy, p. 213.

90 "When I think of football, I think of Coach Bryant.": Evans and McElroy, p. 216.

90 In the 13-2 win over SMU . . . "John, our goal is THATAWAY!": Evans and McElroy, p. 216.

90 I was scared to death and knew what was coming.: Evans and McElroy, p. 216.

91 The tradition began in 1931 . . . a regular in the Corps area.: Schoor, p. 61.

91 The following football season she . . . during a halftime performance.: "Reveille, "Aggie Traditions, http://aggietraditions.tamu.edu/symbols/reveille.html.

91 During World War II, she was made a general in the K-9 Corps.: Schoor, p. 61.

91 That first Reveille died in 1944 and was given a formal military funeral in Kyle Field.: "Reveille."

91 Several other unofficial mascots, such as Tripod, Spot, and Ranger,: "Reveille."

91 Reveille II, a Shetland shepherd, appeared in 1952. Reveille III was the first collie: Schoor, p. 61.

91 Corps company E-2 is the official mascot . . . (and a cell phone).: Dave Wilson, "Texas A&M's Reveille Wants Equal Time," *ESPN.com*, April 5, 2011, http://sports.espn.go.com/page2/story?page=wilson/110405.

91 When a stadium expansion sealed off . . . could keep track of the score.: Wilson.

91 Reveille is a highly cherished mascot and receives only the bet.: "Reveille."

92 His head coach, Tony Barone "just . . . down on his knees and prayed.: Burson, p. 251.

92 He asked God to send someone who could give him a little comfort.: Burson, pp. 251-52.

92 "I was so specific," . . . for me to stay at Texas A&M.": Burson, p. 252.

92 "Almost immediately," McGinnis' academic . . . to send me a real sign.": Burson, p. 252.

92 "Tony, I was just thinking about you. Keep your head up, son. You're going to make it.": Burson, p. 252.

92 South had never been to the room . . . I believe it now. I'm staying.": Burson, p. 252.

93 It had rained all night and all morning in College Station.: Jinx Tucker, "Mighty Texas Aggie Eleven Turns Back Stubborn Mustangs" as quoted in Herskowitz, p. 162.

93 The rain ceased for a while in the third quarter,: Tucker in Herskowitz, p. 160.

93 "the greatest wet weather game in the history of man": Tucker in Herskowitz, p. 162.

93 "the greatest football game waged under adverse circumstances that this country has ever seen.": Tucker in Herskowitz, p. 157.

93 "proved the better bird dog in the mud.": Evans and McElroy, p. 152.

93 they hit a pass to the Aggie 20.: Tucker in Herskowitz, p. 167.

93 The last throw came with one . . . defense batted it away.: Tucker in Herskowitz, p. 162.

93 Each churning step caused moisture to spring from the wet turf.: Tucker in Herskowitz, p. 157.

94 For most of his adult life, Allen . . . his favorite among them all.: Al Carter, "Revisionist History," *The Dallas Morning News*, Sept. 24, 1994, http://nl.newsbank.com/nl-search/we/Archives?p_action=doc&p_docid=0ED3D4F488F0C.

94 "That particular play is etched in my mind,": Carter, "Revisionist History."

94 "turned in a play that left his dad's definition of ecstasy positively time-warped.": Carter, "Revisionist History."

94 According to those around . . . that play was very exciting." Carter, "Revisionist History."

94 I guess he's kind of reliving . . . that makes me feel good.: Carter, "Revisionist History."

95 "At first glance, Texas A&M . . . career as A&M's head football coach.: *Aggies, A Century of Football Tradition*, p. 57.

95 Bryant's flight was five hours late, . . . back to the theater's center stage.: Schoor, p. 99.

95 Bryant later said that publicity . . . those thousands of frenzied Aggies.: *Aggies, A Century of Football Tradition*, p. 57.

95 not even a fire-and-brimstone preacher . . . religion to the adoring masses.": Schoor, p. 99.

95 He first dramatically took off his coat . . . rolled up his sleeves.: *Aggies, A Century of Football Tradition*, p. 57.

95 "the swelling noise sweeping across campus like a prairie fire.": Schoor, p. 99.

95 "It was like voodoo. . . . louder than a hundred of anybody else.": *Aggies, A Century of Football Tradition*, p. 57.

95 This place will grow on you.: *Aggies, A Century of Football Tradition*, p. 57.

WORKS CITED

Aggies: A Century of Football Tradition. New York City: Professional Sports Publications, 1994.

Anderson, Kelli. "Dat Nguyen." *Sports Illustrated.* 29 Aug. 1994. http://sportsillustrated.cnn.com/vault/article/magazine/MAG1005592/index.htm.

Barron, David. "One-Point Safety Catches Both Teams by Surprise." *Houston Chronicle.* 27 Nov. 2004. http://www.chron.com/CDA/archives/archive.mpl?id=2004_3822508.

Bettinger, Jim & Julie S. *The Book of Bowden.* Nashville: TowleHouse Publishing, 2001.

Blinebury, Fran. "Style, Success Passing Notre Dame By." *Houston Chronicle.* 30 Sept. 2001. http://www.chron.com/CDA/archives/archive.mpl?id=2001_3338203.

Bock, Gabe. "TexAgs Talks Texas A&M Women's Hoops with Kelly Krauskopf." *TexAgs.com.* 4 April 2011. http://v.4.texags.com/stories/1868.

Buchanan, Olin. *Stadium Stories: Texas A&M Aggies: Colorful Tales of the Maroon and White.* Guilford, CN: The Globe Pequot Press, 2004.

Burson, Rusty. *Texas A&M: Where Have You Gone?* Champaign, IL: Sports Publishing L.L.C., 2004.

Cantu, Rick. "Aggies Defeat Horns After Score Reversal." *Austin American-Statesman.* 21 Feb. 2010. C05.

Carter, Al. "Revisionist History: Dennis Allen Gives His Dad a New Favorite Aggie Memory." *The Dallas Morning News.* 24 Sept. 1994. http://nl.newsbank.com/nl-search/we/Archives?p_action=doc&p_docid=0ED3D4F488F0C.

Cessna, Robert. "Fast-Pace Offense Strikes Again, Leads Texas &M Past Mississippi State." *The Eagle.* 10 Nov. 2013. http://www.theeagle.com/aggie_sports/football/fast-pace-offense-strikes-again-leads-texas-a-m-past/article.

-----. "Labhart's Journey to Field for Texas A&M a Long, Winding One." *The Eagle.* 17 Oct. 2013. http://www.theeagle.com/aggie_sports/football/labhart-s-journey-to-field-for-texas-a-m-a/article.

Croome, Richard. "Journey Has Been Like a Dream for the Aggies." *theeagle.com.* 8 Feb. 2013. www.theeagle.com/news/local/article_c1ff2fc3-6d74-5d3e-90f0-3282da8f3a21.html.

-----. "Texas A&M's Ogbuehi Remembers Crazy Manziel Play." *The Eagle.* 11 Sept. 2013. http://www.theeagle.com/aggie_sports/football/texas-a-m-s-ogbuehi-remembers-crazy-manziel-play/article.

Cunningham, Kyle. "An Unlikely Superstar: Hodges Battles Adversity to Make Name." *The Battalion.* 23 Nov. 2010. http://www.thebatt.com/sports/an-unlikely-superstar-1.1795020?.

-----. "Safety Saves the Game with Key Picks." *The Battalion.* 22 Nov. 2010. http://www.thebatt.com/sports/safety-saves-the-game-with-key-picks-1.1788415.

Dahlberg, Bruce T. "Anger." *The Interpreter's Dictionary of the Bible.* Nashville: Abingdon Press, 1962. Vol. 1. 135-37.

Evans, Wilbur and H.B. McElroy. *The Twelfth Man: A Story of Texas A&M Football.* Huntsville, AL: The Strode Publishers, 1974.

Feinberg, Doug. "Adams Totes A&M on her Back to Title." *statesman.com.* 6 April 2011. http://www.statesman.com/sports/aggies/adams-totes-a-m-on-her-back-to-1378976.html.

"Fightin' Texas Aggie Band." *Wikipedia, the free encyclopedia.* http://en.wikipedia.org/wiki/Fightin'Texas_Aggie_Band.

"The Fightin' Texas Aggie Band." *Texas A&M University Corps of Cadets.* http://corps.tamu.edu/the-corps-experience/the-fightin-texas-aggie-band.html.

"Former Player Says Texas A&M Women's Basketball Has Come a Long Way." *The Dallas Morning News.* 4 April 2011. http://www.dallasnews.com/sports/college-sports-texas-aggies/20110404.

Forsyth, John D. *The Aggies and the 'Horns.* Austin: Texas Monthly Press, Inc., 1981.

Gold, Eli. *Crimson Nation.* Nashville: Rutledge Hill Press, 2005.

Greenberg, Chris. "Johnny 'Football' Touchdown: Manziel Fumbles, Scrambles, Throws TD vs. Alabama." *The Huffington Post.* 10 Nov. 2012. http://www.huffingtonpost.com/2012/11/10/johnny-football-manziel-touchdown-alabama-fumble_n_2110706.html.

Grimmer, Sarah. "Texas A&M Student-Athlete Spotlight: Meagan May." *Big12Sports.com.* 7 April 2011. http://www.big12sports.com/ViewArticle.dbml?DB_OEM_ID=10410&ATCLID=205131.

Halliburton, Suzanne. "Aggies Lack Title But Not Feeling That They Belong." *Austin American-Statesman.* 31 March 2011. C01.

Harris, David. "No. 19 Aggies Just Keep Fighting: A&M 42, Baylor 30." *The Battalion.* 14 Nov. 2010. http://www.thebatt.com/news/no-19-aggies-just-keep-fighting-

1.1775906.

-----. "One Miracle Gives Aggies Shot at Title." *The Battalion*. 4 April 2011. http://www.thebatt.com/news/ david-harris-one-miracle-gives-aggies-shot-at-title-1.2139661.

-----. "Texas A&M Stuns No. 1 Alabama in Upset." *theeagle.com*. 11 Nov. 2012. www.theeagle.com/news/ local/article_779933e9-e9de0-5271-89dc-2940de8de7d6.html.

Harris, Terrance. "At Just 5-3, Ben Bitner Has Made a Name for Himself as a Defensive Back on the Texas A&M Scout Team." *Houston Chronicle*. 25 Dec. 2006. http://www.chron.com/CDA/archives/archive. mpl?id=2006_4254389.

-----. "Late Heroics Net A&M Win: Ags' TD Pass in 4th, PAT Block in Overtime Overcome Oklahoma St." *Houston Chronicle*. 22 Oct. 2006. http://www.chron.com/CDA/archives/archive.mpl?id=2006_ 4214751.

-----. "The Horrific Scenes of 9/11 Remain Etched in the Mind of A&M's Mark Dodge." *Houston Chronicle*. 11 Sept. 2006. http://www.chron.com/CDA/archives/archive.mpl?id=2006_4188322.

Hayslip, Patrick. "Continuing the Aggie Legacy." *The Battalion*. 1 March 2010. http://www.thebatt.com/ 2.8485/continuing-the-aggie-legacy-1.1181180.

Herskowitz, Mickey. *The 1939 Texas Aggies: The Greatest Generation's Greatest Team*. Houston: Halcyon Press Ltd, 2006.

Hohlfeld, Neil. "A&M Dims Lights on Iowa State's Party." *Houston Chronicle*. 10 Oct. 2004. http://www. chron.com/CDA/archives/archive.mpl?id=2004_3808518.

-----. "Lonesome End: A&M's Carriger Finds Himself Last Scholarship Player Standing at New Position." *Houston Chronicle*. 24 Oct. 2001. http://www.chron.com/CDA/archives/archive.mpl?id=2001_ 3343576.

-----. "Notre Dame-Texas A&M Summary." *Houston Chronicle*. 30 Sept. 2001. http://www.chron.com/CDA/ archives/archive.mpl?id=2001_3338206.

-----. "Texas A&M 42, Kansas State 30: A&M Stops Sproles, Drops K-State." *Houston Chronicle*. 3 Oct. 2004. http://www.chron.com/CDA/archives/archive.mpl?id=2004_3807326.

Holder, Beau. "The Night That Changed Everything." *The Battalion*. 27 March 2010. http://www.thebatt. com/2.8484/the-night-that-changed-everything-1.1283271.

Hyman, Mervin. "Football's Week." *Sports Illustrated*. 15 Oct. 1962. http://sportsillustrated.cnn.com/vault/ article/magazine/MAG1074204/index.htm.

Jacobs, Homer. *The Pride of Aggieland*. New York City: Silver Lining Books, 2002.

Justice. Richard. "After 3-7 League Start, A&M Decides to Fight: Win Was Team Effort." *Houston Chronicle*. 8 March 2009. http://www.chron.com/CDA/archives/archive.mpl?id=2009_4709520.

"Katy Doyle Wins national Championship in the Javelin." *AggieAthletics.com*. 11 June 2004. http://www. aggieathletics.com/sports/c-xctrack/spec-rel/061104aaa.html.

Khan, Sam, Jr. "A&M's Kennedy the Heart of Receiving Corps." *ESPN.com*. 1 Oct. 2014. http://espn. go.com/blog/sec/post/_/id/89890/ams-kennedy-the-heart-of-receiving-corps.

-----. "Myles Garrett's Path to Greatness Off to Strong Start." *ESPN.com*. 15 Dec. 2014. http://espn.go.com/ blog/sec/post/_/id/95469/myles-garretts-path-to-greatness-off-to-strong-start.

Killion, Ann. "Once Unthinkable, Texas A&M Crowned Champions for First Time." *Sports Illustrated*. 6 April 2011. http://sportsillustrated.cnn.com/2011/writers/ann_killion/04/06/texas.am.baylor/ index.html.

Lawrence, Andrew. "Locked Out and Loaded." *Sports Illustrated*. 18 April 2011. http://sportsillustrated. cnn.com/vault/article/magazine/MAG1184409/index.htm.

Lawrence, Mitch. "Aggies Rise from Depths with a Splash: Last-Seeded A&M Routs Baylor to Win SWC Tourney Title." *The Dallas Morning News*. 9 March 1987. http://nl.newsbank.com/nl-search/we/ Archives?p_action=doc&p_docid=0ED3CF2158254.

"Legendary Aggie Hoops Coach Shelby Metcalf Passes Away." *AggieAthletics.com*. 8 Feb. 2007. http:// www.aggieathletics.com/sports/m-baskbl/spec-rel/020807aab.html.

Lester, Sean. "Overcoming Obstacles." *The Battalion*. 9 March 2011. http://www.thebatt.com/news/over coming-obstacles-1.2085126.

Lopez, John P. "No. 12 Fits Perfectly on A&M's Ray." *Houston Chronicle*. 23 Nov. 2005. http://www.chron. com/CDA/archives/archive.mpl?id=2005_4014323.

MacArthur, John. *Twelve Ordinary Men*. Nashville: W Publishing Group, 2002.

Magill, Susie. "Speedy Recovery." *Sharing the Victory Magazine*. June/July 2006. http://www.sharingthe victory.com/vsItemDisplay.lsp?method=display&objectid=5B45AB.

Maisel, Ivan. "College Football." *Sports Illustrated*. 19 Oct. 1998. http://sportsillustrated.cnn.com/vault/article/magazine/MAG1014359/index.htm.

"Malcome Kennedy Named Aggie Heart Award Winner at Football Banquet." *12thman.com*. 12 Dec. 2014. http://www.12thman.com/news/2014/12/12/209806688.aspx?path=football.

Norwood, Robyn. "College Softball World Series: Texas A&M Beats UCLA Twice to Win the Title." *Los Angeles Times*. 25 May 1987. http://articles.latimes.com/1987-05-25/sports/sp-1513_1_college-world-series-game.

Phillips, Alberta. "Big Dance Clearly Shows How A&M's Blair Is in Step with His Players." *Austin American-Statesman*. 9 April 2011. A14.

Pickett, Al. *The Greatest Texas Sports Stories You've Never Heard*. Abilene: State House Press, 2007.

"Reveille." *Aggie Traditions*. http://aggietraditions.tamu.edu/symbols/reveille.html.

Rieken, Kristie. "National Champion Aggies Welcomed Home." *SI.com*. 6 April 2011. http://sports.sportsillustrated.cnn.com/wcbk/story.

Schoor, Gene. *The Fightin' Texas Aggies: 100 Years of A&M Football*. Dallas: Taylor Publishing Company, 1994.

Sherrington, Kevin. "A Shining Career: A&M's R.C. Slocum Has Earned the Longstanding Respect of Many." *The Dallas Morning News*. 28 Oct. 1992. http://nl.newsbank.com/nl-search/we/Archives?p_action=doc&p_docid=0ED3D2755DD5.

Siegel, Joshua. "Manziel Leaves Kyle Field Crowd with One Last Show." *The Eagle*. 10 Nov. 2013. http://www/theeagle.com/aggie_sports/football/manziel-leaves-kyle-field-crowd-with-one-last-show/article.

Staples, Andy. "Texas A&M's Prayers Answered in Largest Last-Minute Comeback Ever." *SI.com*. 21 March 2016. http://www.si.com/college-basketball/2016-03-21/ncaa-tournament-texas-am-aggies-comeback.

"Texas A&M Postgame Quotes: Texas A&M 33, (#11) Oklahoma 19." KBTX.com. 7 Nov. 2010. http://www.kbtx.com/sports/headlines/Texas_AM_Postgame_Quotes.

"Texas A&M Wins School's First Men's NCAA Golf Championship." *USA Today*. 30 May 2009. http://www.usatoday.com/sports/college/golf/2009-05-30-ncaa-mens-golf-championship.

"The Tower of Big Ben." *AggieAthletics.com*. 1 Sept. 2007. http://www.aggieathletic.com.sports/m-footbl/spec-rel/090107aaa.html.

Trotter, Jake. "'We Weren't Ready to Be Done': How Texas A&M Managed Their Comeback." *ESPN.go.com*. 21 March 2016. http://espn.go.com/blog/collegebasketballnation/post/_/id/113628/texas-am-aggies-kept-on-believing-they-could-deliver-miracle.

Wilson, Dave. "Texas A&M's Reveille Wants Equal Time." *ESPN.com*. 5 April 2011. http://sports.espn.go.comj/espn/page2/story?page=wilson/110405.

Zwerneman, Brent. *Game of My Life: 25 Stories of Aggie Football*. Champaign, IL: Sports Publishing L.L.C., 2003.

-----. "Junction Boys the Stuff of A&M Football Legends." chron.com. 28 April 2010. http://www.chron.com/disp/story.mpl/sports/college/texasam/6980725.html.

-----. *More Tales from Aggieland*. Champaign, IL: Sports Publishing L.L.C., 2005.

-----. "Texas A&M 52, Texas Tech 30: Surprise, Surprise in Lubbock: Aggies Answer Blowout with First Road Victory over Raiders Since '93." *Houston Chronicle*. 25 Oct. 2009. http://www.chron.com.CDA/archives/archive.mpl?id=2009_4804978.

NAME INDEX
(LAST NAME, DEVOTION DAY NUMBER)

TEXAS A&M

SCRIPTURES INDEX
(by DEVOTION DAY NUMBER)